MW00580734

CANNIBALS of THE STONE AGE

Heshka

82000 BC

N

W BLABWORLD™ E

S

CONTENTS

BLABWORLD VOLUME 1 NUMBER 2 FOUNDER·EDITOR·DESIGNER: MONTE BEAUCHAMP

SEQUENTIAL ART

ADOLF'S ABERRATION NORA KRUG **5**

DISPATCHES FROM OBLIVION GREG CLARKE **9**

HOLLOW INSIDE ELVIS STUDIO **29**

LIDERC ANDREA DEZSO **33**

LEFTOVERS SERGIO RUZZIER **107**

THE VEXING THING UPSTAIRS DENIS KITCHEN **111**

THE GREAT SEA SERPENT OF BRAZIL'S

PARAHIBA RIVER MARK TODD **113**

VISITATION PETER KUPER **125**

ARTIST PROFILES

A PASSION FOR PAUL RYAN HESHKA **13**

FRED STONEHOUSE: A LIFE IN BETWEEN

BILL NORTH **117**

CARTOONS

EAMES LOUNGE SHAG **37**

THE AGNOSTIC GREG CLARKE **106**

ARTICLES

WILL ELDER DREW FRIEDMAN **38**

THE ZAP IN MY LIFE STEVEN HELLER **90**

THE HEREAFTER

AFTERLIFE RYAN HESHKA **40**

THE HEREAFTER ENSEMBLE ERIC WHITE **42**

MES PETIT CHOUX FEMKE HIEMSTRA **43**

A GRIM HEREAFTER JON MACNAIR **44**

OLD GROWTH ROB SATO **46**

THE END OF THE INVINCIBLE MAN JANA BRIKE **48**

ISLE OF THE DEAD MARTIN WITTFOOTH **50**

LET'S GO HOME BROOK SLANE **51**

POST MORTEM VISION LUCIANO SCHERER **52**

GHOSTLY GARY TAXALI **54**

IN THE AFTERMATH CATHIE BLECK **56**

THE NOTICE CRAIG LAROTUNDA **57**

HIMMELSBLICK MARC BURCKHARDT **58**

GARDEN MARC BURCKHARDT **59**

VANITAS SWEET LAURIE HOGAN **60**

VANITAS MEATY LAURIE HOGAN **61**

BUM REAP TRAVIS LAMPE **62**

HADES ROBERT CONNETT **64**

PEACE OUT CHET ZAR **65**

LENORE NICOLETTA CECCOLI **66**

THE TOUCH XIAOQING DING **67**

INTO THE ABYSS KEVIN SCALZO **68**

ENDLESS CIRCLE YOKO D'HOLBACHIE **70**

THE GOD OF DEATH YOKO D'HOLBACHIE **71**

DOUBLE RAINBOW CHARLES GLAUBITZ **72**

AFTERLIFE 1 AND 2 ELVIS STUDIO **74**

OUR DIRTY LITTLE SECRETS BASEMAN **76**

THE POWER AND THE GLORY LARRY DAY **78**

THE END LOU BEACH **79**

DEVIL DOG FIONA HEWITT **80**

AFTER HE KILLED HER LOU BROOKS **81**

CICADAS MICHAEL NOLAND **82**

UP! ERIK MARK SANDBERG **84**

ICARUS CHRISTOPHER BUZELLI **86**

RIDDLE OWEN SMITH **87**

BARASINGHA KRIS KUKSI **88**

UNTITLED GAS SHELL REMNANT JEAN-PIERRE ROY **89**

FRONT COVER: Gary Taxali **BACK COVER:** Marc Burckhardt, Greg Clarke, Nicoletta Ceccoli

PUBLISHED BY: Last Gasp of San Francisco
Ronald E. Turner, Publisher

777 Florida Street, San Francisco, CA 94110
www.lastgasp.com

BLABWORLD #2, Summer 2012. Published annually. All stories, articles, and artwork copyright ©2012 by the respective artists unless otherwise indicated. All rights reserved. No part of this book may be reproduced or transmitted in any form or by any means electronic or mechanical, including photocopying, recording, xerography, scanning, or any information storage or retrieval system now available or developed in the future without the written consent of the copyright holders and/or the editor and the publisher.

Printed in China

First Printing 2012

SPECIAL THANKS TO: Ron and Colin Turner, Gary Taxali, Ha.com, Glenn Bray, Ryan Heshka, Mark Alvarado, Fred Stonehouse, Becky Hall, and Brenda Byers.

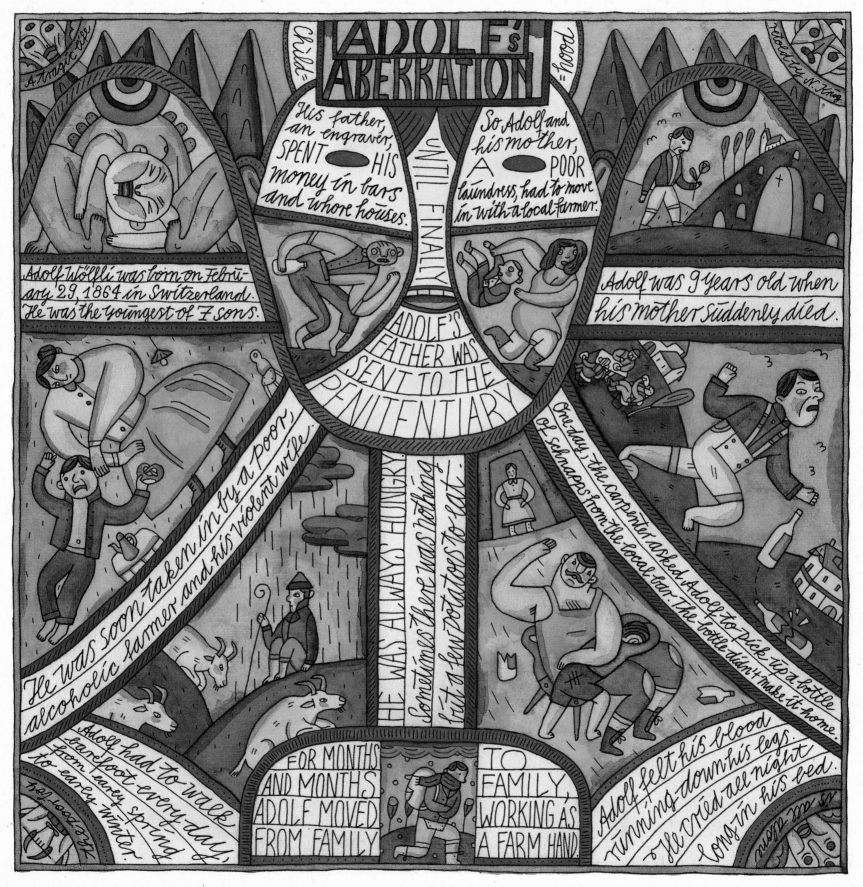

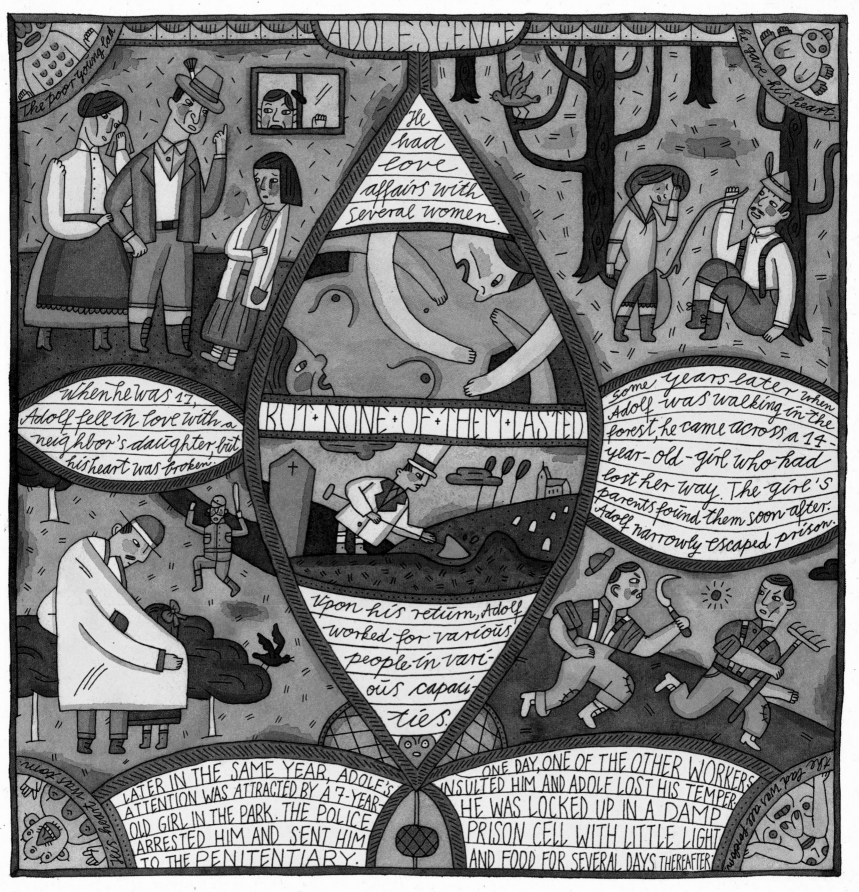

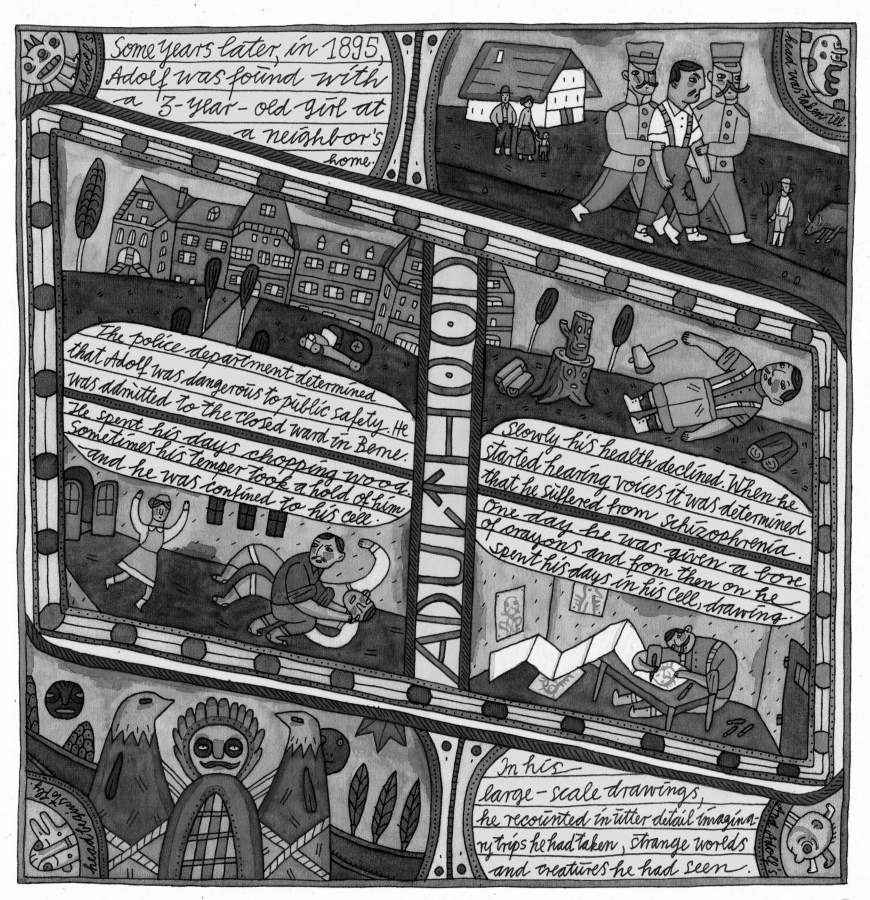

Some years later, in 1895, Adolf was found with a 3-year-old girl at a neighbor's home.

The police department determined that Adolf was dangerous to public safety. He was admitted to the closed ward in Berne. He spent his days chopping wood. Sometimes his temper took a hold of him and he was confined to his cell.

Slowly his health declined. When he started hearing voices it was determined that he suffered from schizophrenia. One day he was given a box of crayons and from then on he spent his days in his cell, drawing.

In his large-scale drawings, he recounted in utter detail imaginary trips he had taken, strange worlds and creatures he had seen.

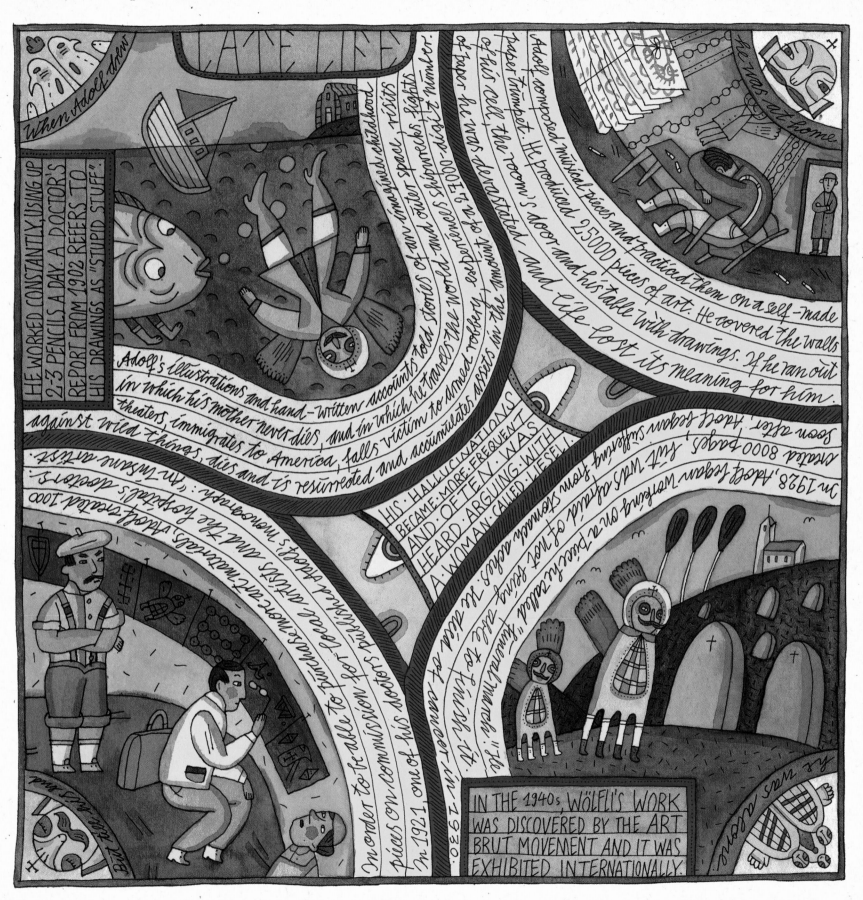

DISPATCHES
FROM
OBLIVION

By

GREG CLARKE

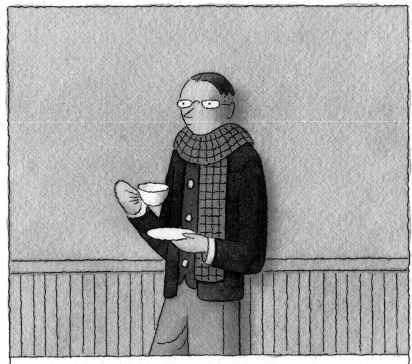

Edward had issues with the impermanence of organic matter.

His therapist went so far as to suggest that dwelling on such matters might be the source of his malaise (not to mention his inflamed epiglottis).

He envied his cat Charles who lived only in the present, unburdened by thoughts of death and decay.

Alas, as much as Edward yearned for an escape from this vale of tears...

...he took no comfort in religion or the notion of an afterlife, regarding both as products of wishful thinking.

Yet, he amused himself by fantasizing that he was receiving cryptograms from the great beyond.

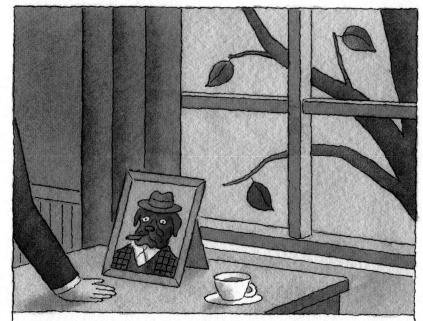

When he observed the late October leaves of his dogwood tree, they appeared to be turning the same red-oxide hue as Felton, his late French Mastiff.

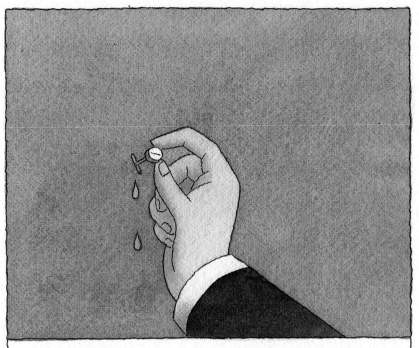

There was the time he discovered his late father's Bulgari cufflinks inexplicably resting at the bottom of his glass of Lagavulin.

A recurring erotic dream involving a youthful Claudia Cardinale and a bottle of Chateau Haut-Brion was invariably interrupted by the specter of his deceased mother-in-law.

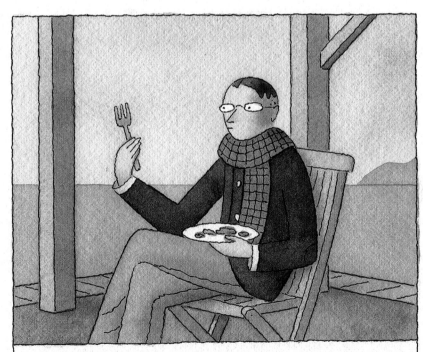

One afternoon, while dining al fresco, Edward swore he saw the visage of M.F.K Fisher reflected in the tines of his fork.

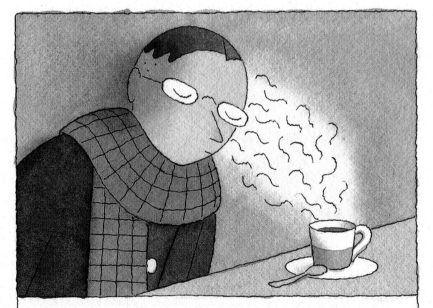

And he would never forget the intoxicating, pheromonal scent curiously emanating from a late-evening cup of espresso. It was that of Constance, an ex-lover who had perished in an unfortunate coffee-grinding accident.

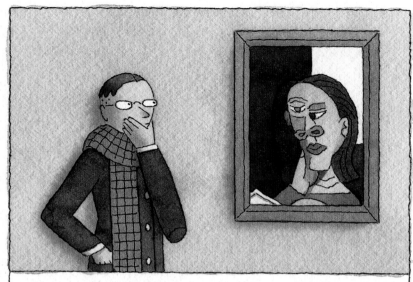

There was the ghostly voice in his head (belonging to his departed grandfather Frank, a notorious art thief from the 1930's), constantly reminding him that the aesthetic measure of an object was the ratio of its symmetry to its complexity.

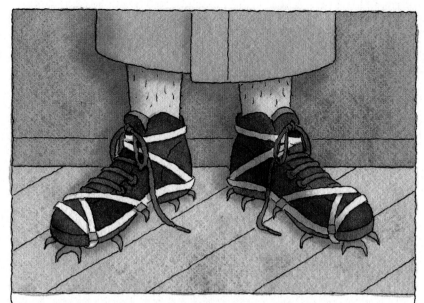

And it was a bit peculiar when he awoke one morning wearing crampons, perhaps a missive from his Uncle Vincent, a renowned mountain climber swallowed some years back by a crevasse on the western slope of K2.

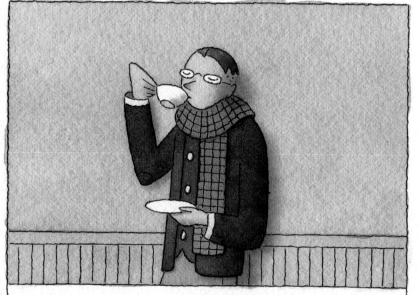

In the end, Edward felt his line of communication with the dead was as good as anyone's, but a collect phone call from the other side could have settled the matter once and for all.

THE
END

Fantastic Adventures Volume 1 Number 2 (backcover) July 1939

A PASSION FOR PAUL

PROFILE BY ILLUSTRATOR RYAN HESHKA

It was The Star Wars Album, the first book on the making of *Star Wars*, that first turned me on to the art of Frank R. Paul. On an interior spread that revealed George Lucas's inspirations behind the making of his epic blockbuster was a wondrous antiquated cover to an early science fiction magazine, *Amazing Stories*. Crude, yet beautifully painted, its futuristic portrayal of a clan of nude women sporting folding, wing-like headgear, observing a distant, globe-shaped space-craft was so odd and alien to my seven-year-old sensibilities, I pondered whether it had been produced on some far-off planet.

This single cover, dated December 1926 (which I later learned to be the artist's own personal favorite image that he created), led me to an enduring appreciation for the art of Paul.

Born in Vienna on April 18, 1884, Frank Rudolph Paul immigrated to New York City in 1906. His training in Europe as an artist and architect provided him with drawing skills and a visual understanding of perspective, environments, machinery, and textures.

In 1908, inventor and entrepreneur Hugo Gernsback launched *Modern Electrics*, the first radio and electronics magazine to appear in America. Shortly thereafter, he started a publishing company that specialized in scientific periodicals. Thanks to an art agency for which Paul had been freelancing, the two crossed paths in 1914. Gernsback, impressed by the artist's diverse illustration abilities, quickly hired the thirty-year-old, providing him with gainful employment. This chance meeting would prove life-changing for Paul, as Gernsback funneled a steady stream of assignments his way for much of his professional career.

In spring 1926, Gernsback entered the pulp magazine field, launching *Amazing Stories*, the first magazine devoted to "scientific-fiction" (a term later dubbed science fiction). From the get-go, Paul rendered the publication's full-color covers and interior pen-and-ink illustrations, and he also designed and hand-lettered the cover's commanding logotype. The novel new magazine showcased reprinted stories by popular authors of the day such as H.G. Wells and Jules Verne, among others. *Amazing Stories* proved a resounding success, inspiring Gernsback to release similar titles in the months ahead.

Pulp magazines, named for the thick, inexpensive pulpwood paper on which they were printed, were notorious for their gaudy, lurid appearance and poorly penned tales. Shy, easily embarrassed patrons of such fiction would often tear off the covers to read them in public without raising eyebrows. Since hundreds of such titles were crammed onto newsstands at any given time, publishers insisted that cover illustrators use every trick (and color) in the book to grab a potential buyer's attention—a demand that Paul easily adapted to.

Paul used primary gouache colors squeezed straight from the tube to serve as [*cont. page 20*]

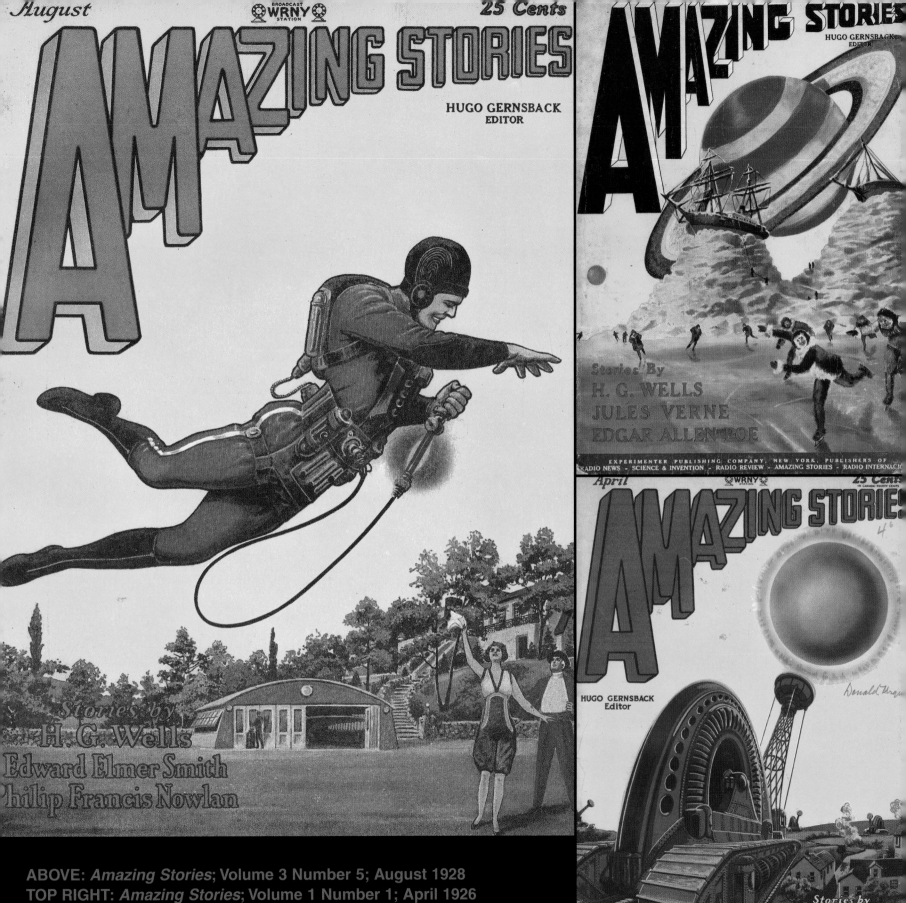

ABOVE: *Amazing Stories*; Volume 3 Number 5; August 1928
TOP RIGHT: *Amazing Stories*; Volume 1 Number 1; April 1926
BOTTOM RIGHT: *Amazing Stories*; Volume 4 Number 1; April 1929

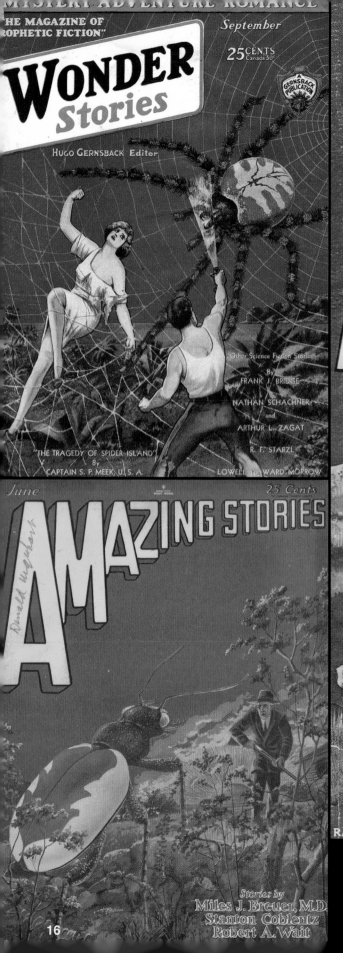

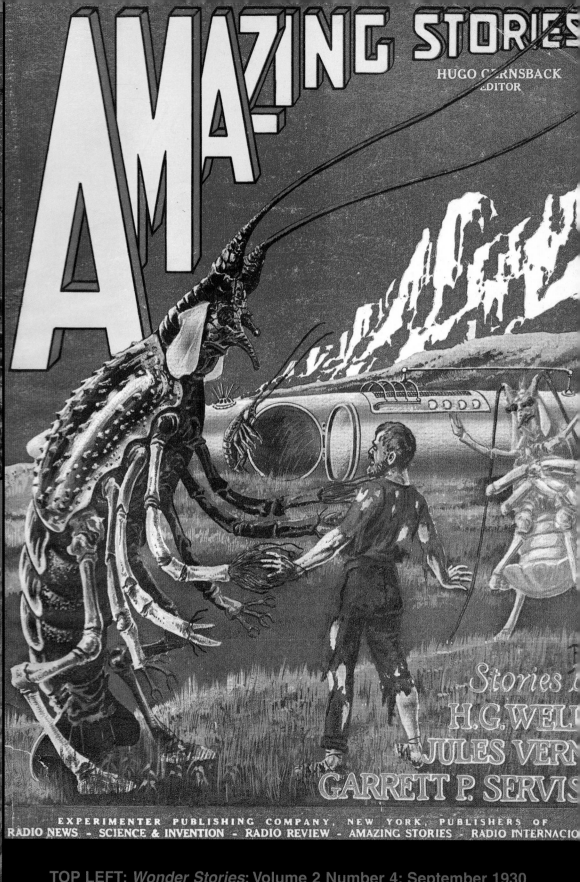

TOP LEFT: *Wonder Stories*; Volume 2 Number 4; September 1930
BOTTOM LEFT: *Amazing Stories*; Volume 4 Number 3; June 1929
ABOVE: *Amazing Stories*; Volume 1 Number 7; October 1926

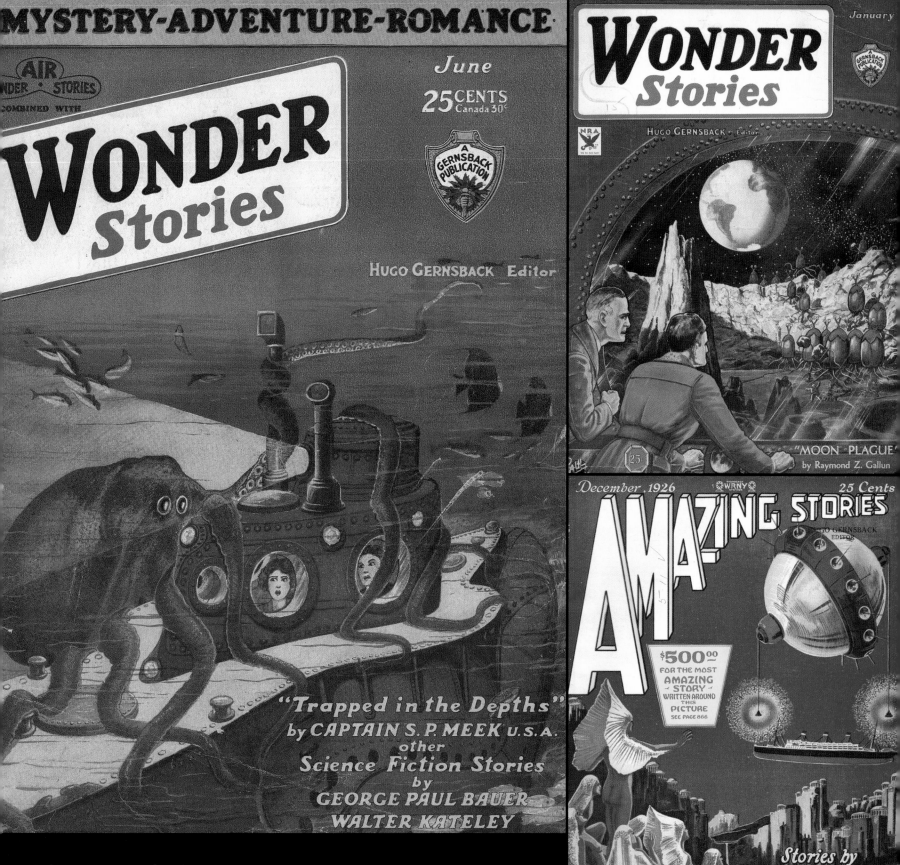

MYSTERY-ADVENTURE-ROMANCE

AIR Wonder Stories COMBINED WITH

WONDER
Stories

June
25 CENTS
Canada 30¢

A GERNSBACK PUBLICATION

HUGO GERNSBACK Editor

"Trapped in the Depths"
by CAPTAIN S. P. MEEK U.S.A.
other
Science Fiction Stories
by
GEORGE PAUL BAUER
WALTER KATELEY

January

Wonder
Stories

A GERNSBACK PUBLICATION
NRA

Hugo GERNSBACK · Editor

"MOON PLAGUE"
by Raymond Z. Gallun

December, 1926 WRNY STATION 25 Cents

AMAZING STORIES

HUGO GERNSBACK EDITOR

$500.00
FOR THE MOST
AMAZING
STORY
WRITTEN AROUND
THIS
PICTURE
SEE PAGE 866

Stories by
**H. G. WELLS
GARRETT P. SERVISS
A. HYATT VERRILL**

ABOVE: *Wonder Stories*; Volume 2 Number 1; June 1930
TOP RIGHT: *Wonder Stories*; Volume 5 Number 6; January 1934
BOTTOM RIGHT: *Amazing Stories*; Volume 1 Number 9; December 1926

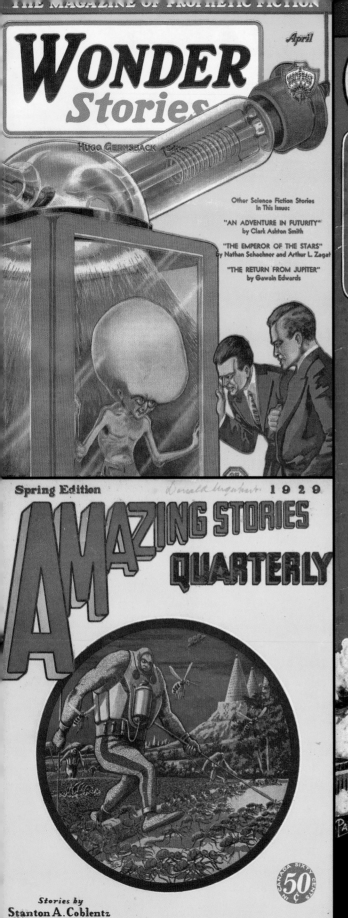

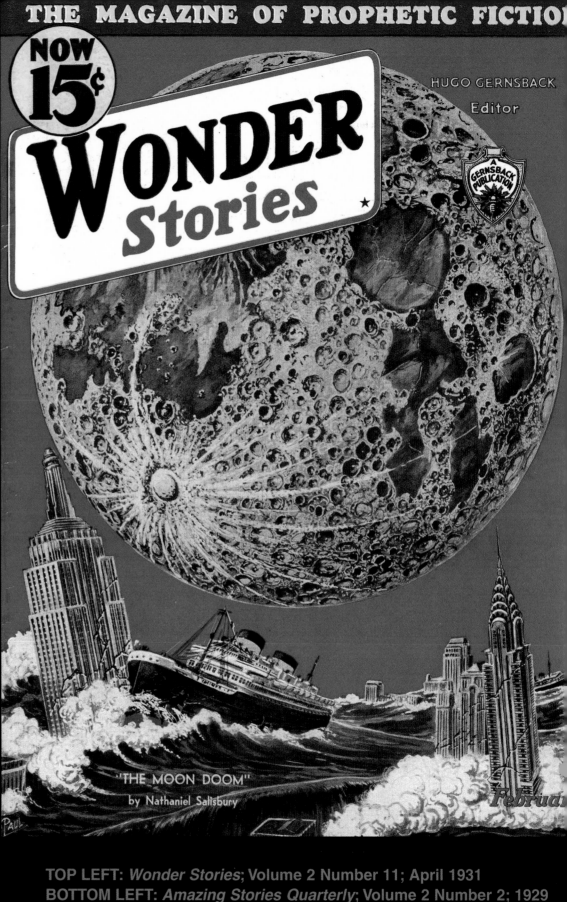

TOP LEFT: *Wonder Stories*; Volume 2 Number 11; April 1931
BOTTOM LEFT: *Amazing Stories Quarterly*; Volume 2 Number 2; 1929
ABOVE: *Wonder Stories*; Volume 4 Number 9; February 1933

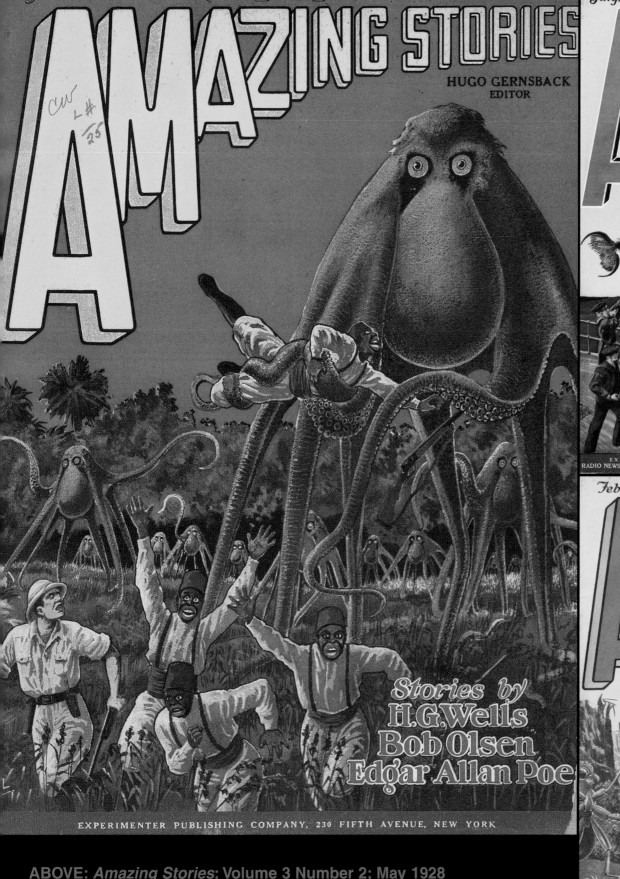

Amazing Stories

HUGO GERNSBACK
EDITOR

Stories by
H. G. Wells
Bob Olsen
Edgar Allan Poe

EXPERIMENTER PUBLISHING COMPANY, 230 FIFTH AVENUE, NEW YORK

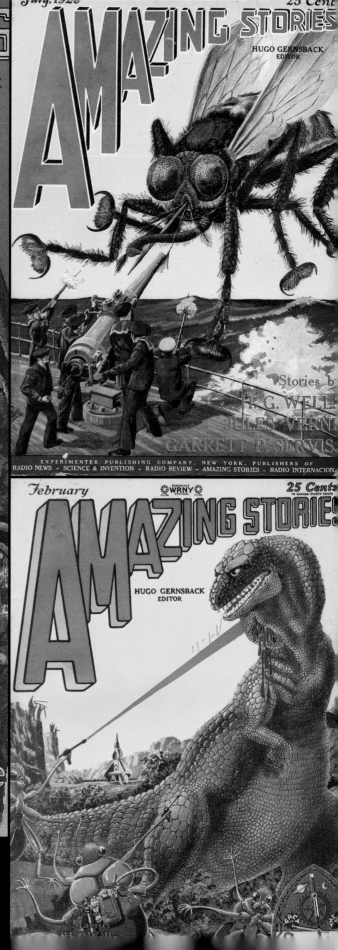

his composition's background, and then over stark Technicolor skies he painted phantasmagorical cover scenarios, the likes of which had never been envisioned before. Followers of Gernsback's groundbreaking line not only raved about Paul's imagination and inventiveness, they hounded the publisher for original art. Thanks to such fans, and Gernsback himself—who was savvy enough to archive the original art—prime examples exist today. The exception, sadly, is Paul's oeuvre for *Amazing Stories*, which Gernsback lost control of in 1929 due to some shady business partners. None of these originals have ever resurfaced, leaving one to assume they wound up in a dumpster once Gernsback was ousted.

Whereas most other pulp illustrators aspired to work for the "slicks"—magazines such as *Life* or *The Saturday Evening Post*, which had a higher profile and paid better—Paul was very content working for the pulps. He had found his niche and was absolutely at home there. The mild-mannered artist preferred the company of aliens and astronauts to that of white-picket-fenced families and warm apple pie.

Reportedly a pleasant individual and devout family man, Paul took immense pleasure in creating scenes of interplanetary havoc and mayhem. He destroyed the Empire State Building and the Chrysler Building on many occasions. He leveled the Woolworth Building. He hauled the Eiffel Tower up into space via a tentacled flying saucer. Paul unleashed more alien horrors onto mankind (and other interplanetary races as well) than anyone else, until Hollywood got up to speed in the 1950s.

Paul was a true visionary. Though never a household name, his influence on the course of popular culture and even modern science is with us daily. Aside from pioneering a vast inventory of science fiction iconography, perhaps more importantly, Paul visualized many concepts of space travel that came to be realized not long after his passing in 1963. For all the destruction he rendered, Paul possessed a miraculous imaginative mind in terms of scientific possibilities and growth, envisioning futuristic scenarios we now take for granted: space walks, moon walks, vertical rocket take-offs, space suits, space stations, satellites, satellite dishes, and even civilian space travel—long before commercial air flight was available to the everyday citizen. And he never stopped at dreaming these concepts up. In the pages of the tawdry, throwaway pulp magazine, Paul painstakingly illustrated detailed cutaway views of all manner of space stations and space suits, labeling each and every working part as though he were preparing drawings for the U. S. patent office. His was an imagination truly unhindered.

Aside from his formative training in architecture and art, Paul seemed to have no strong, obvious, direct visual influences—no solid reference to rely on, as scant little illustration of

this sort existed up to that point in time. Unencumbered by preconceived notions as to what science fiction illustration should or should not be, his style took on an almost childlike or folk-art-like quality. With no boundaries, anything was game for the artist. There were no right or wrong colors to use; in fact, the louder the colors, the better.

Paul's style of rendering humans has been referred to as "mannequin-like" or wooden; the poses stiff, with facial expressions not much better. Whatever he may have lacked in anatomical knowledge, he more than made up for with an emotive quality present in each and every new piece of art that he created.

Hugo Gernsback (after whom the prestigious science fiction award, the Hugo, is named) remained Paul's staunchest supporter, even when his prized illustrator moonlighted for the competition. A rarity among editors, Gernsback always allowed Paul's imagination to run wild, seldom tampering with his creative process. The result? A staggering inventory of commercial illustration reflective of Paul's originality and inexhaustible ability to create and invent. Each cover that Paul rendered, no matter how challenging or hair-raising for the standards of its day, was passionately infused with a true sense of wonder.

Though seemingly simplistic and clichéd by today's standards of big-budget, cinematic blockbusters and illustration, Paul's compositions most certainly floored readers when they first appeared on newsstands in the pre-television days of the twenties and thirties.

Though his approach to concepting varied, once Gernsback green-lighted a cover idea, Paul single-mindedly composed it, working upwards of fourteen hours a day until he completed it. Not one to clutter the stage with unimportant background detail, Paul's compositions consisted of just the logotype; a flat, bright background color; and then the money shot—a phantasmagorical scene unfolding right before the viewer's eyes.

There were no lengths to which Paul wouldn't go to bring his creations to life, with attention to detail being a key trademark. Machinery was finely rendered down to the smallest cog or spring; every slimy bump, pore, or scale of an alien's skin was lovingly delineated; distant buildings were adorned with all manner of ornate gargoyles and caryatids.

Paul seemed to have a particular soft spot for depicting futuristic cityscapes, due in no small part to his formal training as an architect. Though he handled all themes equally well, Paul excelled at painting the world of tomorrow, instilling his imagined cities with a majestic calm and beauty befitting that of a utopia. Many of these scenes evidenced no human struggle or conflict, just simple portrayals of Paul's idealized vision of a gleaming, streamlined world where air cars zipped from rooftop to rooftop, panoramic skyscrapers towered above an antiquated [cont. page 27]

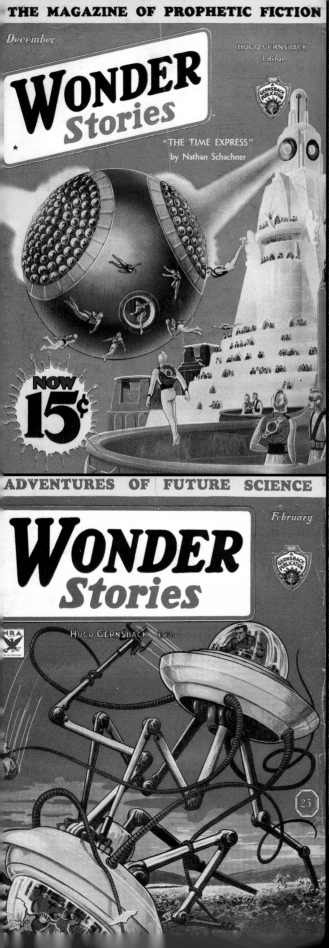

THE MAGAZINE OF PROPHETIC FICTION

December

HUGO GERNSBACK
Editor

WONDER Stories

GERNSBACK PUBLICATION

"THE TIME EXPRESS"
by Nathan Schachner

NOW 15¢

ADVENTURES OF FUTURE SCIENCE

February

WONDER Stories

GERNSBACK PUBLICATION

HUGO GERNSBACK Editor

NRA

25

TOP LEFT: *Wonder Stories*; Volume 4 Number 7; December 1932
BOTTOM LEFT: *Wonder Stories*; Volume 5 Number 7; February 1934
ABOVE: *Fantastic Adventures*; Volume 2 Number 3; March 1940

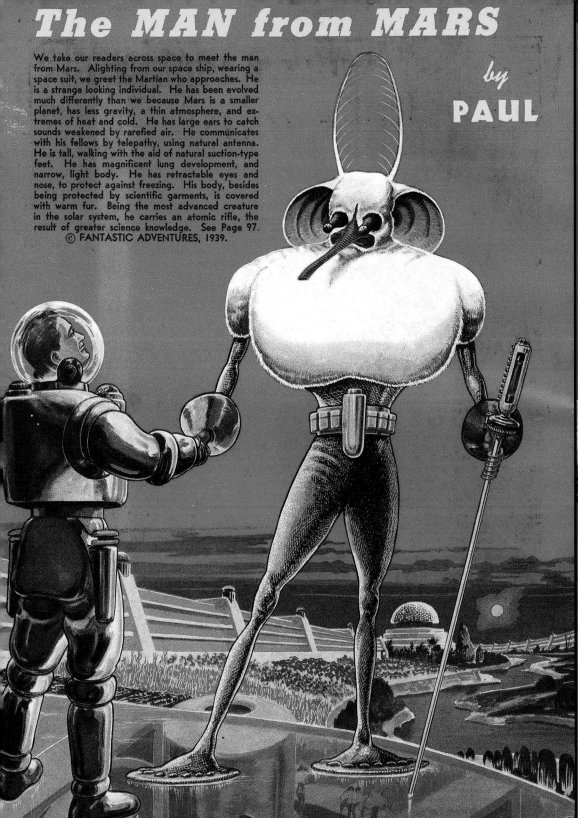

The MAN from MARS

We take our readers across space to meet the man from Mars. Alighting from our space ship, wearing a space suit, we greet the Martian who approaches. He is a strange looking individual. He has been evolved much differently than we because Mars is a smaller planet, has less gravity, a thin atmosphere, and extremes of heat and cold. He has large ears to catch sounds weakened by rarefied air. He communicates with his fellows by telepathy, using natural antenna. He is tall, walking with the aid of natural suction-type feet. He has magnificent lung development, and narrow, light body. He has retractable eyes and nose, to protect against freezing. His body, besides being protected by scientific garments, is covered with warm fur. Being the most advanced creature in the solar system, he carries an atomic rifle, the result of greater science knowledge. See Page 97.
© FANTASTIC ADVENTURES, 1939.

by PAUL

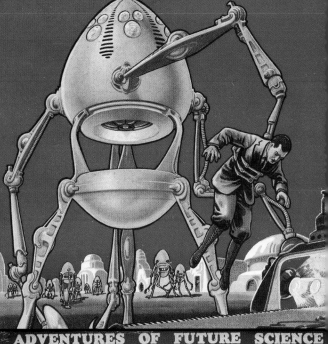

October

WONDER Stories

HUGO GERNSBACK Editor

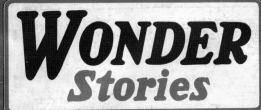

November

WONDER Stories

HUGO GERNSBACK Editor

NRA

ABOVE: *Fantastic Adventures*; Volume 1 Number 1; May 1939
TOP RIGHT: *Wonder Stories*; Volume 3 Number 5; October 1931
BOTTOM RIGHT: *Wonder Stories*; Volume 5 Number 4; November 1933

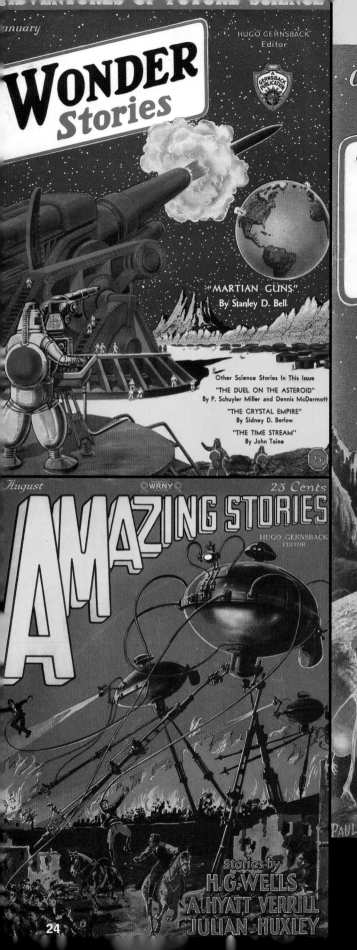

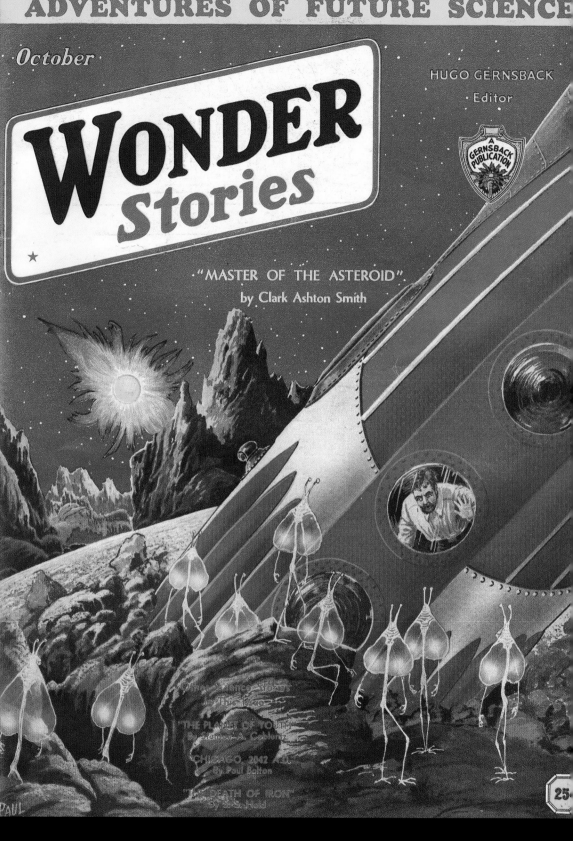

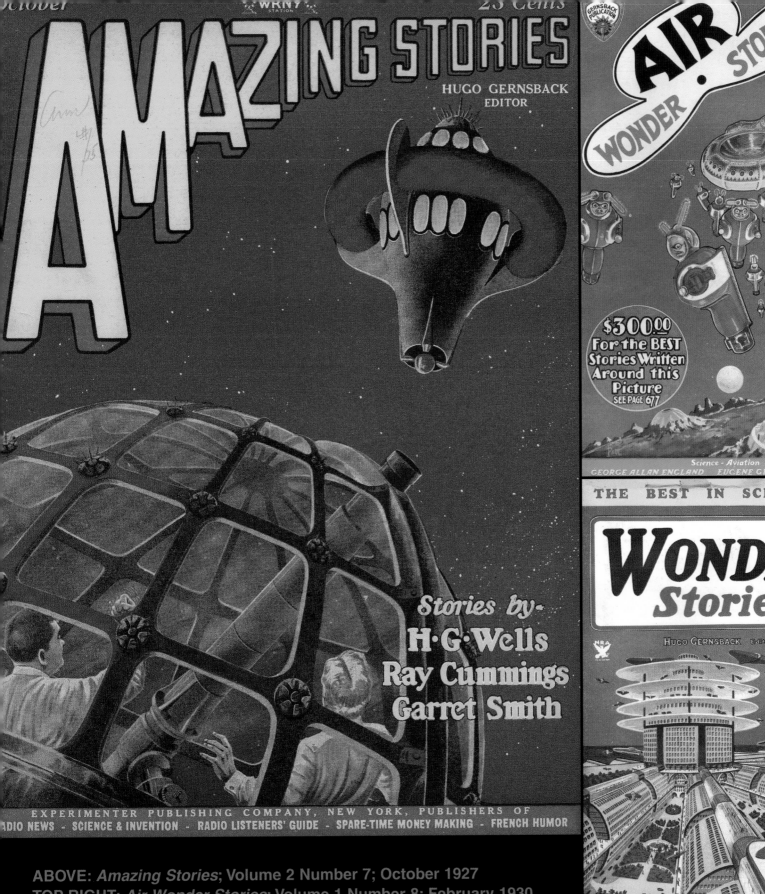
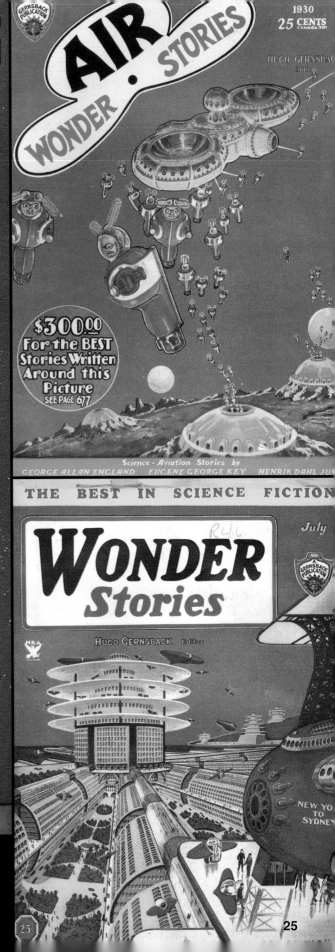

ABOVE: *Amazing Stories*; Volume 2 Number 7; October 1927
TOP RIGHT: *Air Wonder Stories*; Volume 1 Number 8; February 1930
BOTTOM RIGHT: *Wonder Stories*; Volume 6 Number 2; July 1934

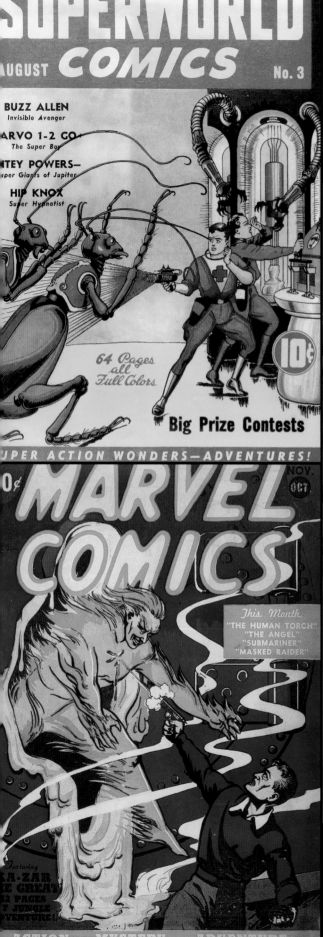

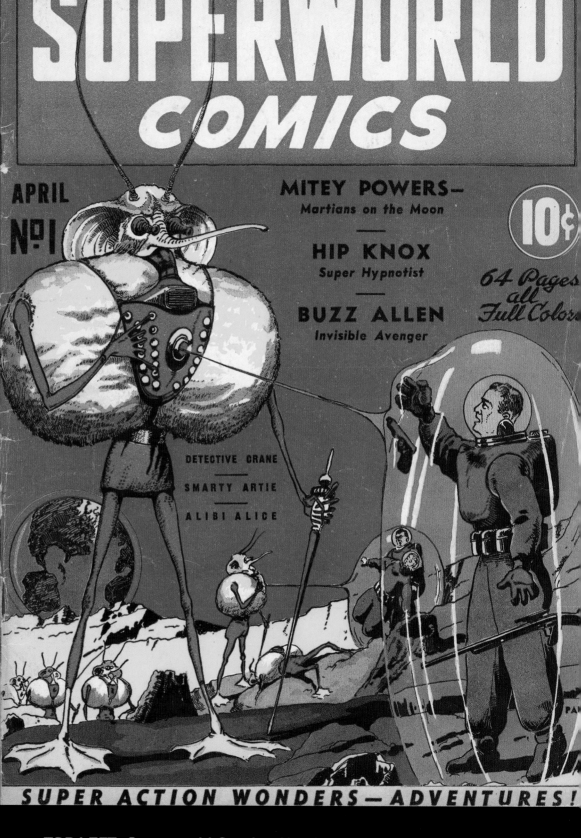

Empire State Building, and ultimate urban beauty and harmony had been achieved. Here, architecture was the star of the show, not man or beast. It was Metropolis taken to the next level.

At the height of Paul's career, the mid-to-late thirties, turbulence shook the thriving pulp magazine field. Sales figures of highly popular series were shorn in half, with titles phased out altogether. As a cost-saving measure, the expansive formats that once provided illustrators a splendorous platform were diminished in size—an unnerving, one-two punch from the new media of pocket-sized paperbacks and comic books, and the paper shortages of WWII.

As both genres siphoned readers away, Paul remained in the ring, producing a resplendent body of back covers for *Fantastic Adventures* and *Amazing Stories*. The exemplary series, depicting interplanetary life forms and their imagined environments, remains to this day an unparalleled body of work.

Hugo Gernsback, Paul's longtime editor and patron, saw that pulps were dying. *Batman* and *Superman* had proven that comic books were potential goldmines. Paul realized it too, having illustrated a riveting portrayal of the Human Torch for the cover of *Marvel Comics #1*. The premiere issue blazed through two entire print runs, establishing its publisher, Timely Comics (now known as Marvel), as a heavyweight contender in the burgeoning new market. Gernsback took a roll of the dice, forming his own comics company—Kosmos Publications.

Though not a storyteller by nature, Paul dove feet first into this strange, new sequential world, drawing covers and stories for *Superworld Comics*, which debuted in the spring of 1940. Paul came up with some fun, quirky stories and bizarrely entertaining sequences. But Gernsback's science fiction series failed to deliver the goods the kids of the day wanted—long-underweared heroes—and folded after three issues.

Paul continued on his way, painting covers and rendering pen-and-ink interiors for several of the remaining pulp titles and, during the war years, supplementing his income as a salaried designer for the United States government.

In 1953, Gernsback enlisted Paul to art direct and illustrate a slick, new series, *Science Fiction Plus*. Paul was thrilled to be reunited with his former employer, yet the stint was short-lived. After seven issues, Gernsback aborted the title.

"Prolific"… "innovative"… "visionary"… descriptives once attributed to Paul no longer mattered. Popular tastes had changed too drastically. Paul's days as the science fiction artist of choice were over, and his remaining career was relegated to drawing textbook illustrations.

But fans never really let go of his work. Paul's pulp covers are reproduced in books and on merchandise right up through present day. In the last decade, his original gouache paintings and

pen-and-ink drawings have graced the walls of fine art museums, as part of exhibitions focused on the art of American pulp illustration.

In June 2003, I was fortunate enough to be in New York City during a retrospective of pulp illustration at the Brooklyn Museum of Art. The show consisted of pieces from the Robert Lesser collection. Out of over one hundred paintings majestically displayed, twelve were by Paul, enabling me to study and absorb his diverse artistic techniques firsthand.

As splendid as the printed versions of Paul's pulp covers were, I was floored to discover the amount of detail that had dropped out of the original art due to inferior printing techniques of the era. I won't say Paul was particularly brilliant in his technical skills (paint was often clumsily applied, and his choice of heavily textured illustration board made it impossible to control the line work well), yet none of this mattered. Paul's heart shone through in these paintings; boundless enthusiasm and sheer joy pulsed forth from the paint and board of these ancient creations. Viewing his original cover art full-scale, sans text titles and logos, changed me forever.

Among the examples on display was the December 1932 cover of *Wonder Stories*. It's a stirring scene, featuring futuristic flying men approaching a gargantuan blue metallic globe held aloft by magnetic beams of light. The fine rendering of the gold chain-mail suits and rocket packs of two foreground figures is forever burned into my retinas. Incidentally, it was this very magazine that a young Jack Kirby pulled from a flooded gutter during his childhood that influenced his decision to become an artist. Science fiction authors have had similar Paul epiphanies, among them Arthur C. Clarke and Ray Bradbury.

As with Kirby, Paul's work has greatly influenced my own art. I've been a die-hard fan for so long that I have to be extra cautious not to allow his influence to spill directly over into my own paintings. Aside from the obvious surface elements that initially attracted me to his work, it's the dream-like nature that has held me in its grip for over thirty years now, and counting. As with other personal favorites, ranging from David Lynch to Henry Darger, to contemporaries such as Fred Stonehouse and Neo Rauch, Paul's work comprises yin-yang qualities, like the exoskeleton of an exotic beetle: beautiful on the one hand, disturbing on the other. It just may be an obscure quality only I see after decades of continuous exposure to his work.

Paul created a cohesive world that, upon entering, I was never able or willing to leave. His oeuvre is one of the best examples of the sense of wonder that humankind is capable of conjuring up. It's this very quality that I have always admired and attempted to capture in my own work. It is an intangible thread that runs through all of Paul's work, regardless of content, and is perhaps the strongest testimony to the genius of Frank R. Paul. **BW**

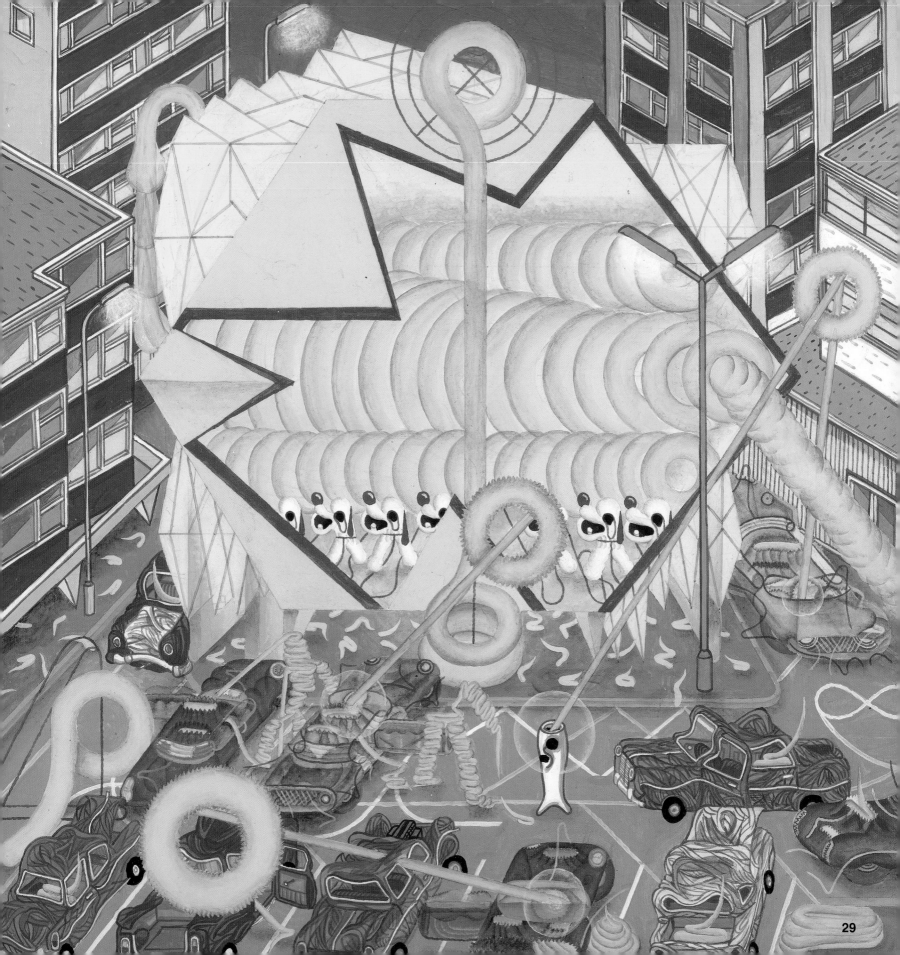

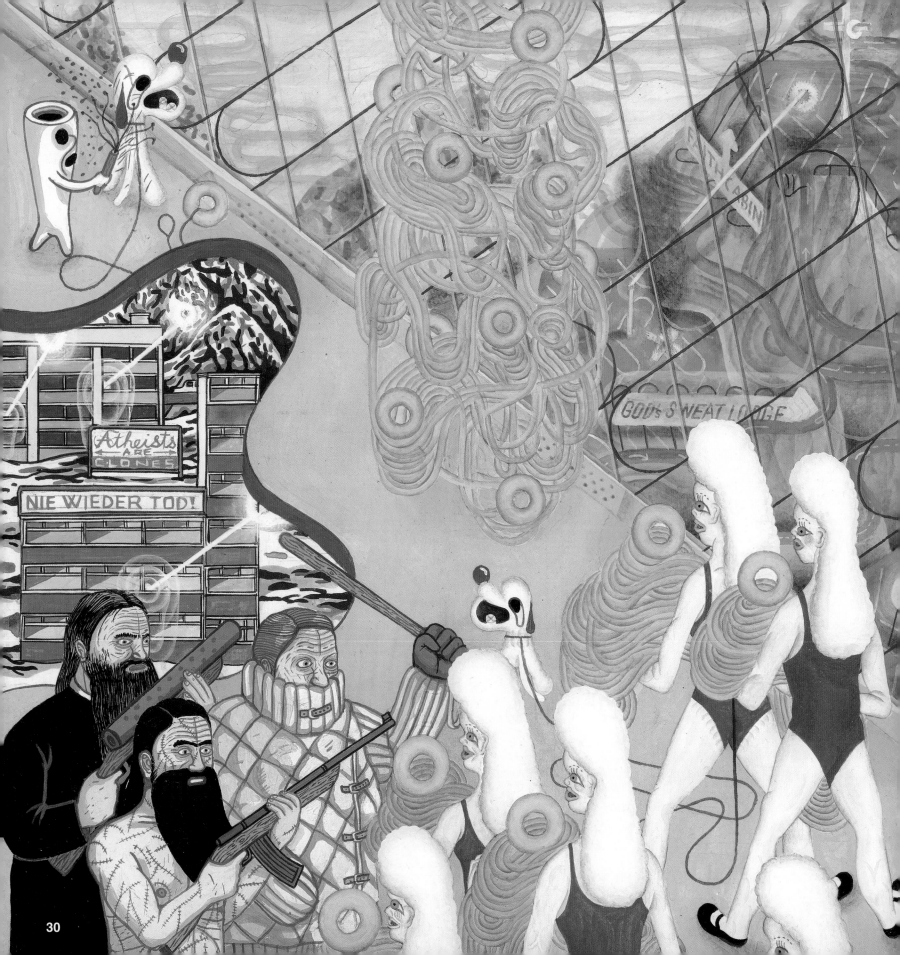

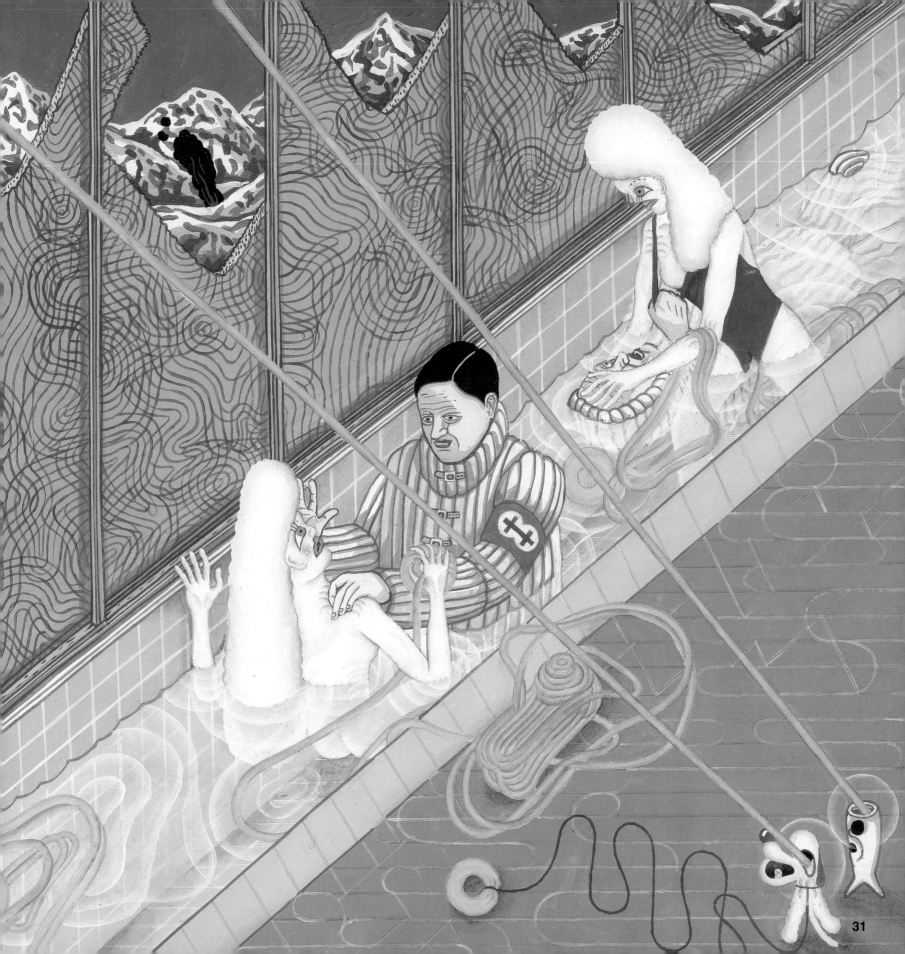

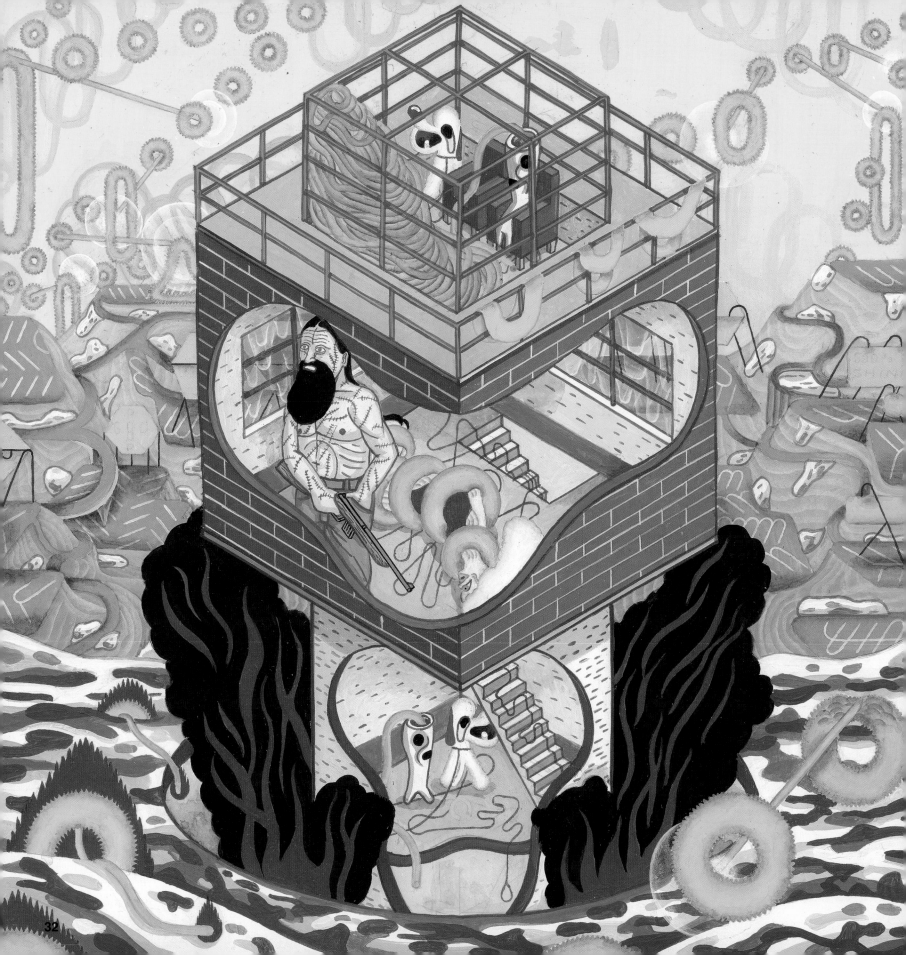

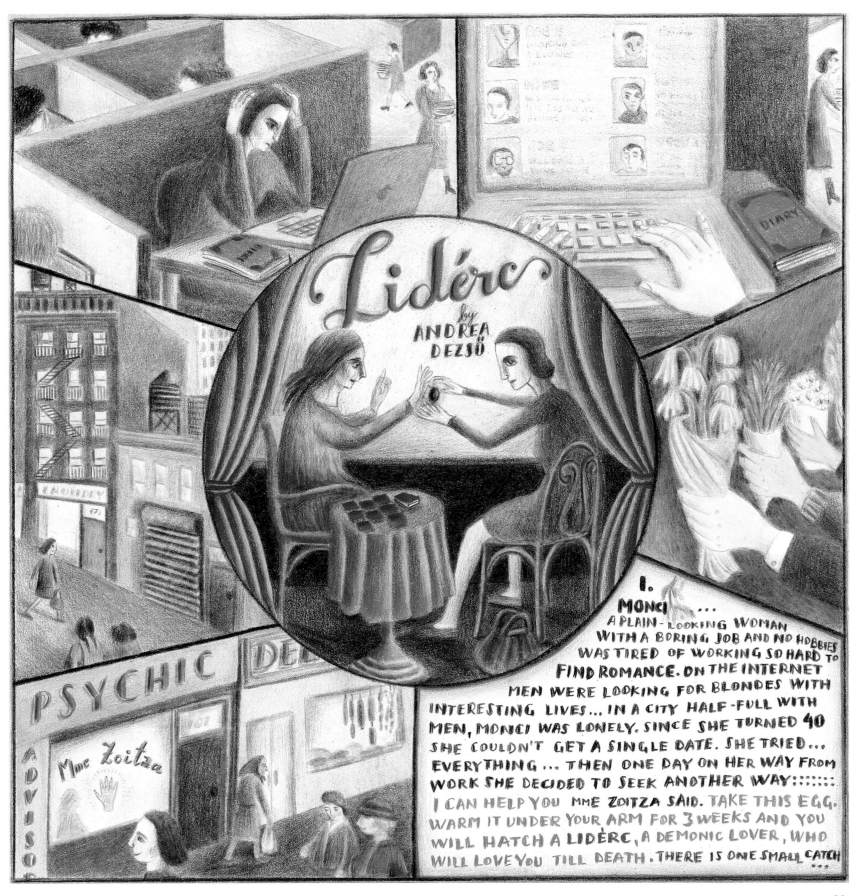

Lidérc by ANDREA DEZSŐ

I.

MONCI...
A PLAIN-LOOKING WOMAN WITH A BORING JOB AND NO HOBBIES WAS TIRED OF WORKING SO HARD TO FIND ROMANCE. ON THE INTERNET MEN WERE LOOKING FOR BLONDES WITH INTERESTING LIVES... IN A CITY HALF-FULL WITH MEN, MONCI WAS LONELY. SINCE SHE TURNED 40 SHE COULDN'T GET A SINGLE DATE. SHE TRIED... EVERYTHING... THEN ONE DAY ON HER WAY FROM WORK SHE DECIDED TO SEEK ANOTHER WAY::::::::
I CAN HELP YOU MME ZOITZA SAID. TAKE THIS EGG. WARM IT UNDER YOUR ARM FOR 3 WEEKS AND YOU WILL HATCH A LIDÉRC, A DEMONIC LOVER, WHO WILL LOVE YOU TILL DEATH. THERE IS ONE SMALL CATCH...

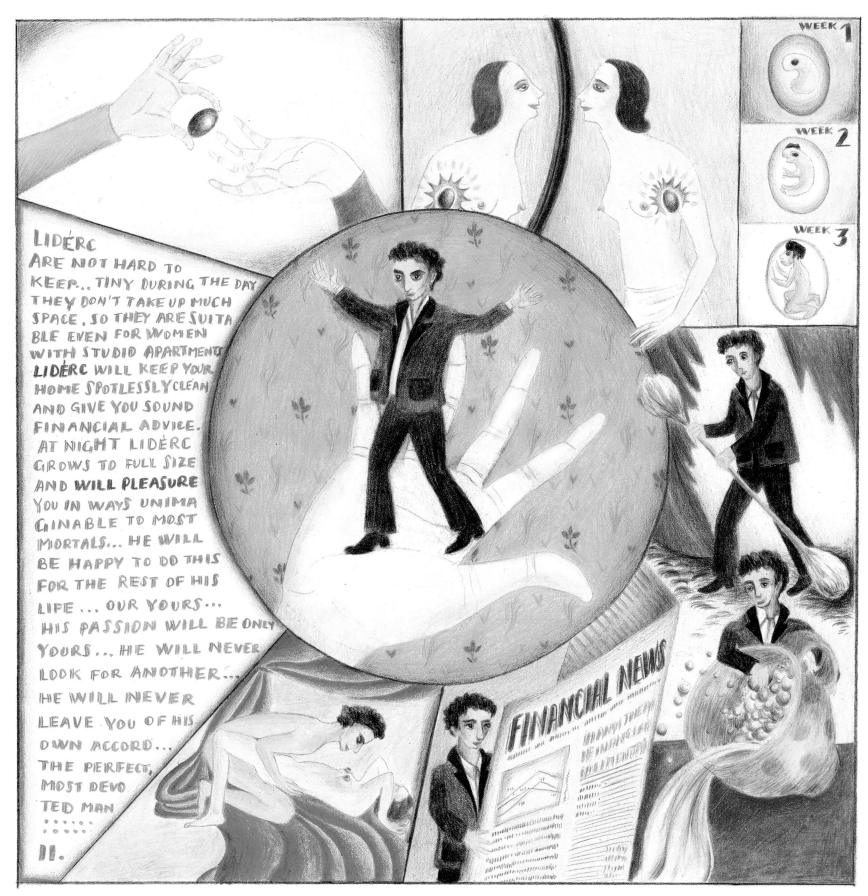

LIDÉRC
ARE NOT HARD TO
KEEP... TINY DURING THE DAY
THEY DON'T TAKE UP MUCH
SPACE, SO THEY ARE SUITA
BLE EVEN FOR WOMEN
WITH STUDIO APARTMENT
LIDÉRC WILL KEEP YOUR
HOME SPOTLESSLY CLEAN
AND GIVE YOU SOUND
FINANCIAL ADVICE.
AT NIGHT LIDÉRC
GROWS TO FULL SIZE
AND **WILL PLEASURE**
YOU IN WAYS UNIMA
GINABLE TO MOST
MORTALS... HE WILL
BE HAPPY TO DO THIS
FOR THE REST OF HIS
LIFE... OUR YOURS...
HIS PASSION WILL BE ONLY
YOURS... HE WILL NEVER
LOOK FOR ANOTHER...
HE WILL NEVER
LEAVE YOU OF HIS
OWN ACCORD...
THE PERFECT,
MOST DEVO
TED MAN
......
II.

WEEK 1

WEEK 2

WEEK 3

FINANCIAL NEWS

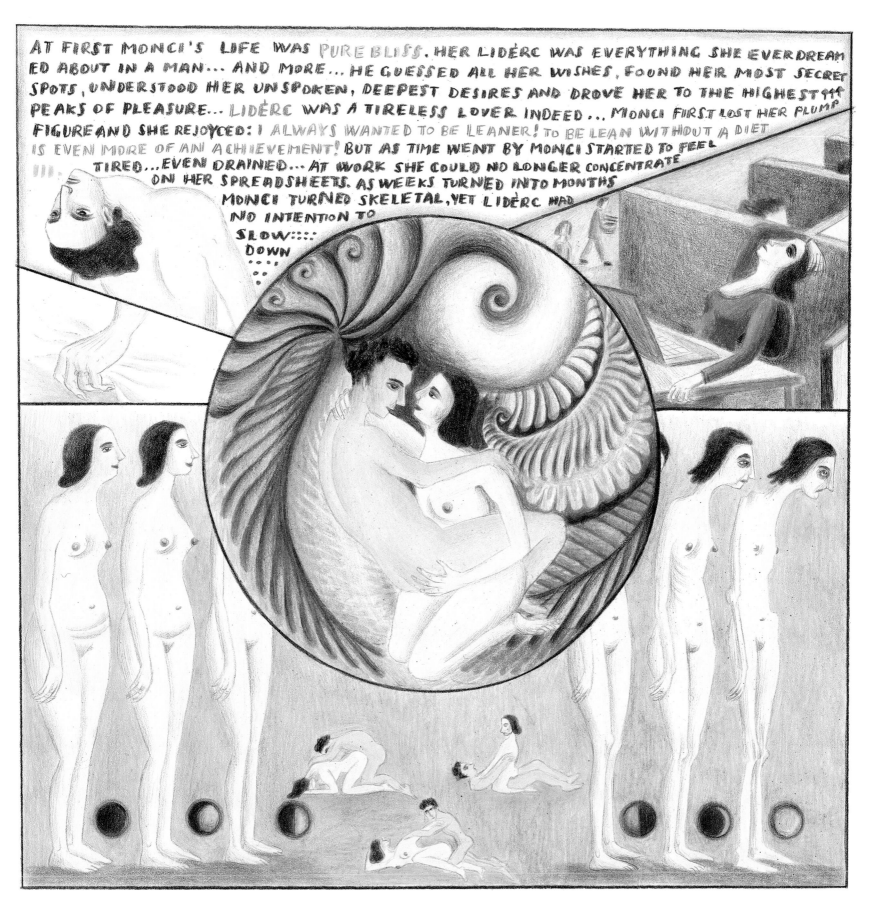

AT FIRST MONCI'S LIFE WAS PURE BLISS. HER LIDÉRC WAS EVERYTHING SHE EVER DREAMED ABOUT IN A MAN... AND MORE... HE GUESSED ALL HER WISHES, FOUND HER MOST SECRET SPOTS, UNDERSTOOD HER UNSPOKEN, DEEPEST DESIRES AND DROVE HER TO THE HIGHEST!!! PEAKS OF PLEASURE... LIDÉRC WAS A TIRELESS LOVER INDEED... MONCI FIRST LOST HER PLUMP FIGURE AND SHE REJOYCED: I ALWAYS WANTED TO BE LEANER! TO BE LEAN WITHOUT A DIET IS EVEN MORE OF AN ACHIEVEMENT! BUT AS TIME WENT BY MONCI STARTED TO FEEL TIRED... EVEN DRAINED... AT WORK SHE COULD NO LONGER CONCENTRATE ON HER SPREADSHEETS. AS WEEKS TURNED INTO MONTHS MONCI TURNED SKELETAL, YET LIDÉRC HAD NO INTENTION TO SLOW:::: DOWN

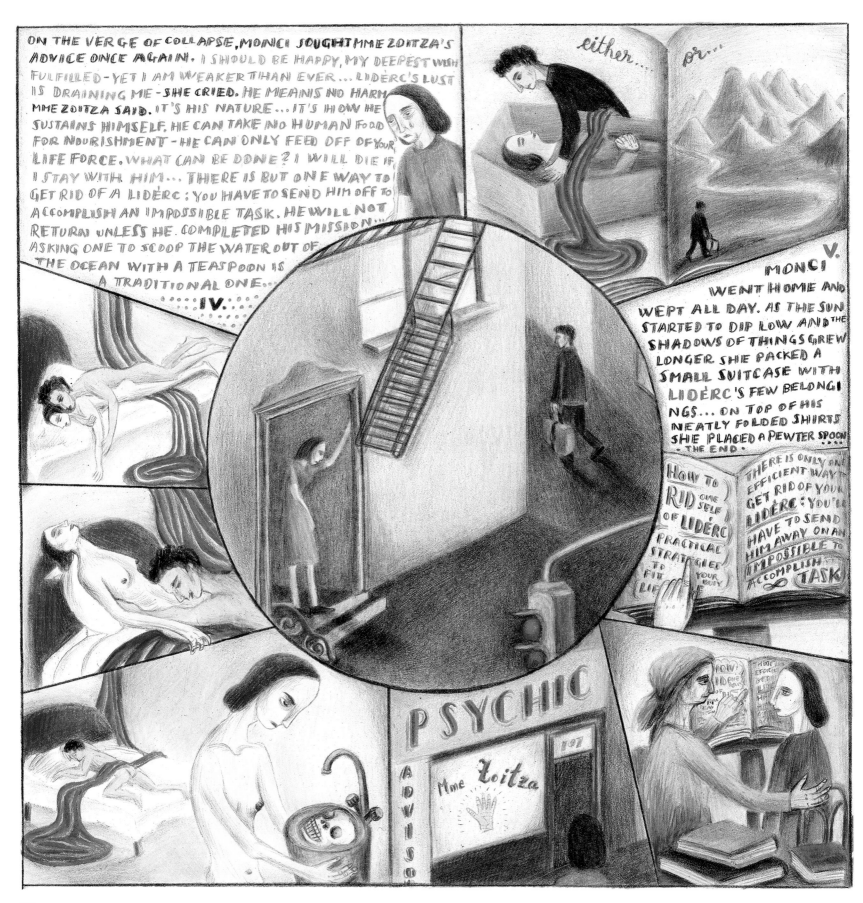

ON THE VERGE OF COLLAPSE, MONCI SOUGHT MME ZOITZA'S ADVICE ONCE AGAIN. I SHOULD BE HAPPY, MY DEEPEST WISH FULFILLED - YET I AM WEAKER THAN EVER... LIDÈRC'S LUST IS DRAINING ME - SHE CRIED. HE MEANS NO HARM, MME ZOITZA SAID. IT'S HIS NATURE... IT'S HOW HE SUSTAINS HIMSELF. HE CAN TAKE NO HUMAN FOOD FOR NOURISHMENT - HE CAN ONLY FEED OFF OF YOUR LIFE FORCE. WHAT CAN BE DONE? I WILL DIE IF I STAY WITH HIM... THERE IS BUT ONE WAY TO GET RID OF A LIDÈRC: YOU HAVE TO SEND HIM OFF TO ACCOMPLISH AN IMPOSSIBLE TASK. HE WILL NOT RETURN UNLESS HE COMPLETED HIS MISSION... ASKING ONE TO SCOOP THE WATER OUT OF THE OCEAN WITH A TEASPOON IS A TRADITIONAL ONE...

either...

or...

IV...

V.

MONCI WENT HOME AND WEPT ALL DAY. AS THE SUN STARTED TO DIP LOW AND THE SHADOWS OF THINGS GREW LONGER SHE PACKED A SMALL SUITCASE WITH LIDÈRC'S FEW BELONGINGS... ON TOP OF HIS NEATLY FOLDED SHIRTS SHE PLACED A PEWTER SPOON. THE END.

HOW TO RID ONE SELF OF LIDÈRC PRACTICAL STRATEGIES TO FIT YOUR BUSY LIFE

THERE IS ONLY ONE EFFICIENT WAY TO GET RID OF YOUR LIDÈRC: YOU'LL HAVE TO SEND HIM AWAY ON AN IMPOSSIBLE TO ACCOMPLISH TASK

PSYCHIC

ADVISOR

Mme Zoitza

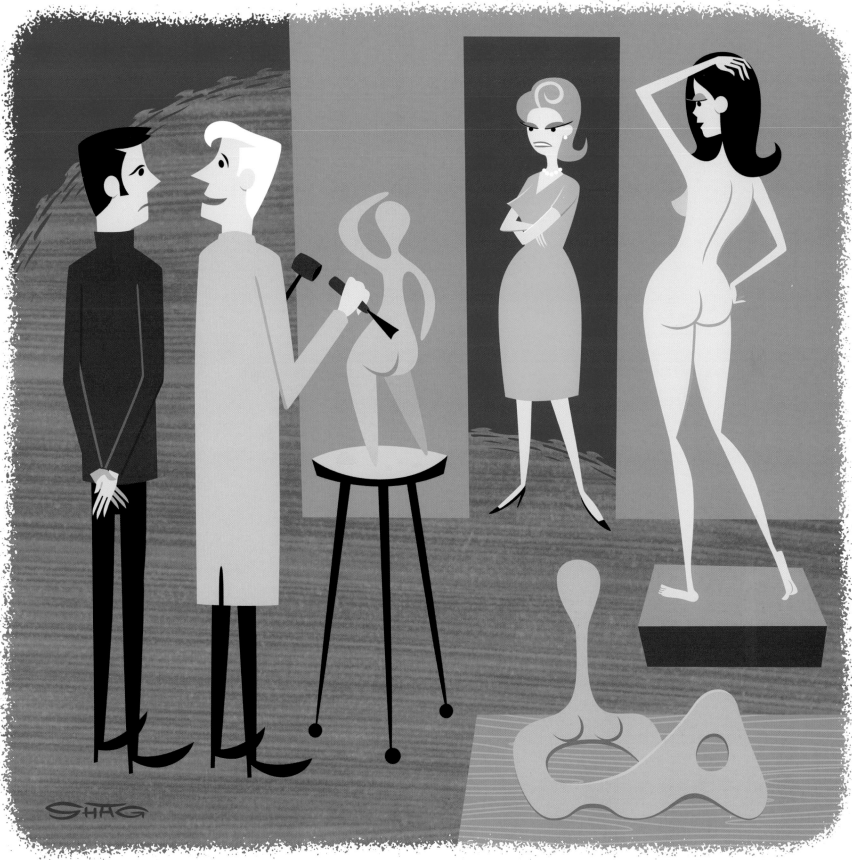

"I don't know why she's so angry. She INSISTED I get a hobby when I retired."

WILL ELDER

(Wolf William Eisenberg) 1921–2008 by Drew Friedman

WILL ELDER WAS A FORCE OF NATURE, an artist that leaves you scratching your head, asking, "How did he do it?" Without a doubt, the original "*Mad's* Maddest (or Zaniest) Artist" (he was also a legendary prankster) had an insane eye for detail. His rampant, sometimes-subversive background gags (referred to as "Chicken Fat") and his uncanny knack for mimicking and improving on the styles of other artists (from Walt Disney to Norman Rockwell) have never been equaled. He's also influenced countless cartoonists and satirists, including myself.

As a youngster, I'd stare in wonder at his incredibly busy panels in the paperback reprints of the original *Mad* comics. I remember thinking, "How could the person who drew 'Mickey Rodent!' be the same person who drew 'Starchie'? And the guy who drew 'Howdy Dooit!' couldn't possibly be the same guy who drew 'Poopeye!'" All that varied, brilliant drawing came from one person? I assumed that there must be a staff of artists who signed their work "Elder."

Like almost every kid in the sixties, I devoured *Mad* magazine. But where was Will Elder? I knew his art from the early paperbacks, but it was nowhere to be seen in the magazine. I would eventually connect all the dots, but almost to this day (well, maybe last week) I have speculated about Will Elder possibly continuing on as a *Mad* contributor after Harvey Kurtzman famously left *Mad* along with Will to found *Trump*.

Even so, his career was still dizzying, beginning at *Mad* and *Panic*, followed by *Trump*, *Humbug*, and *Help!*—where he rendered the beautifully crosshatched art for Goodman Beaver, then finally moving on to *Playboy*, creating the lush watercolor artwork for Little Annie Fanny. His art continued to evolve and can be fully appreciated in his career anthology, *The Mad Playboy of Art*.

I met Will Elder only once, at an outdoor party thrown by my friend Phil Felix, who had lettered Little Annie Fanny. I got to know Harvey Kurtzman when I was a student at the School of Visual Arts (where the stories of classroom insanity have been greatly exaggerated over the years), but at that point I had not yet met the more elusive Will Elder. Finally having the opportunity, I tried not to gush, but I was slightly tongue-tied. We chatted briefly, but I sensed he wasn't feeling great, so I left him alone to enjoy the day with his family.

I also met Will's son-in-law, Gary Vandenberg, that day. Gary later commissioned me to do a portrait of Will that he could present as a gift to his wife (Will's daughter), Nancy. Before beginning, I asked Gary if there were any photos of Will in his studio, as I often like to imagine my favorite artists in their work environment, but aside from one photo of Will bent over his desk, there were none. The photo did, however, show enough of the background of his modest art studio for me to create this portrait of the legendary Will Elder. **BW**

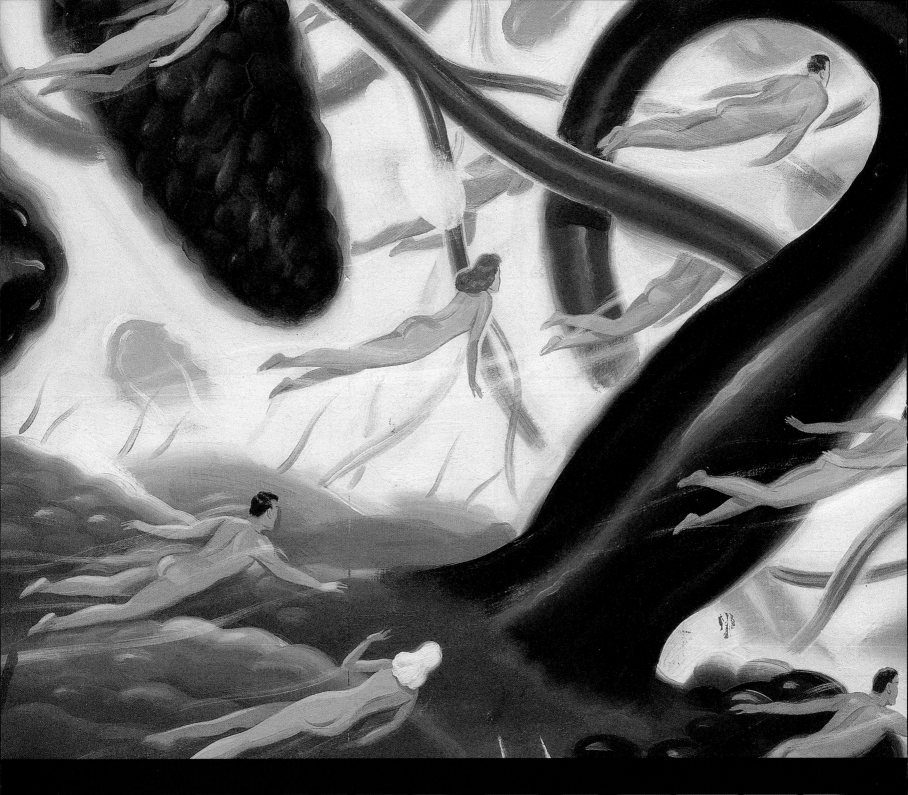

THE HEREAFTER

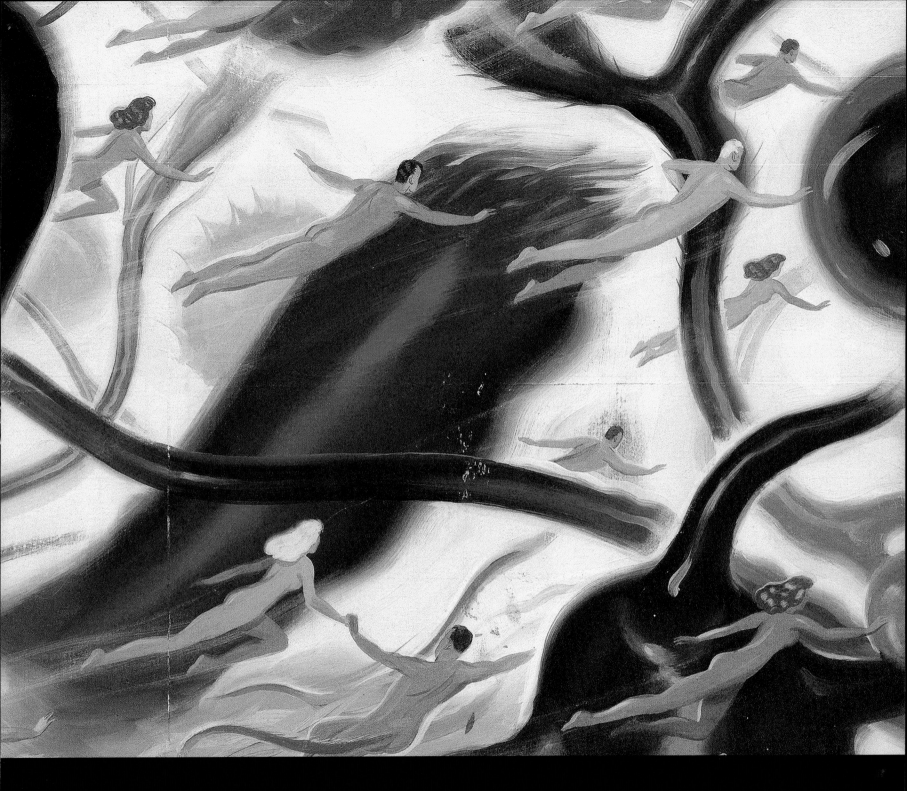

PAINTINGS AND DRAWINGS BY: RYAN HESHKA JON MACNAIR ERIC WHITE FEMKE HIEMSTRA ERIK MARK SANDBERG LARRY DAY BROOK SLANE CHRISTOPHER BUZELLI GARY TAXALI LUCIANO SCHERER CATHIE BLECK CRAIG LAROTUNDA LAURIE HOGAN MARC BURCKHARDT MARTIN WITTFOOTH TRAVIS LAMPE ROBERT CONNETT LOU BEACH KRIS KUKSI LOU BROOKS YOKO D'HOLBACHIE CHARLES GLAUBITZ ELVIS STUDIO KEVIN SCALZO FIONA HEWITT JEAN-PIERRE ROY CHET ZAR ROB SATO MICHAEL NOLAND NICOLETTA CECCOLI XIAOQING DING JANA BRIKE BASEMAN AND OWEN SMITH

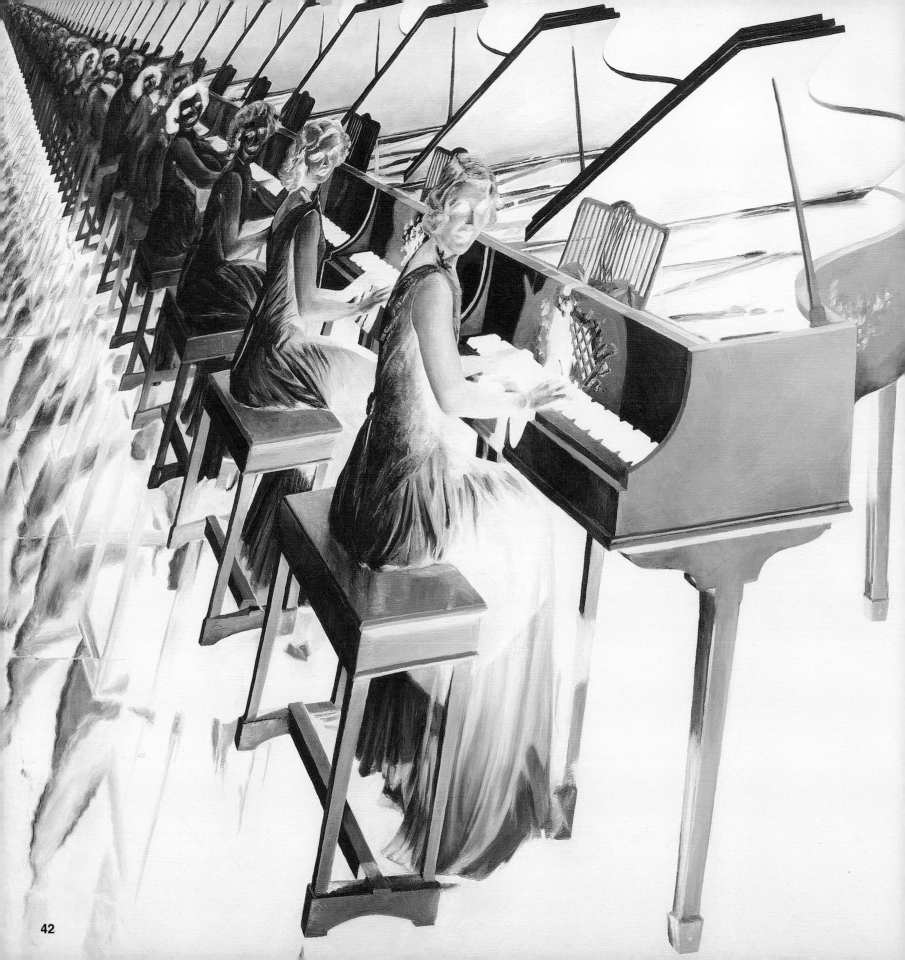

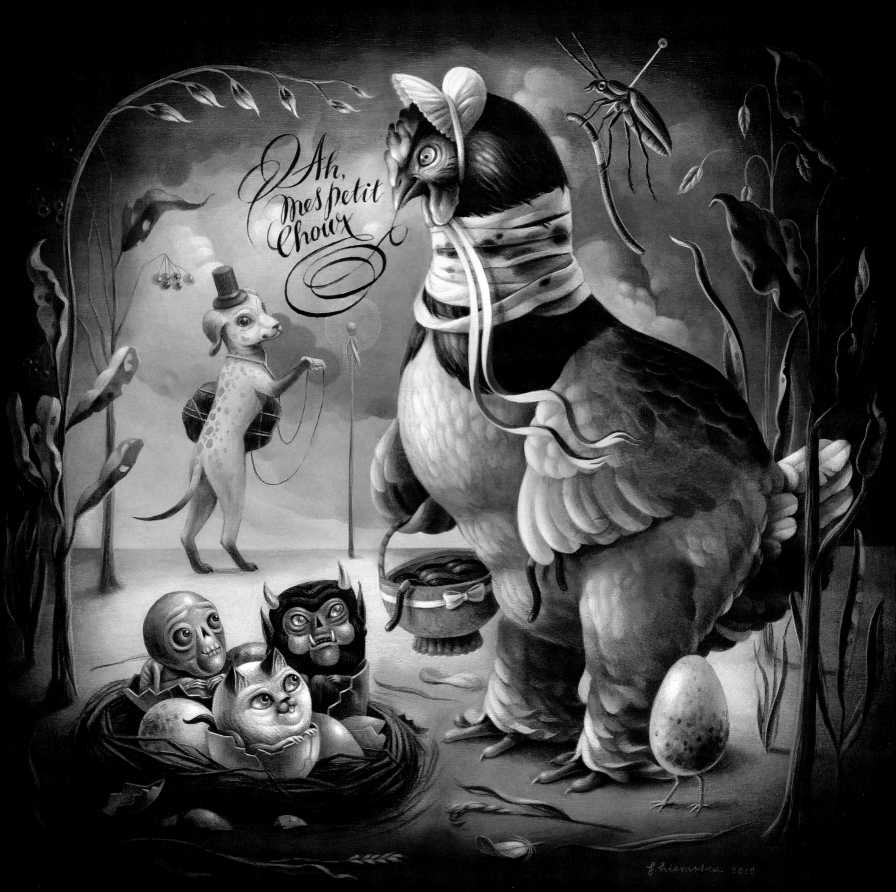

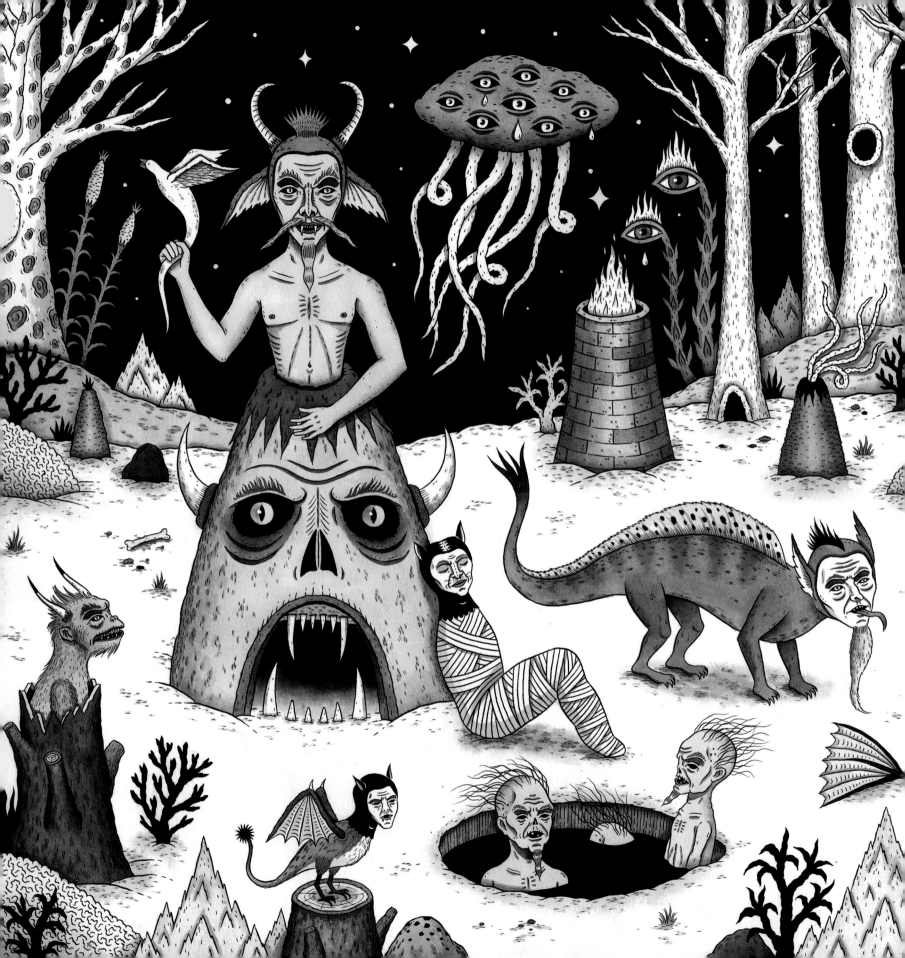

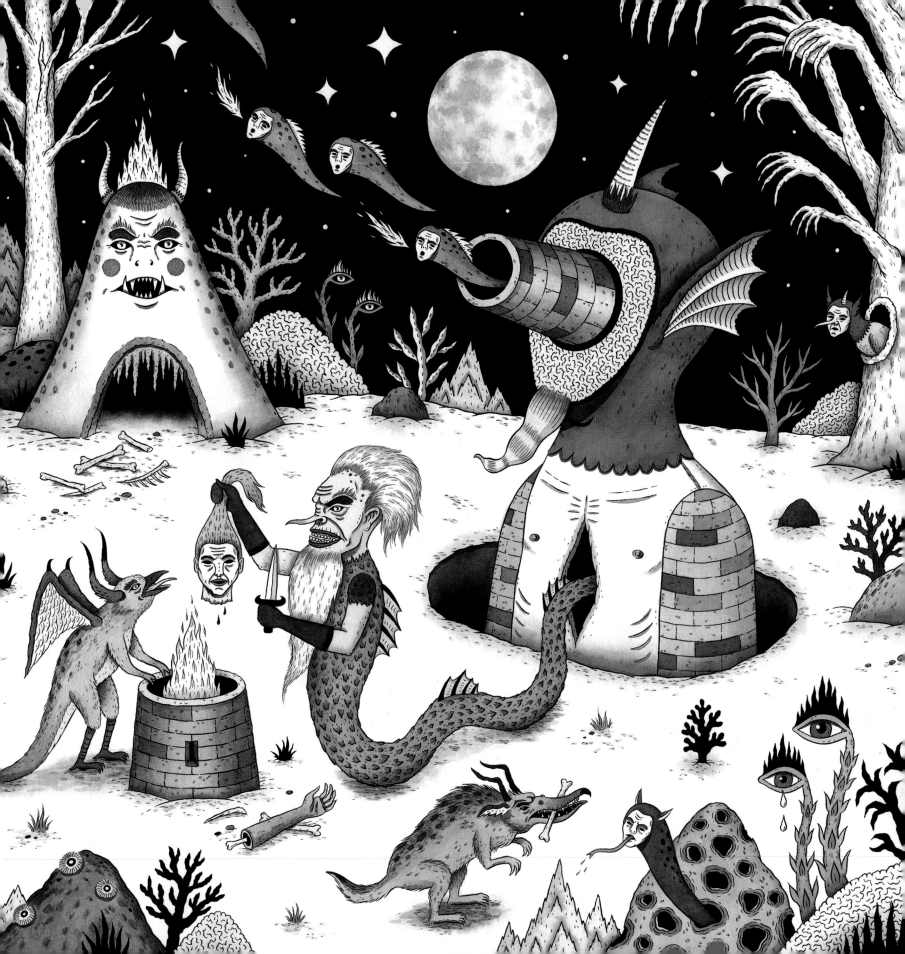

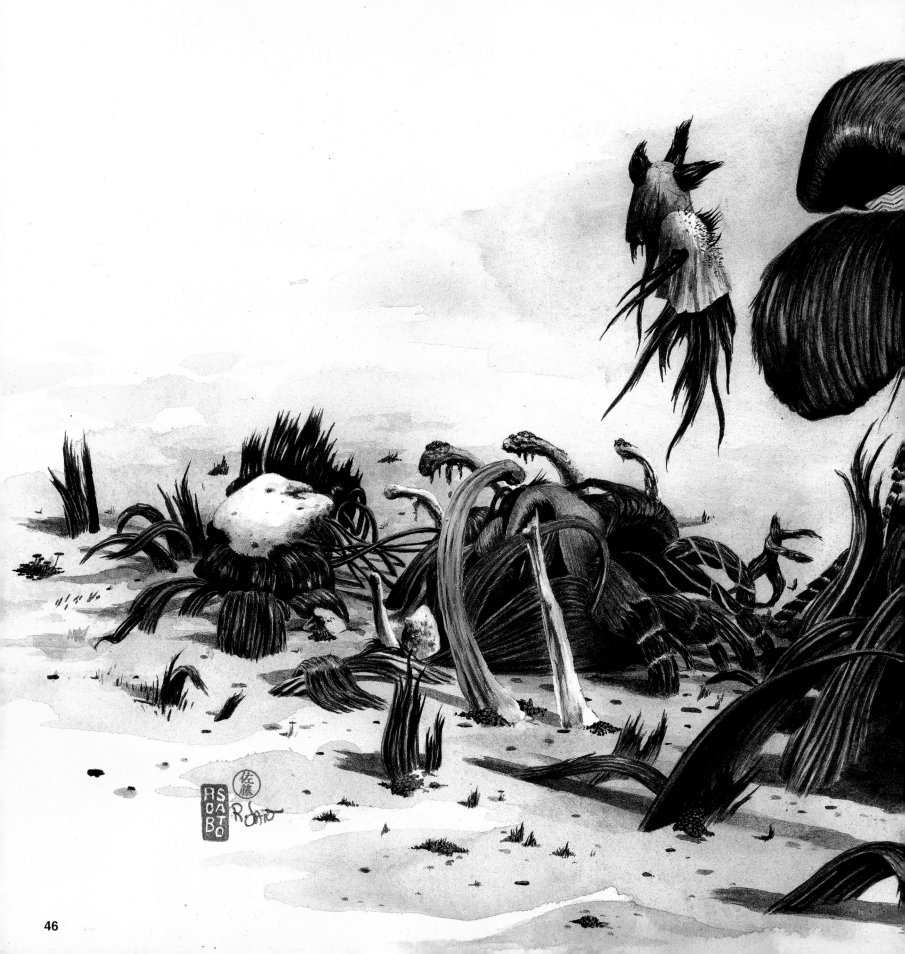

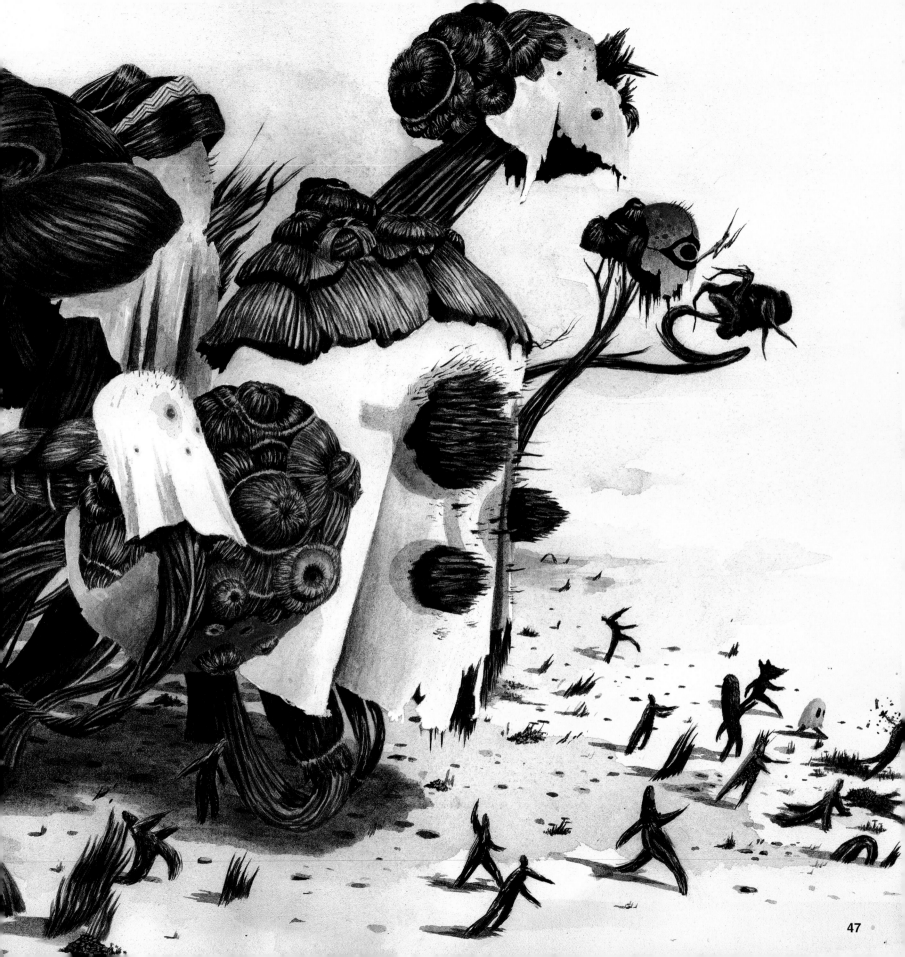

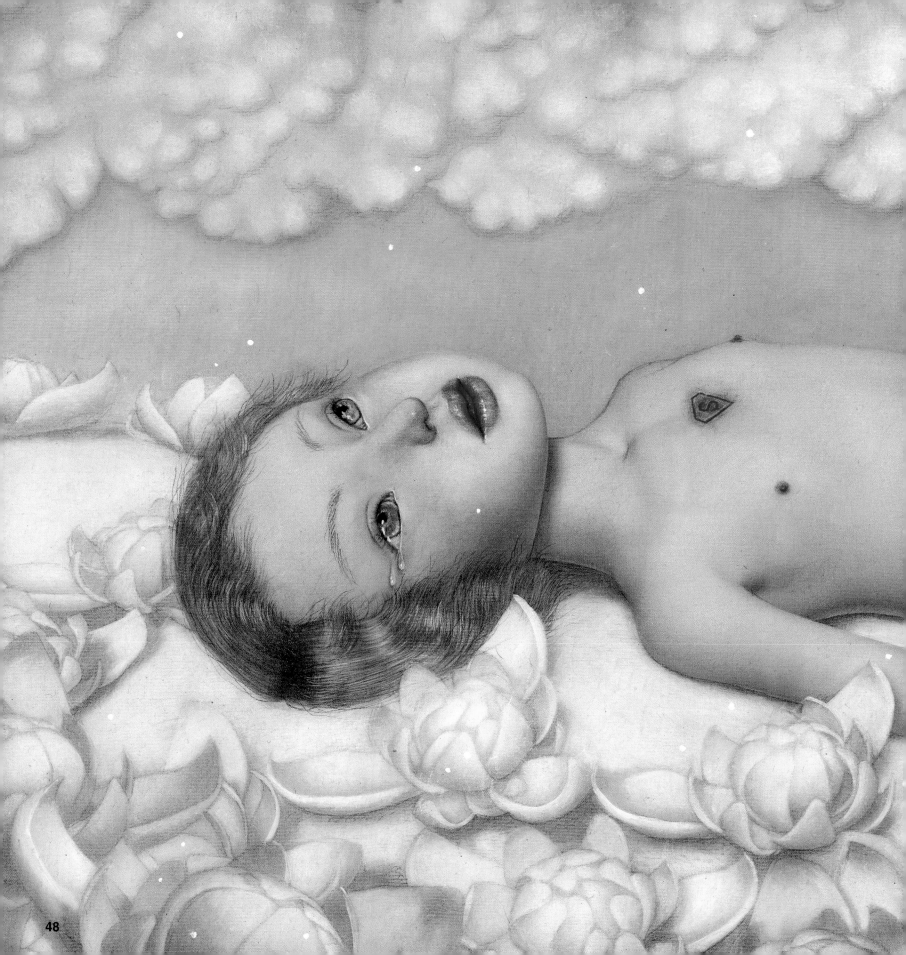

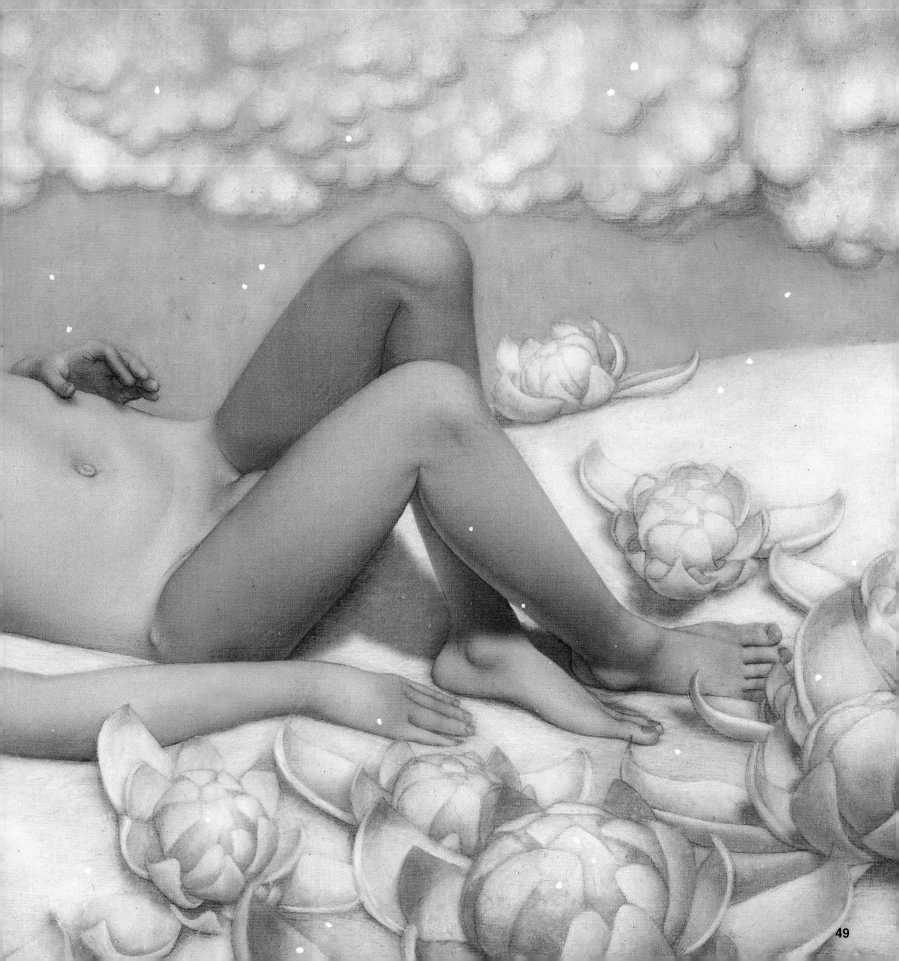

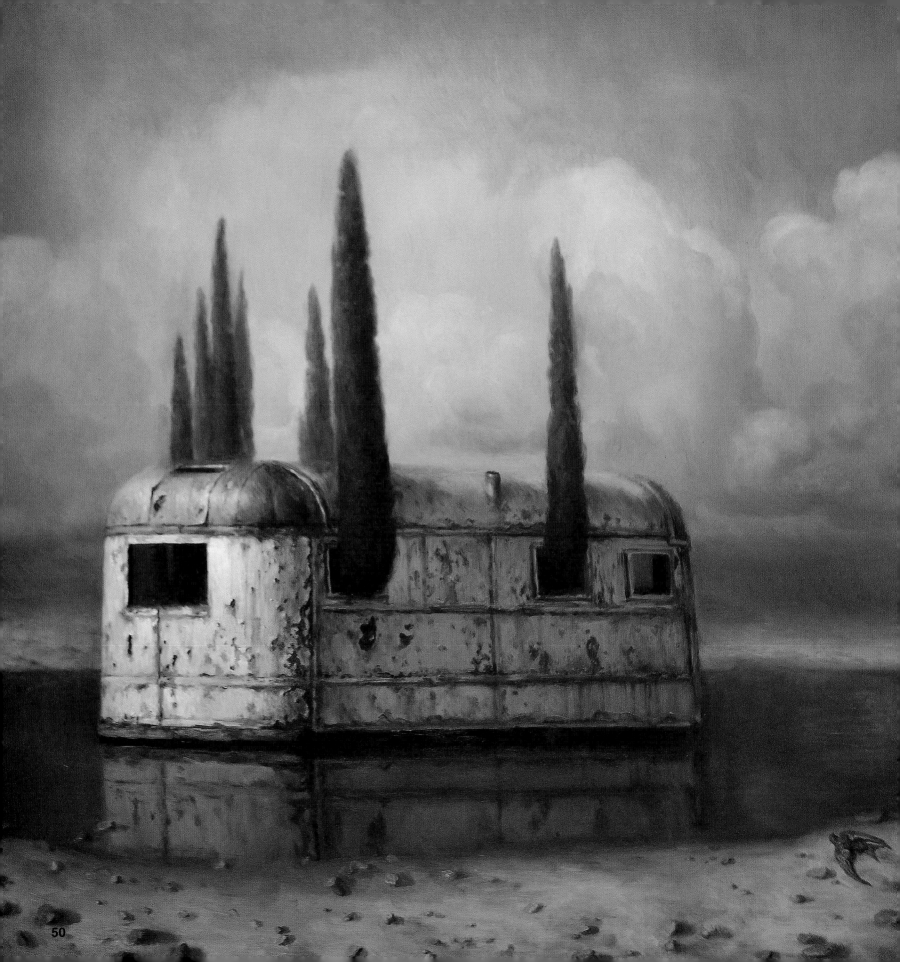

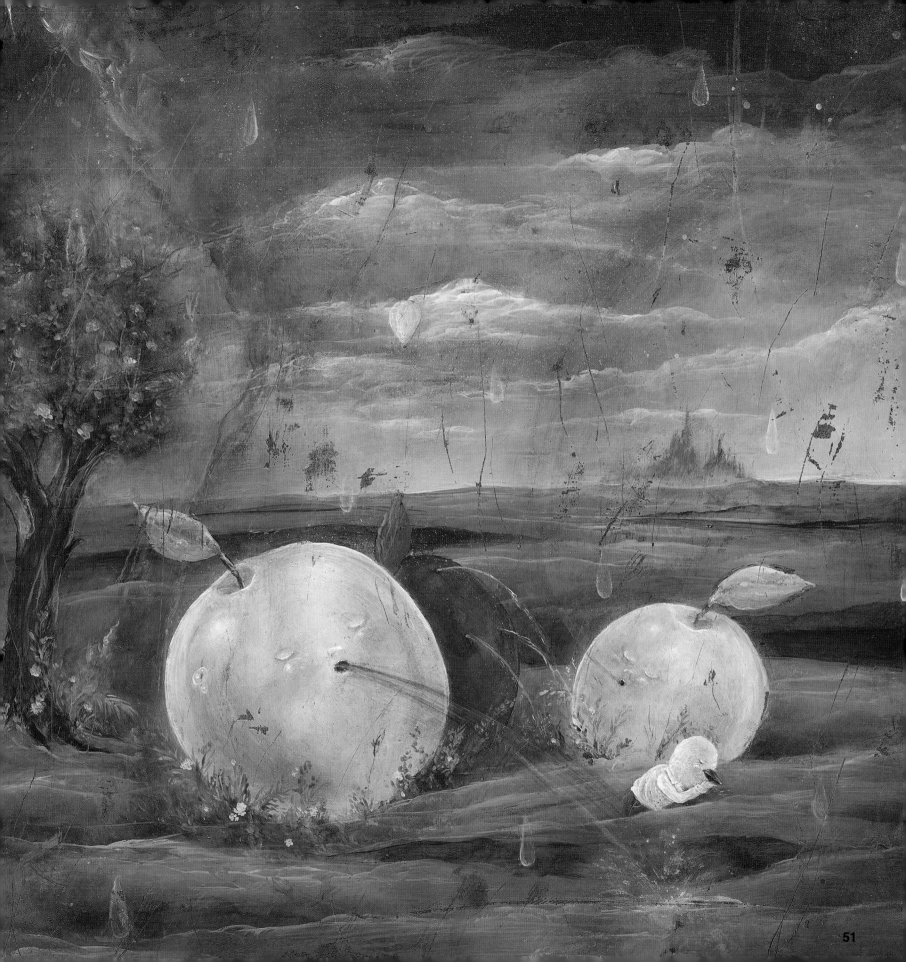

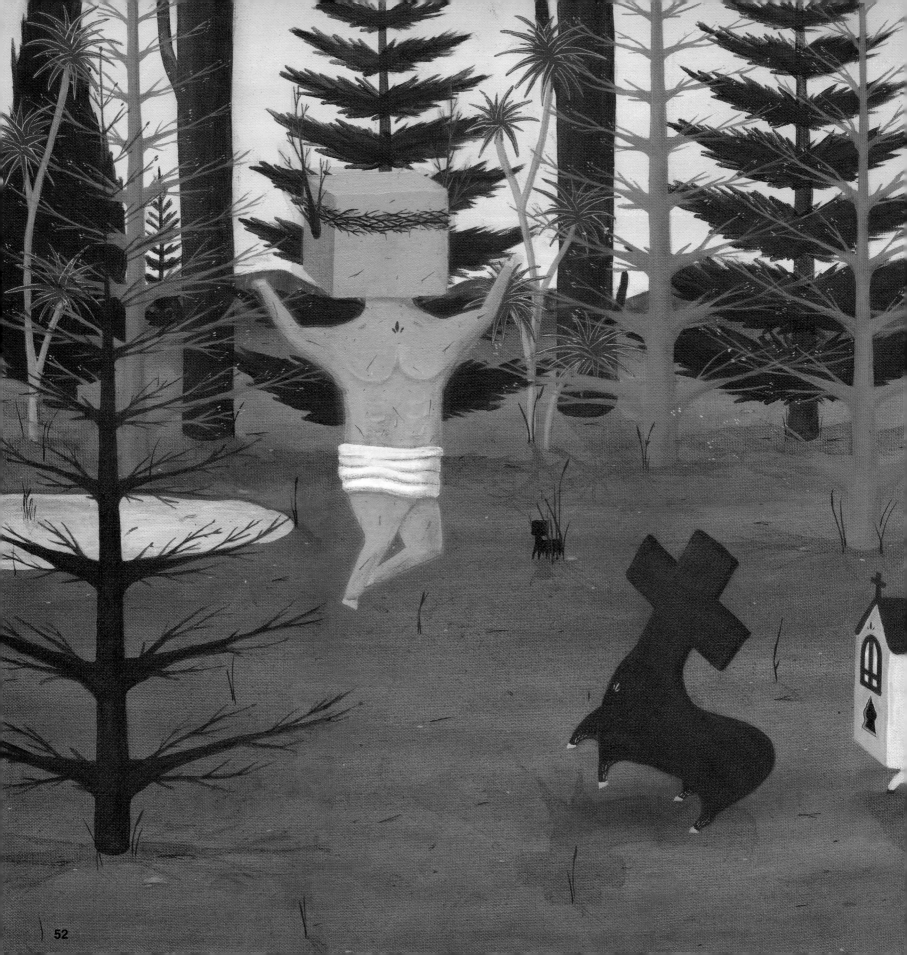

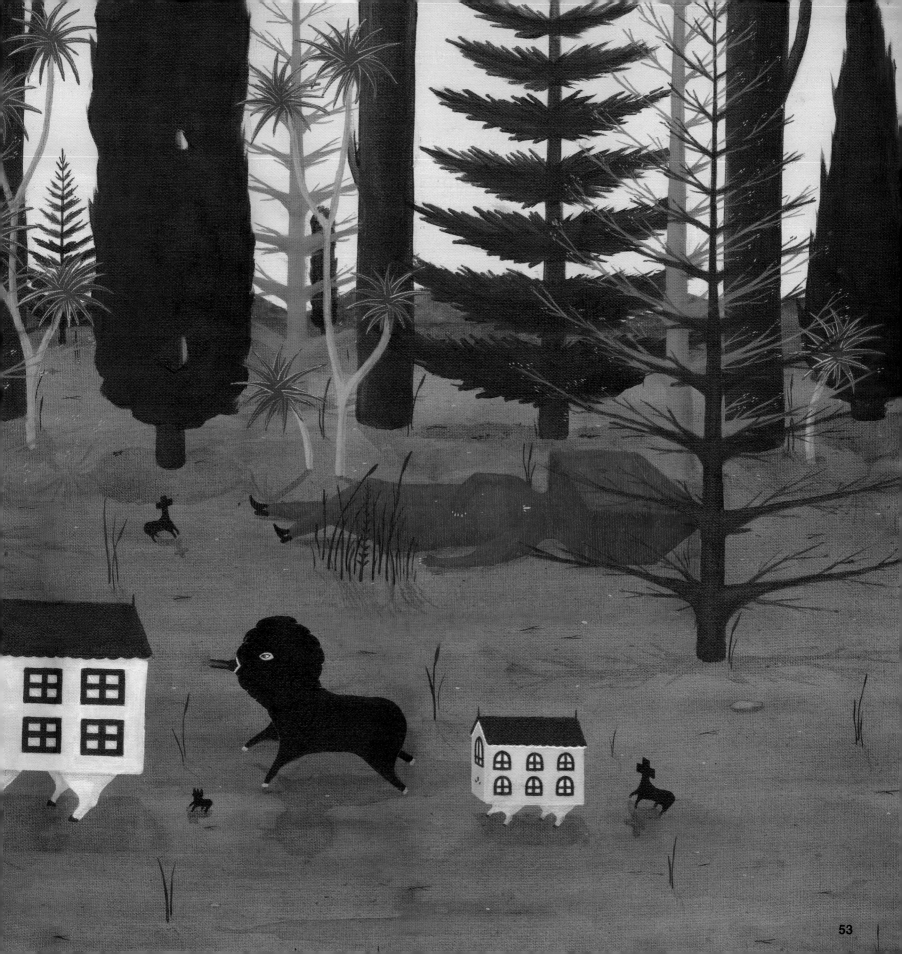

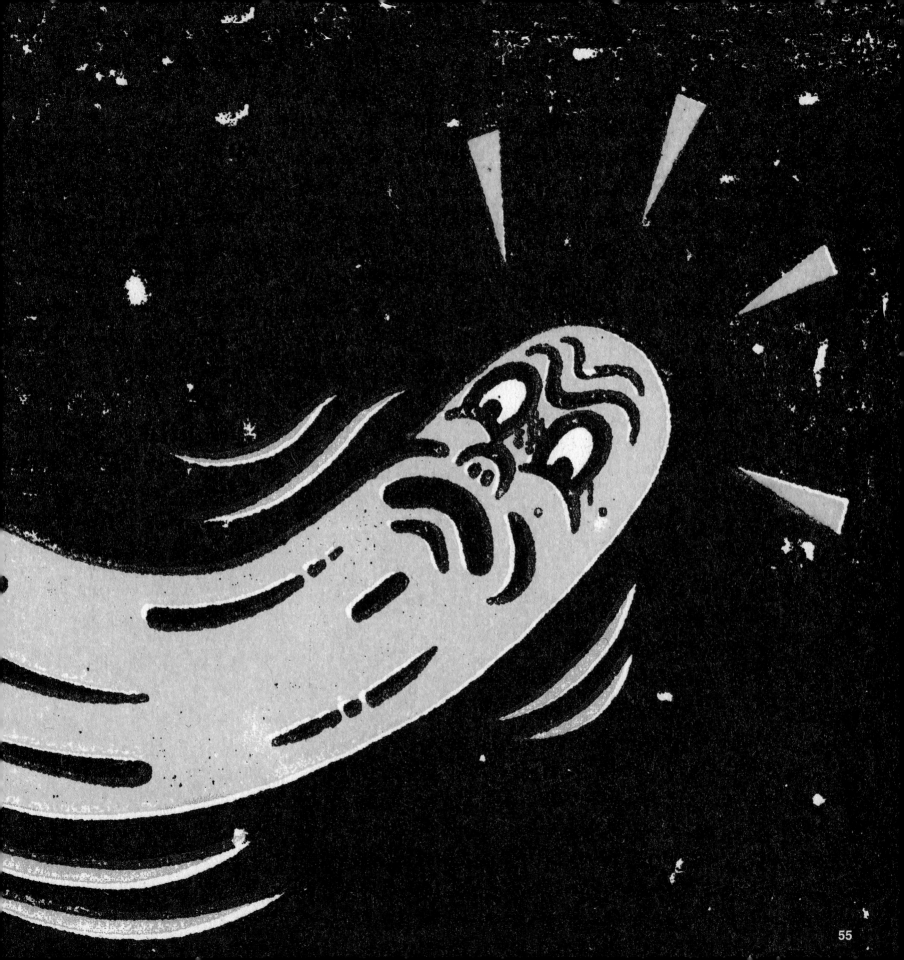

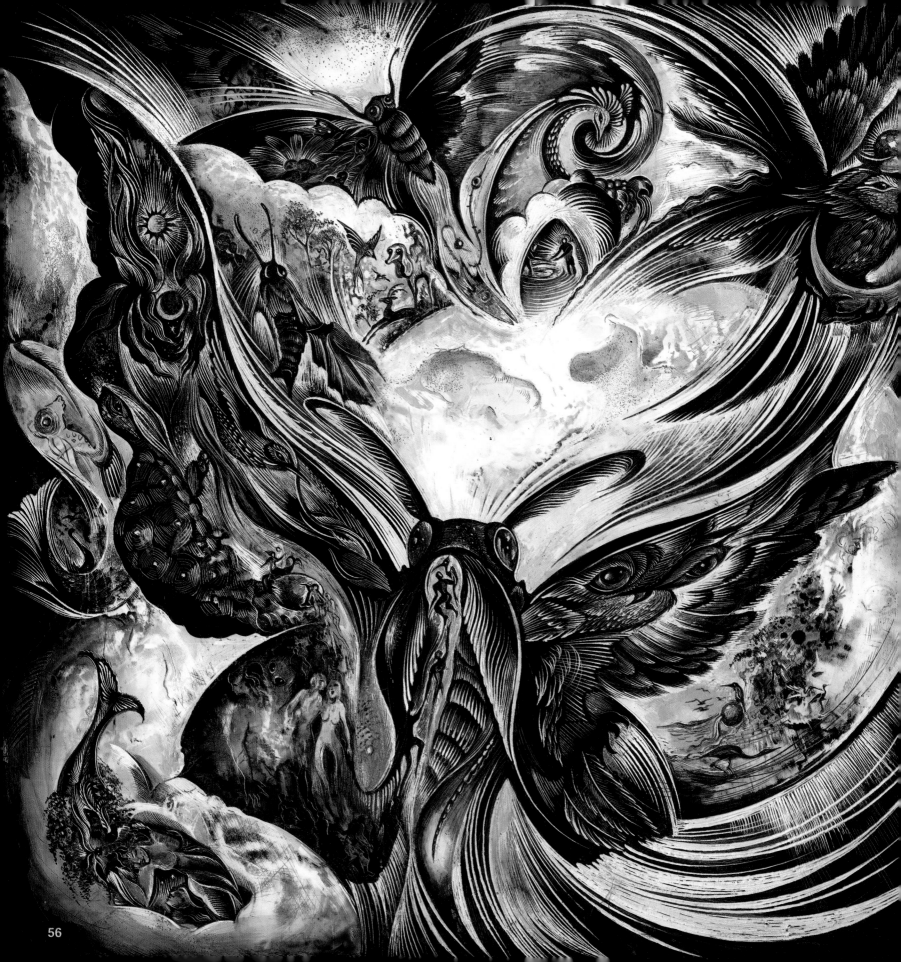

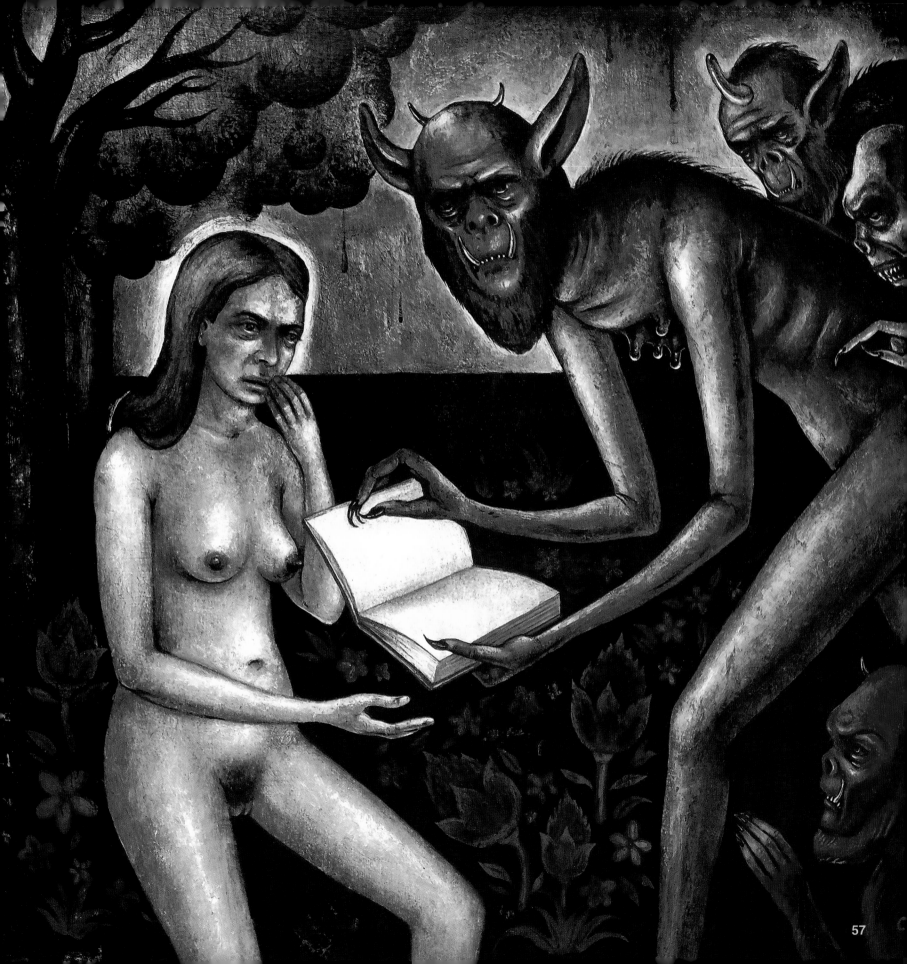

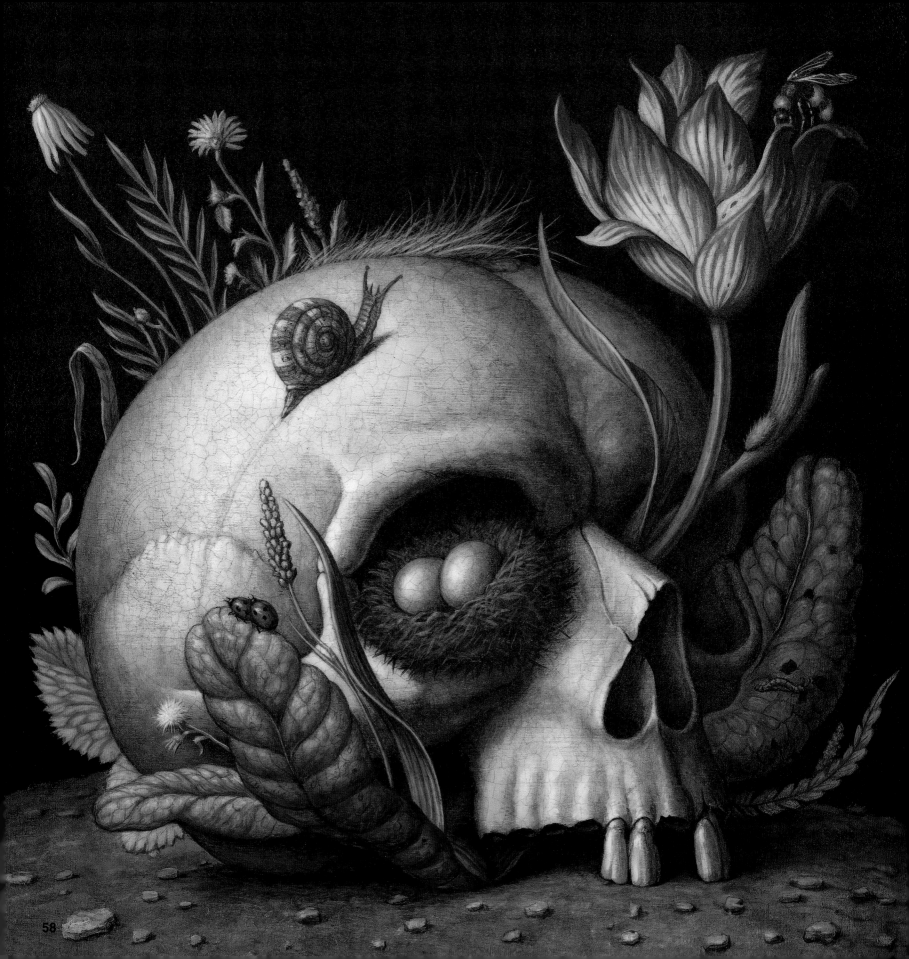

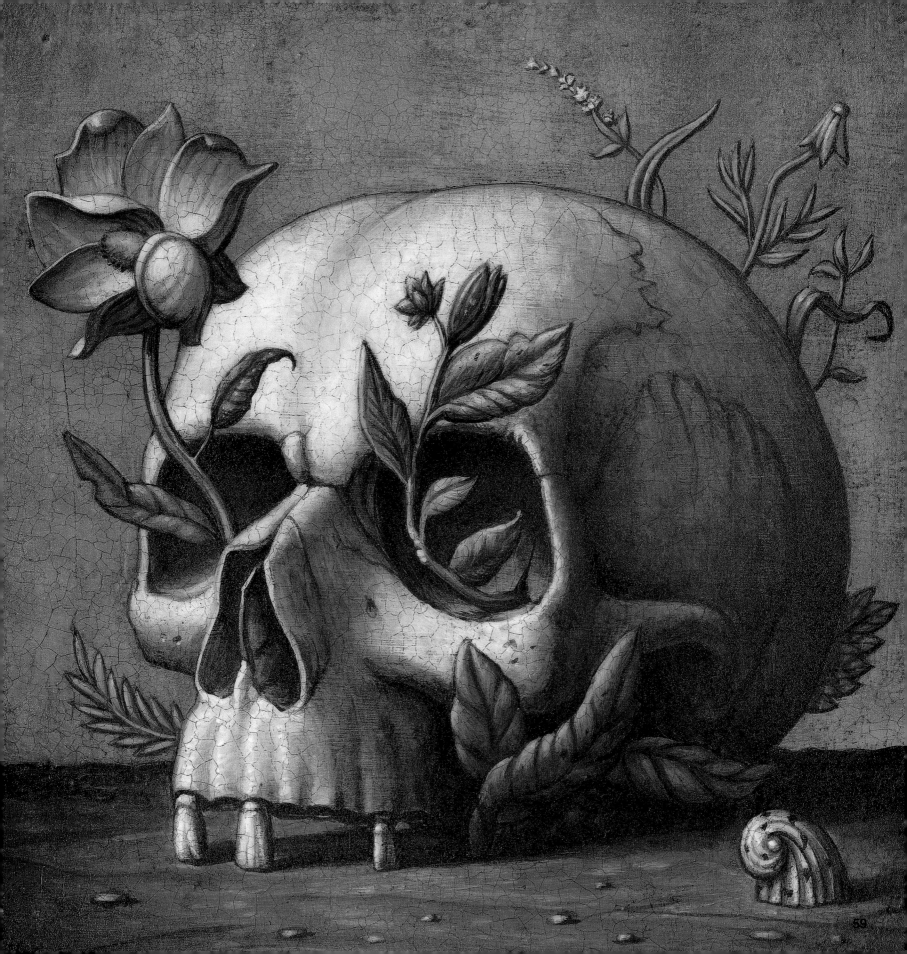

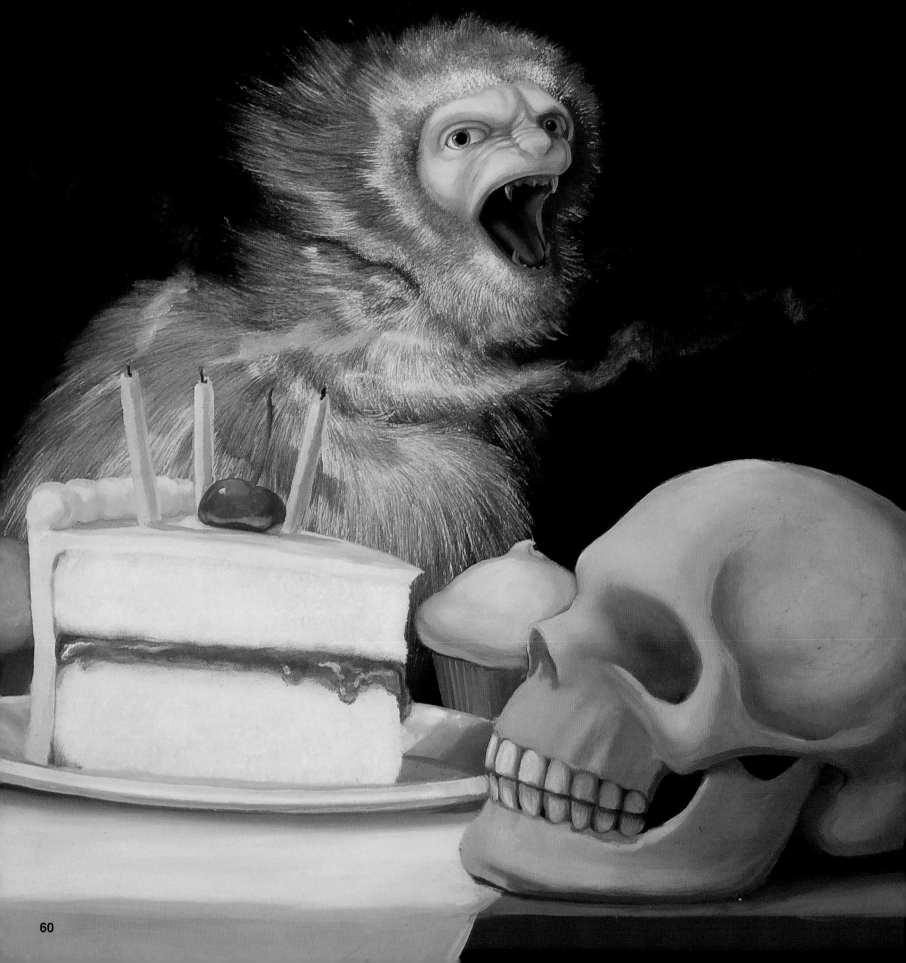

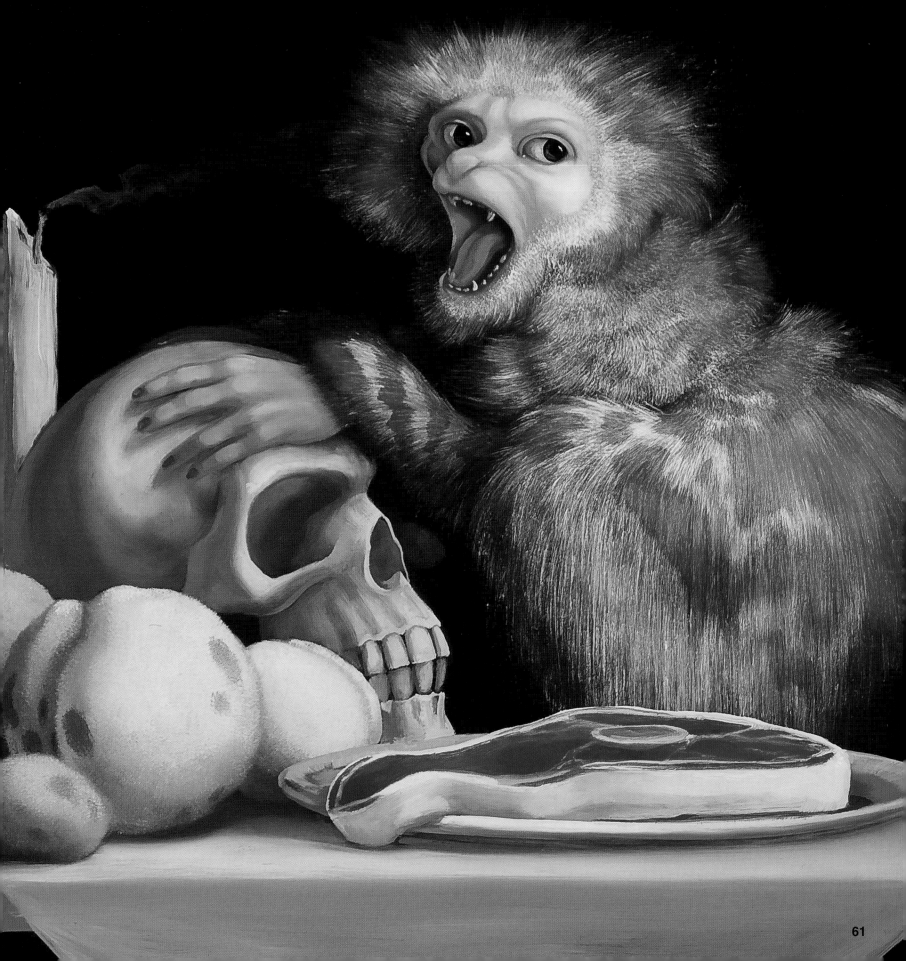

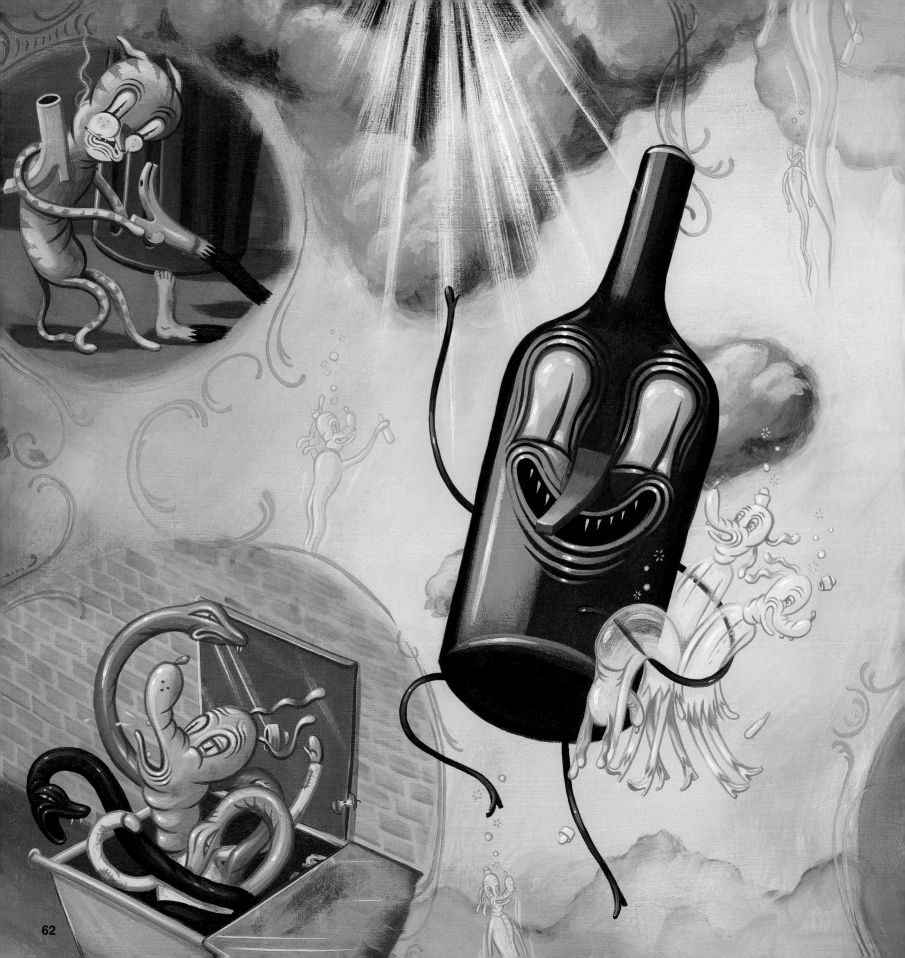

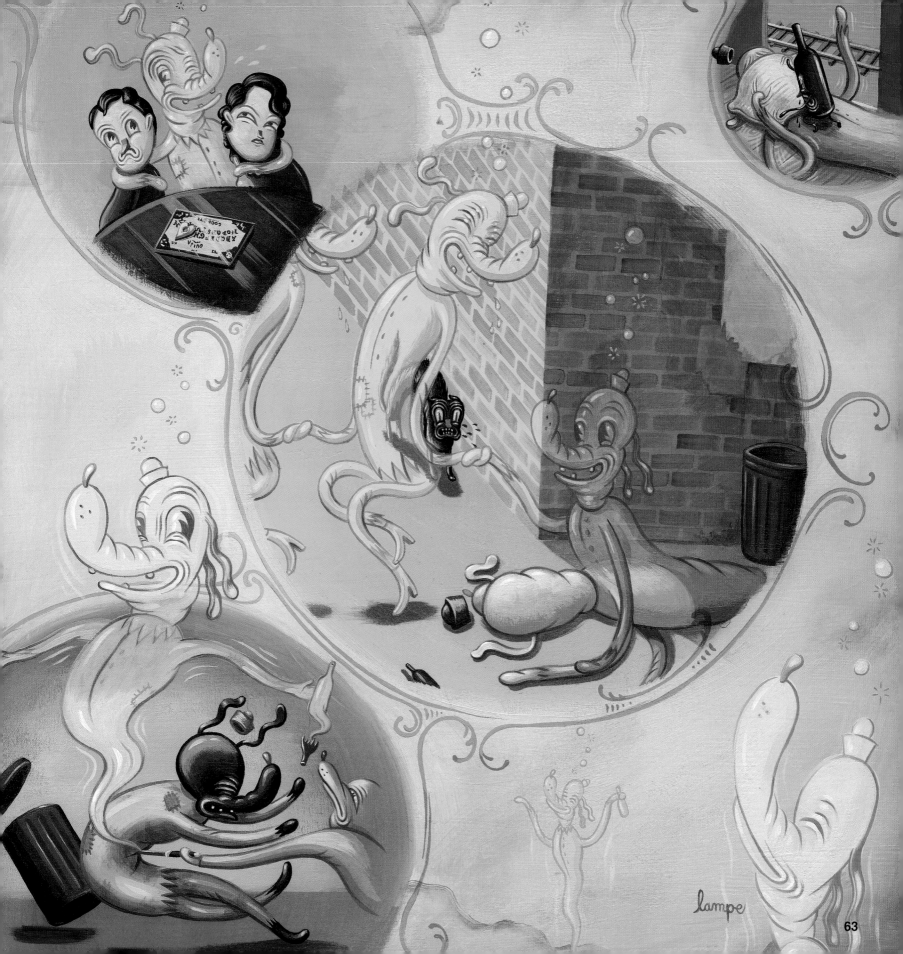

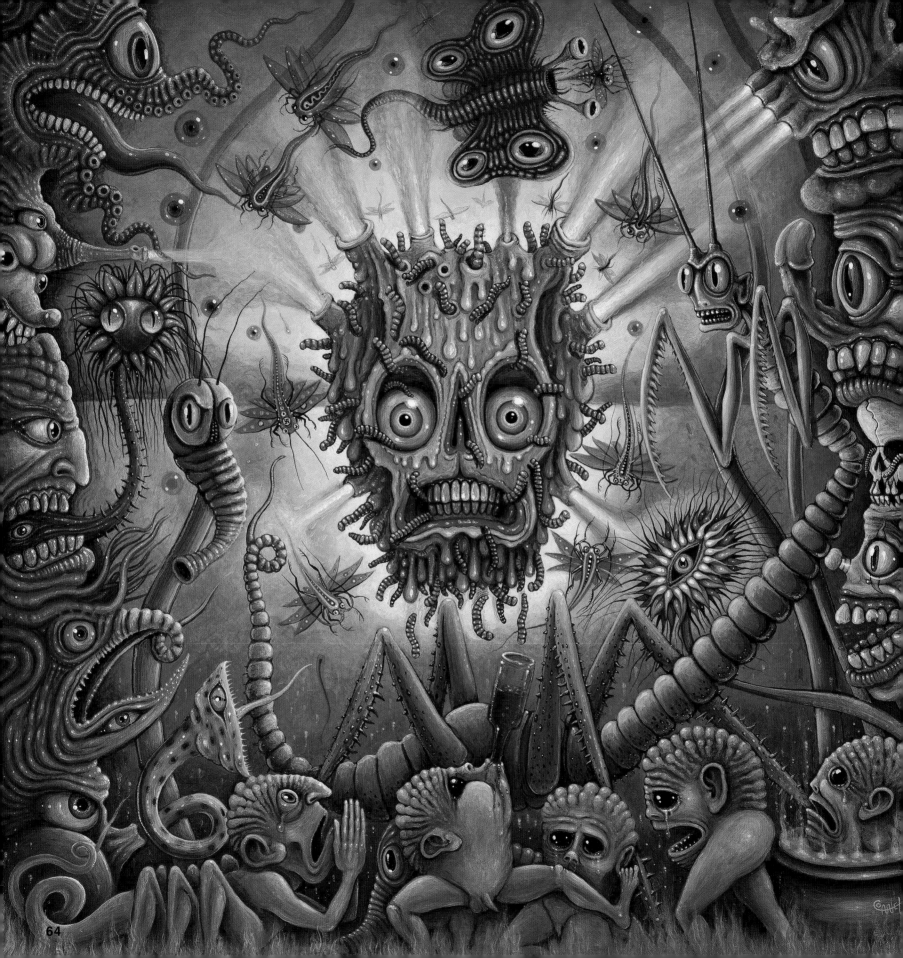

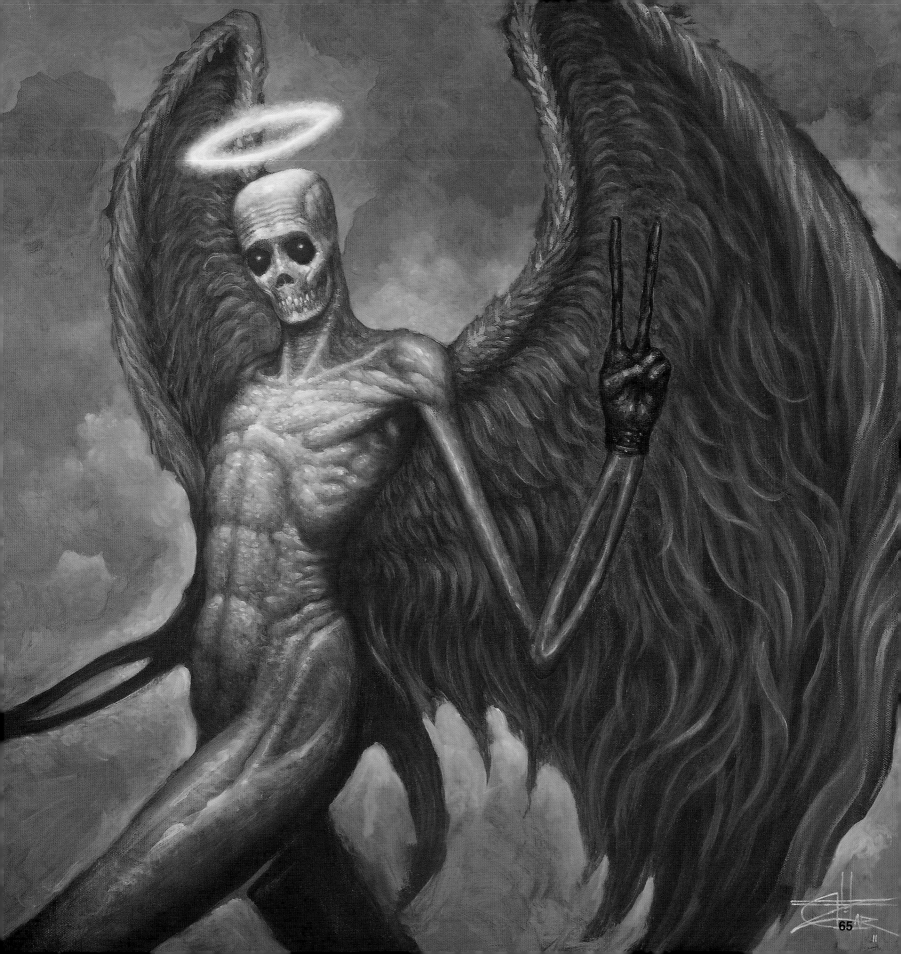

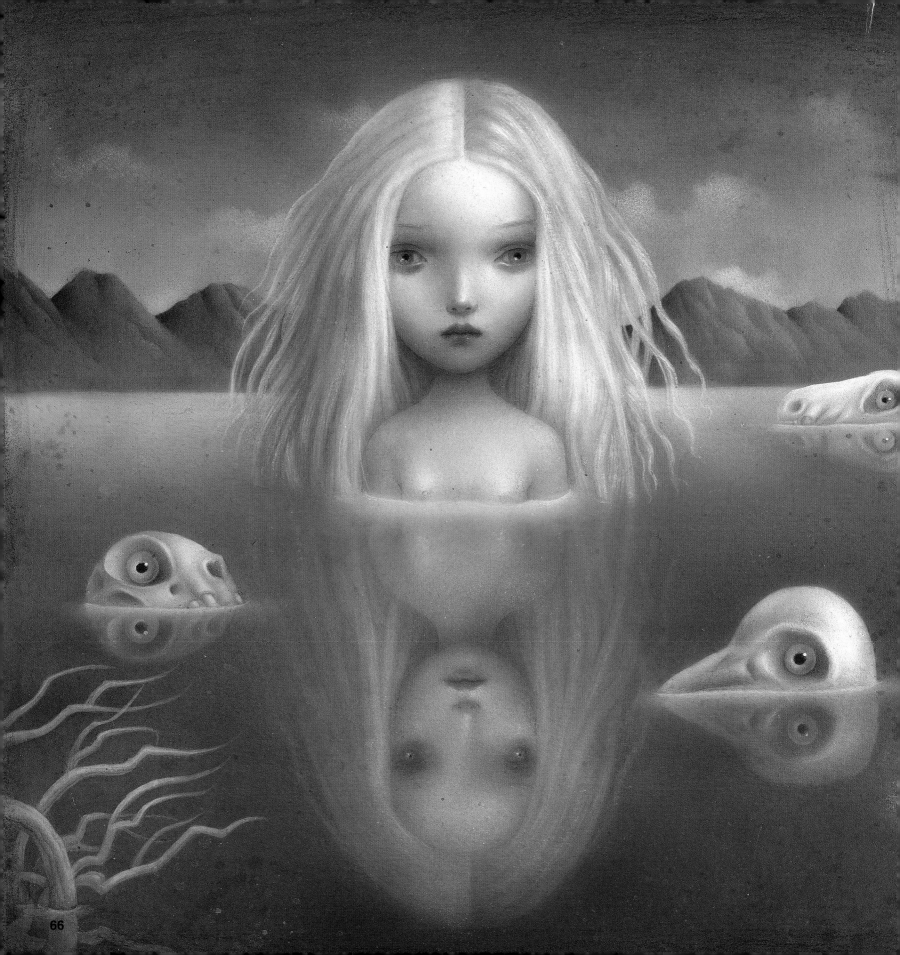

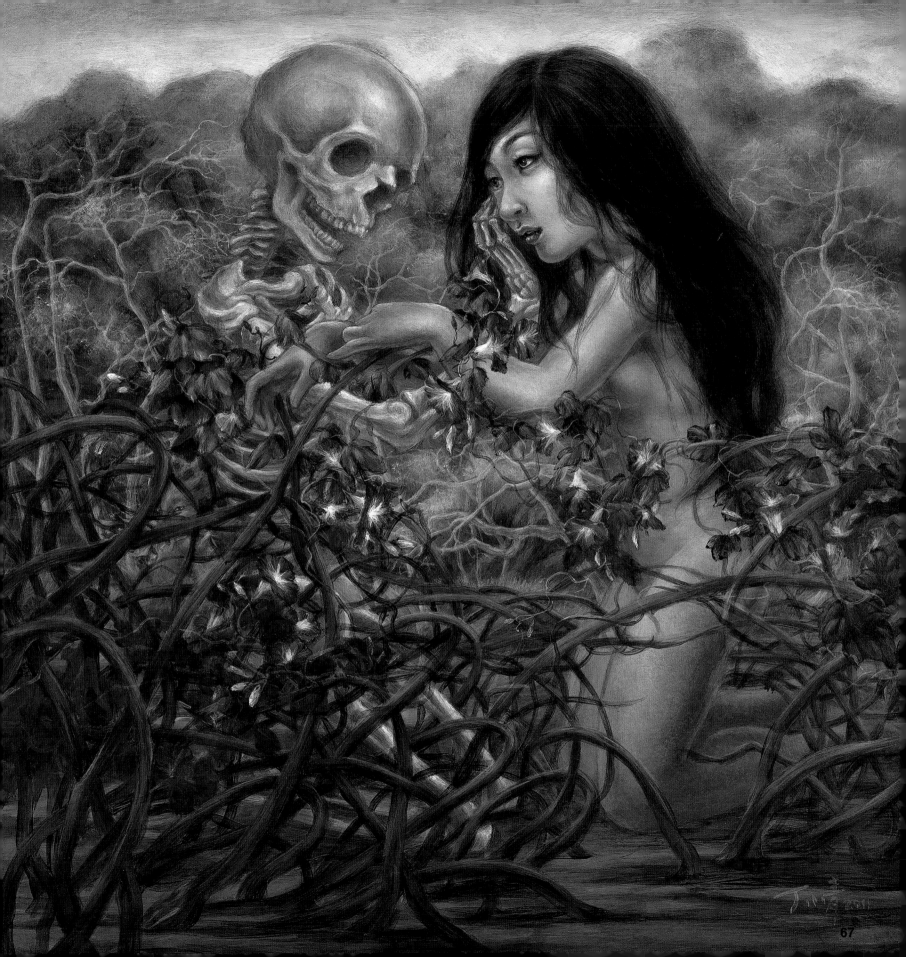

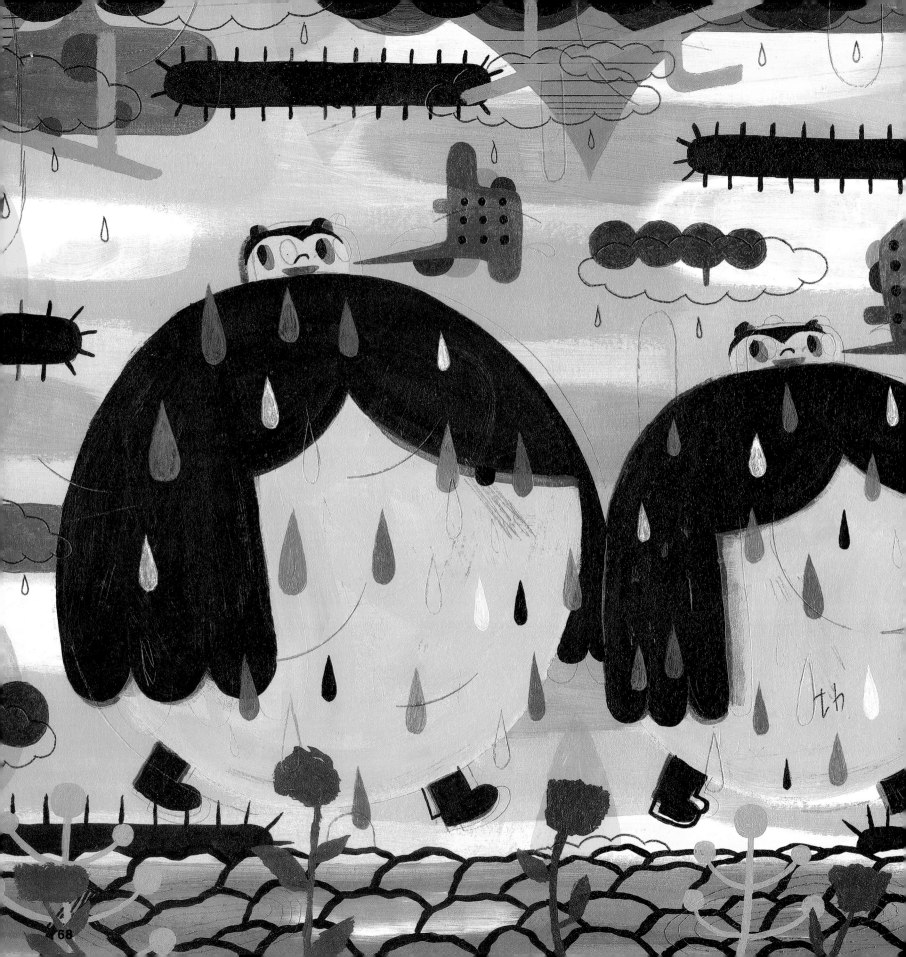

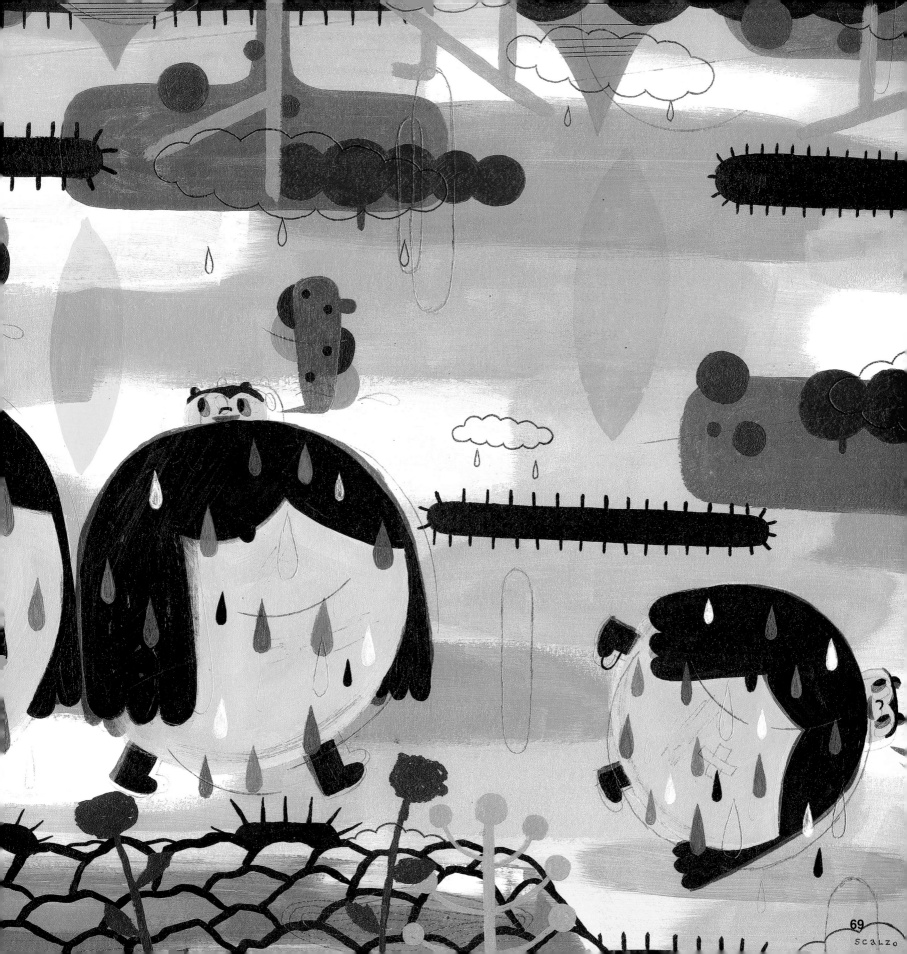

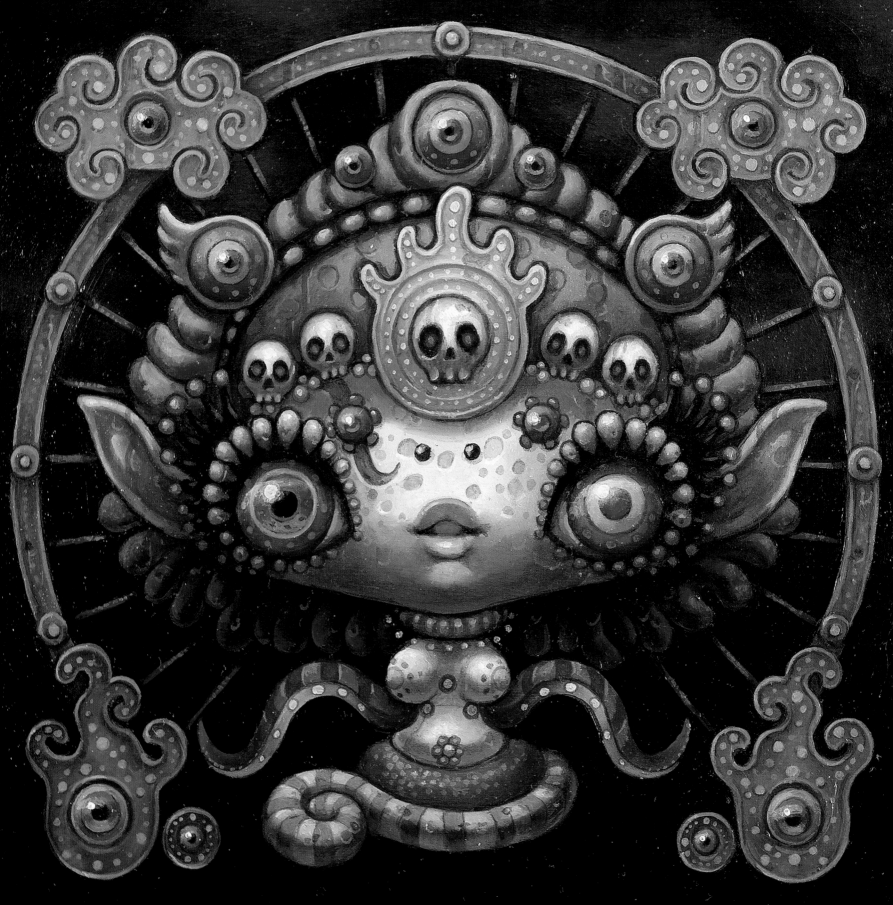

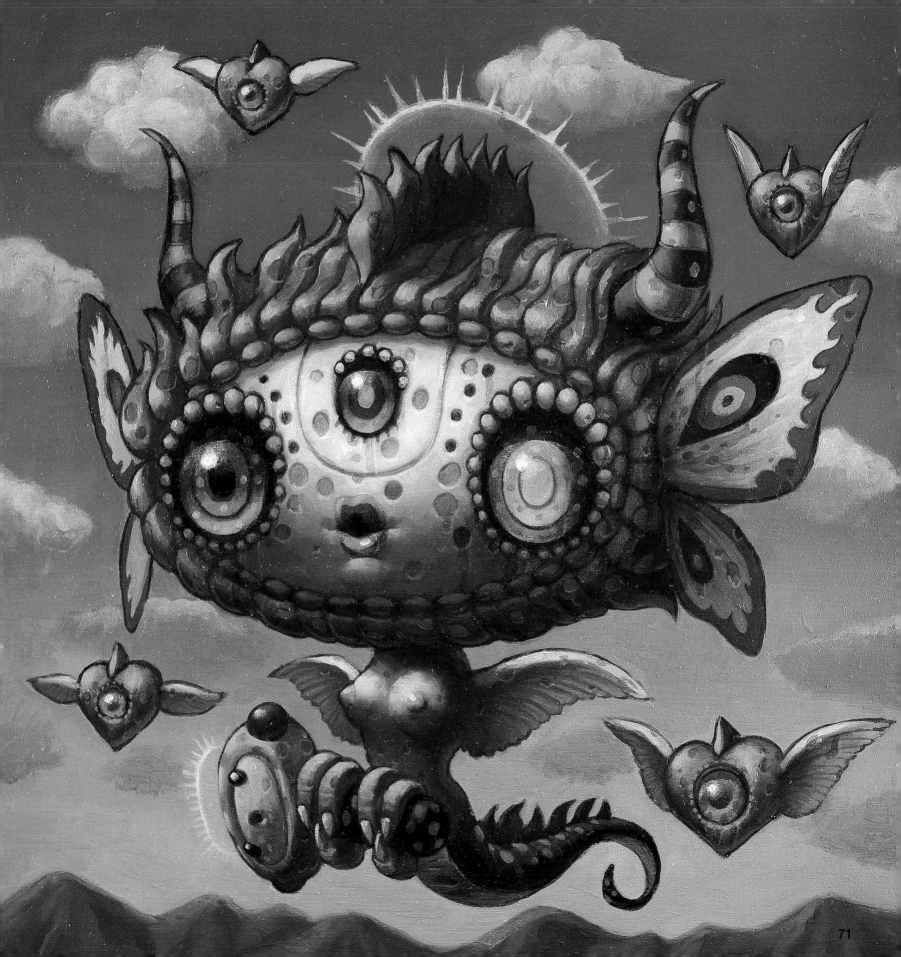

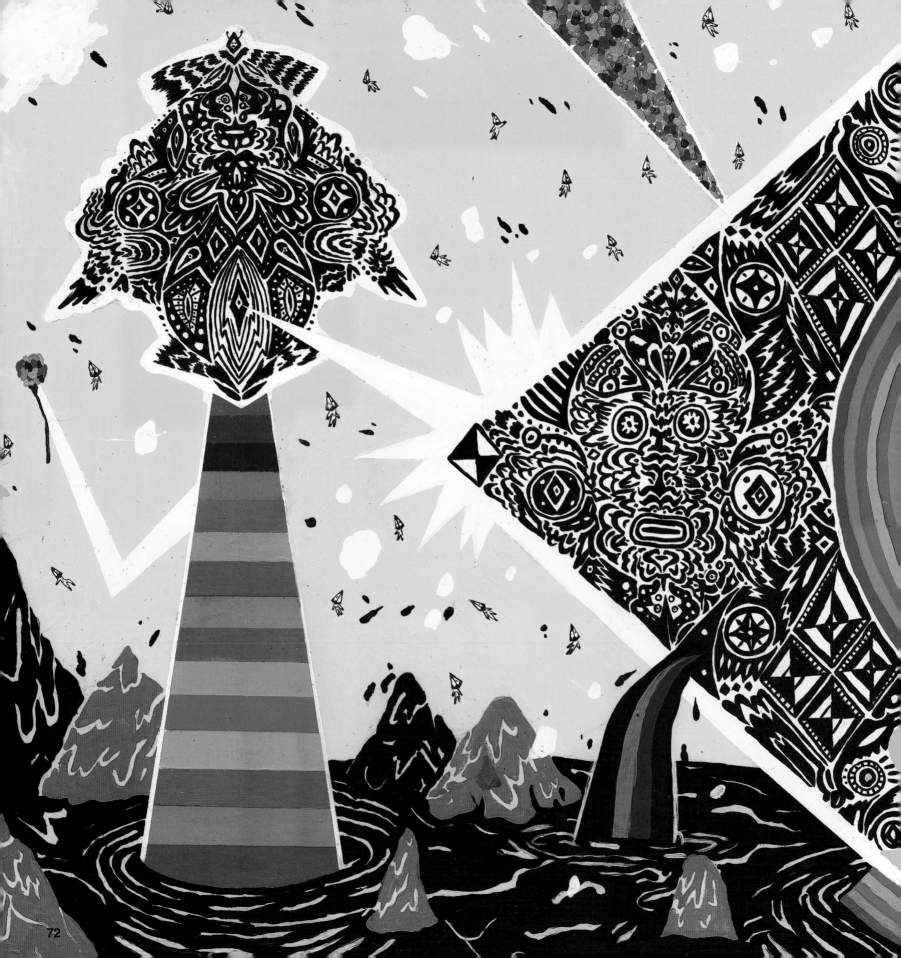

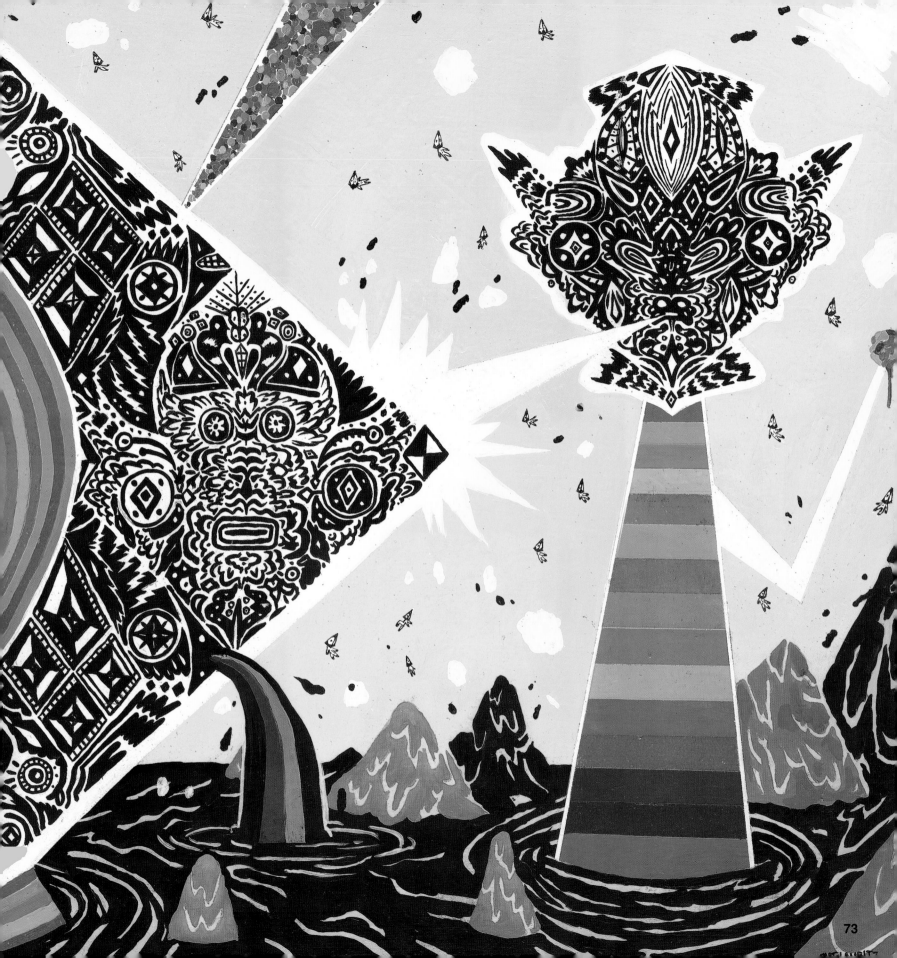

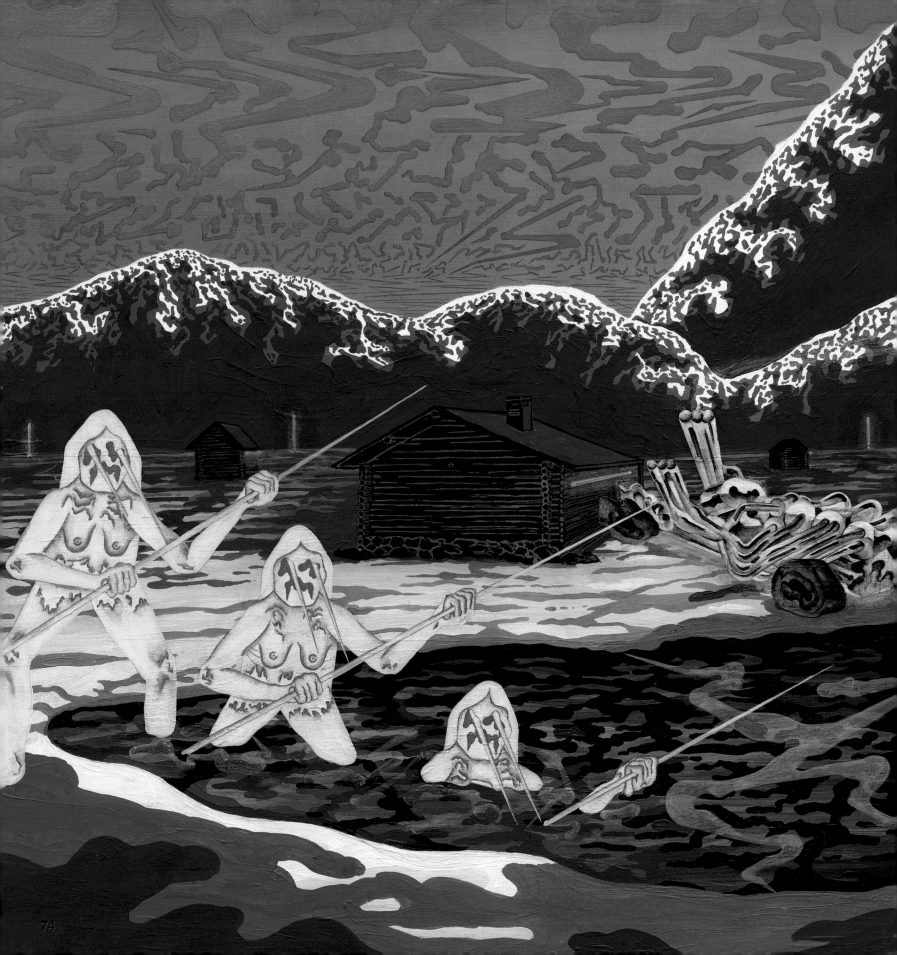

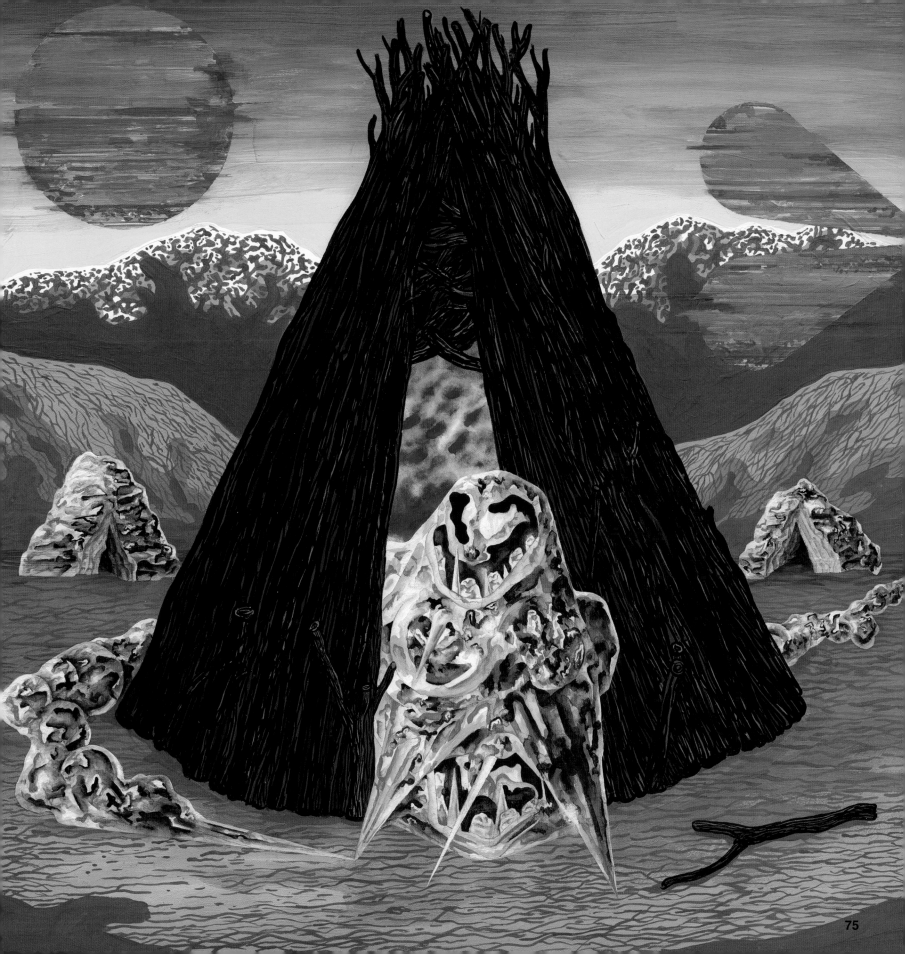

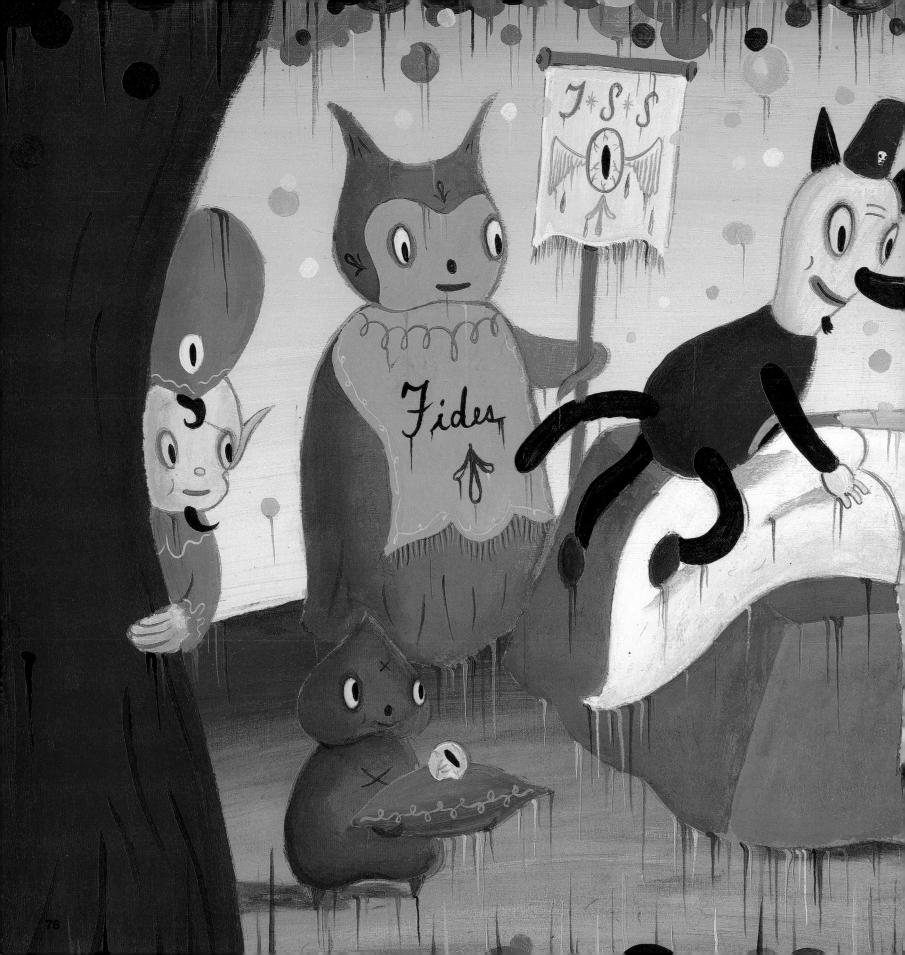

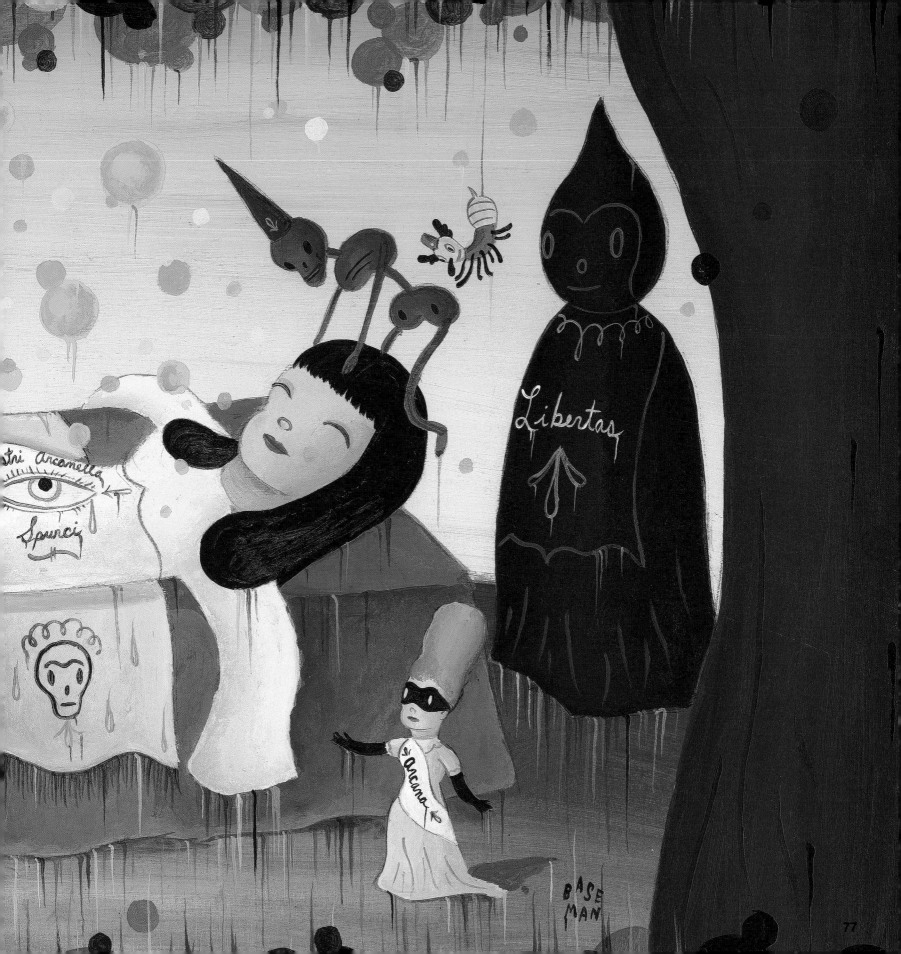

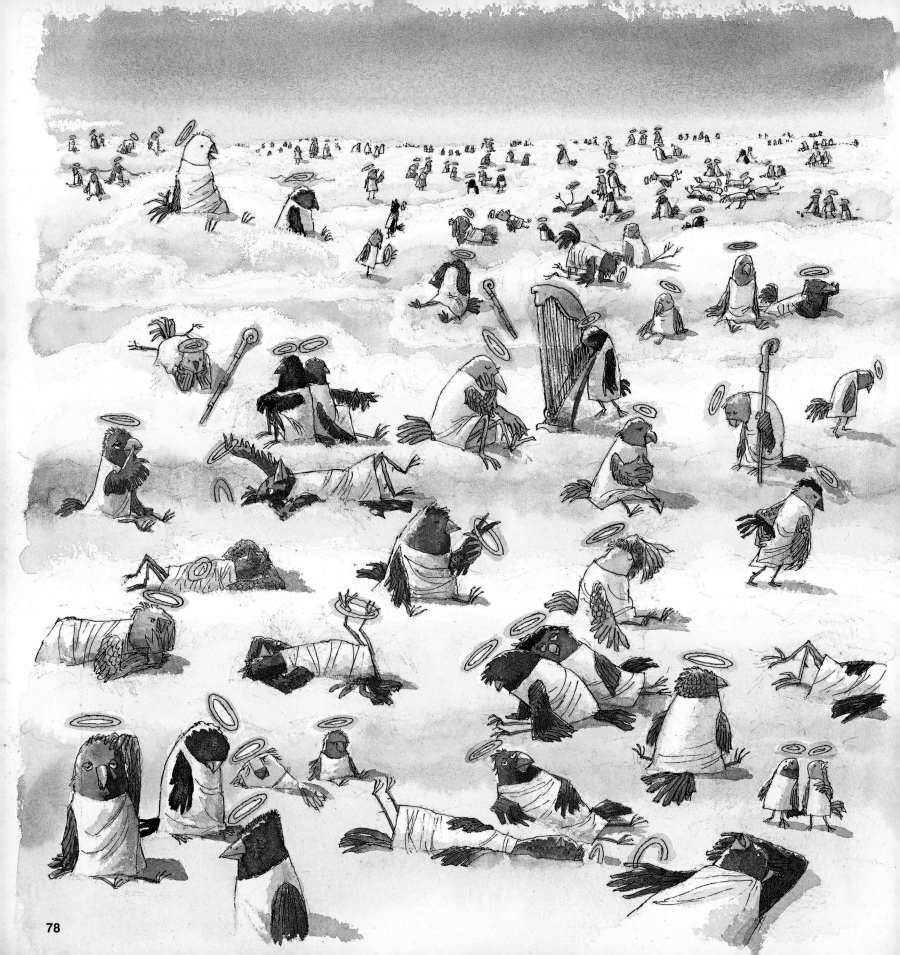

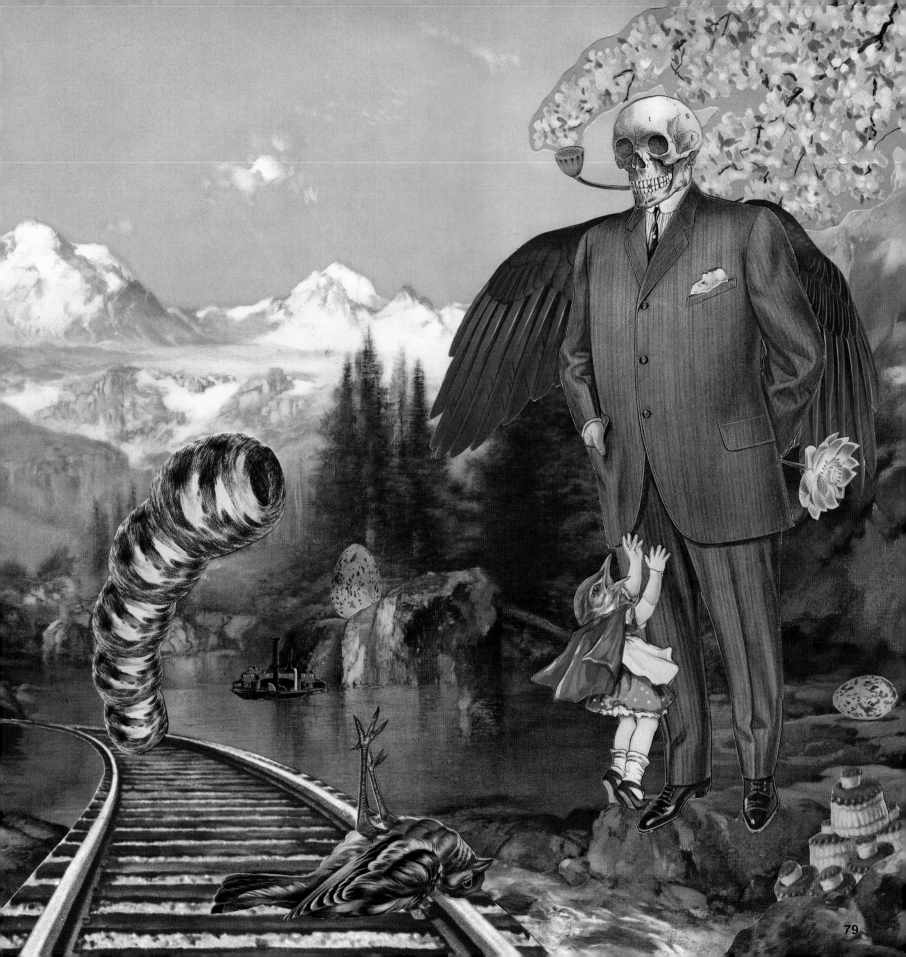

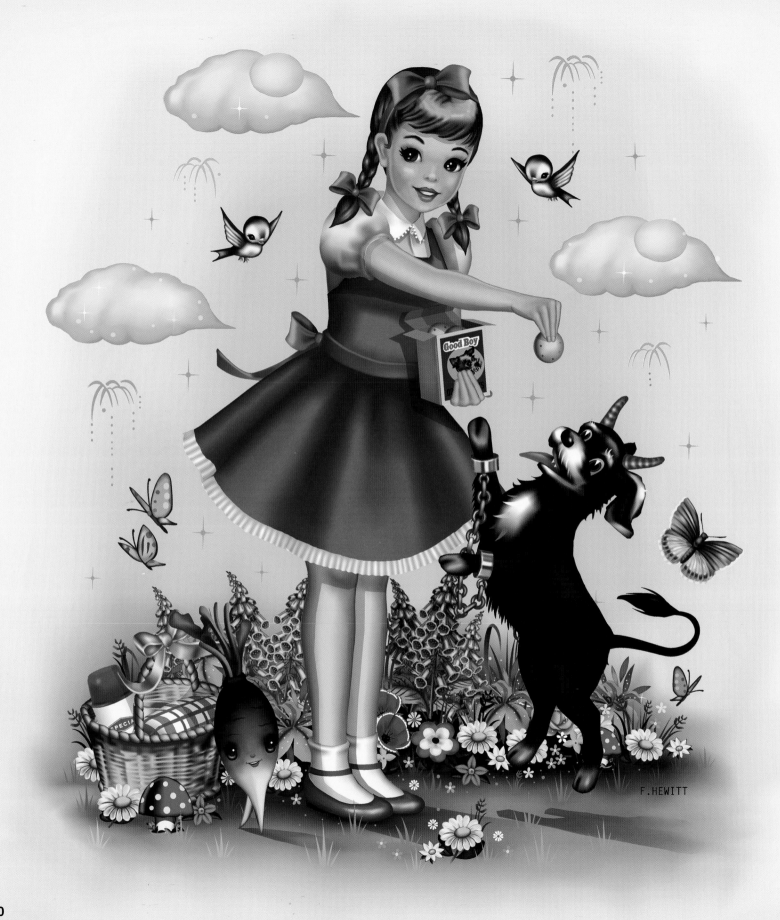

Good Boy

F. HEWITT

80

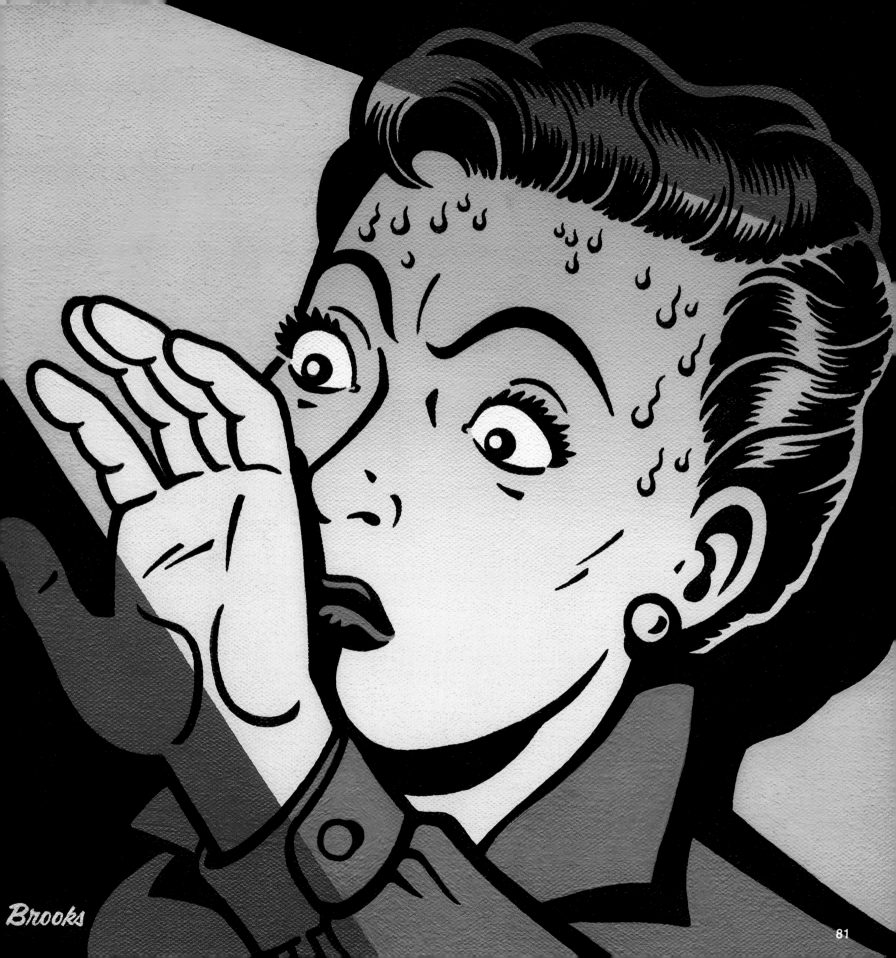

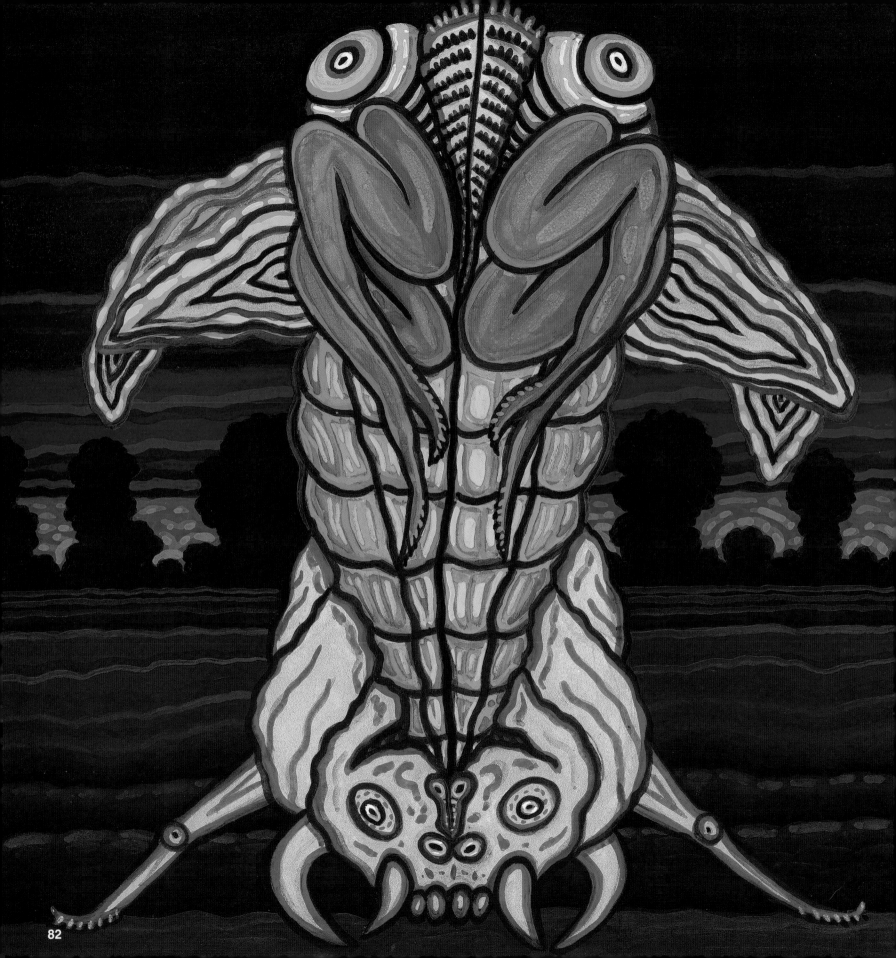

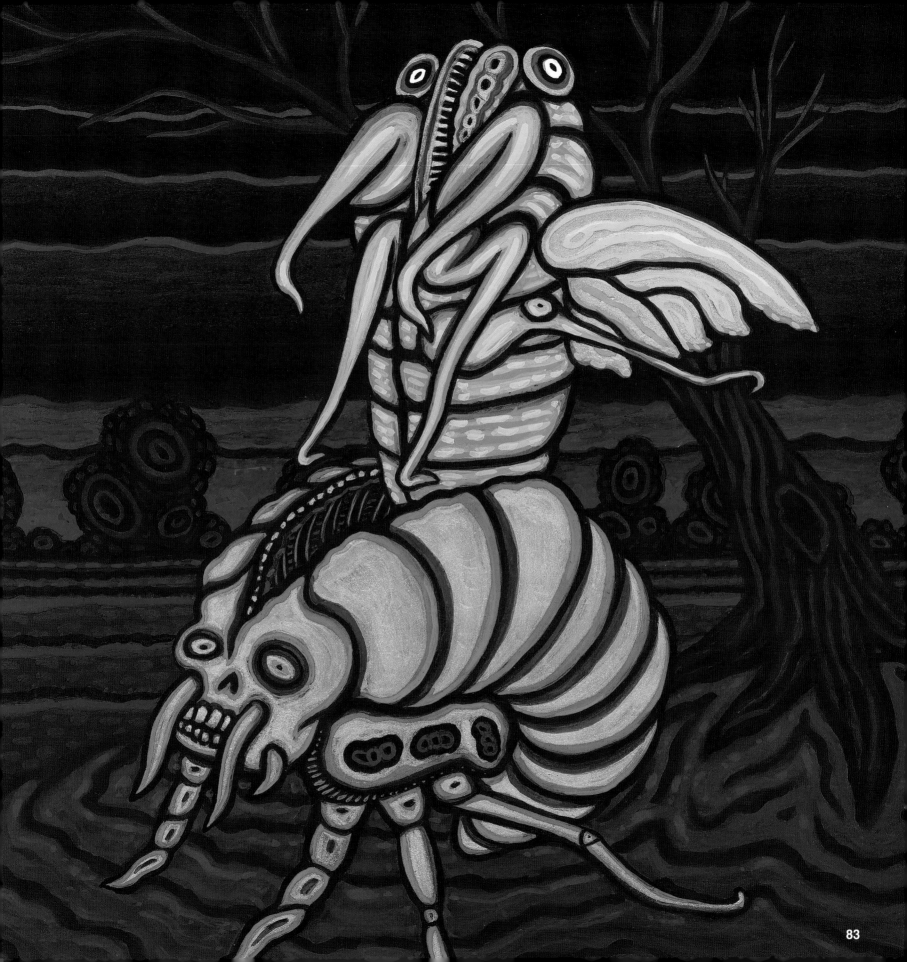

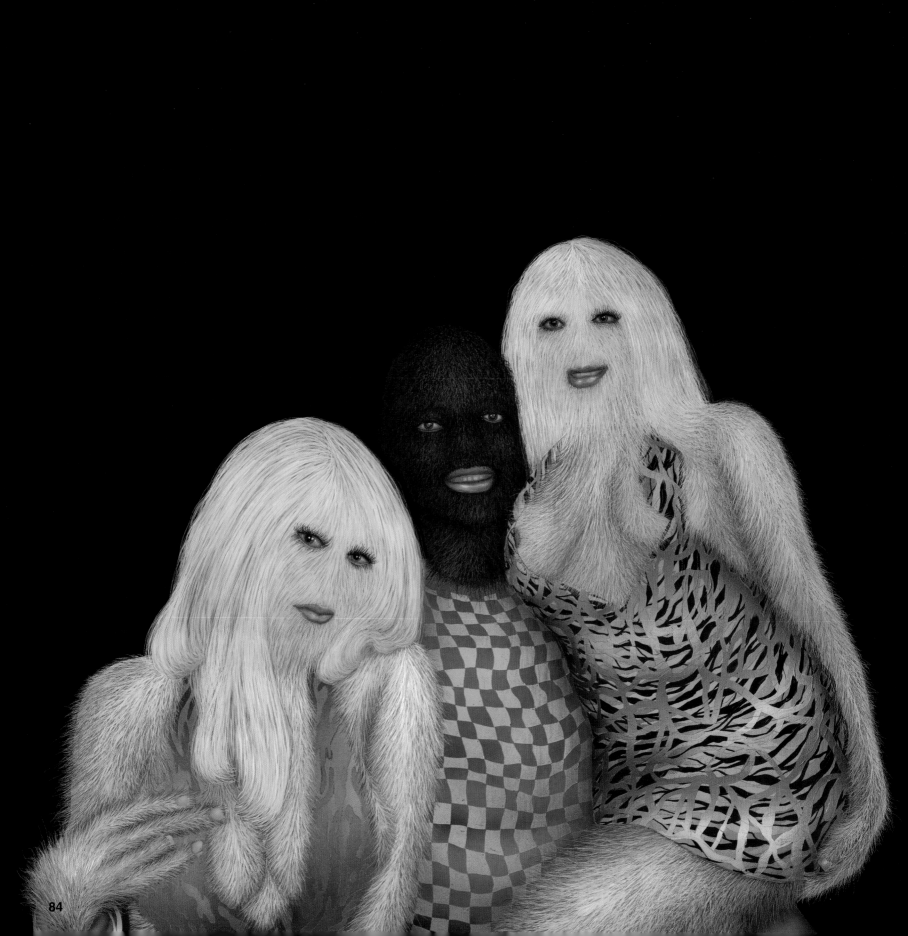

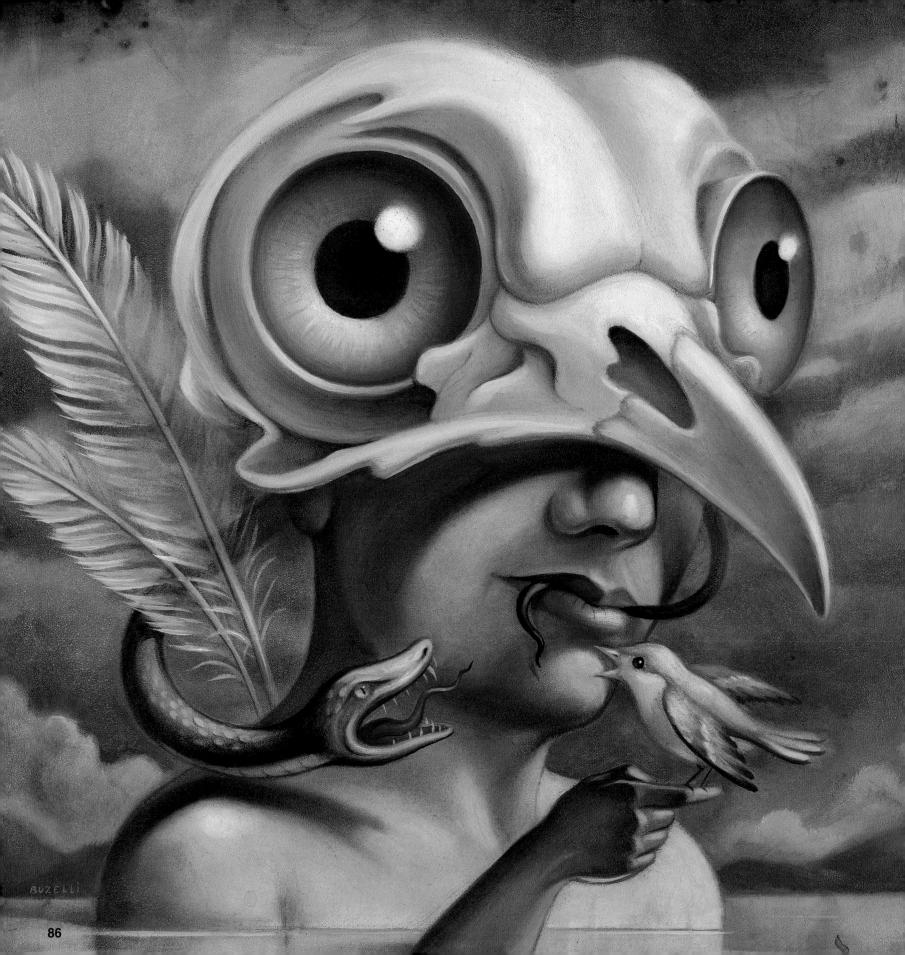

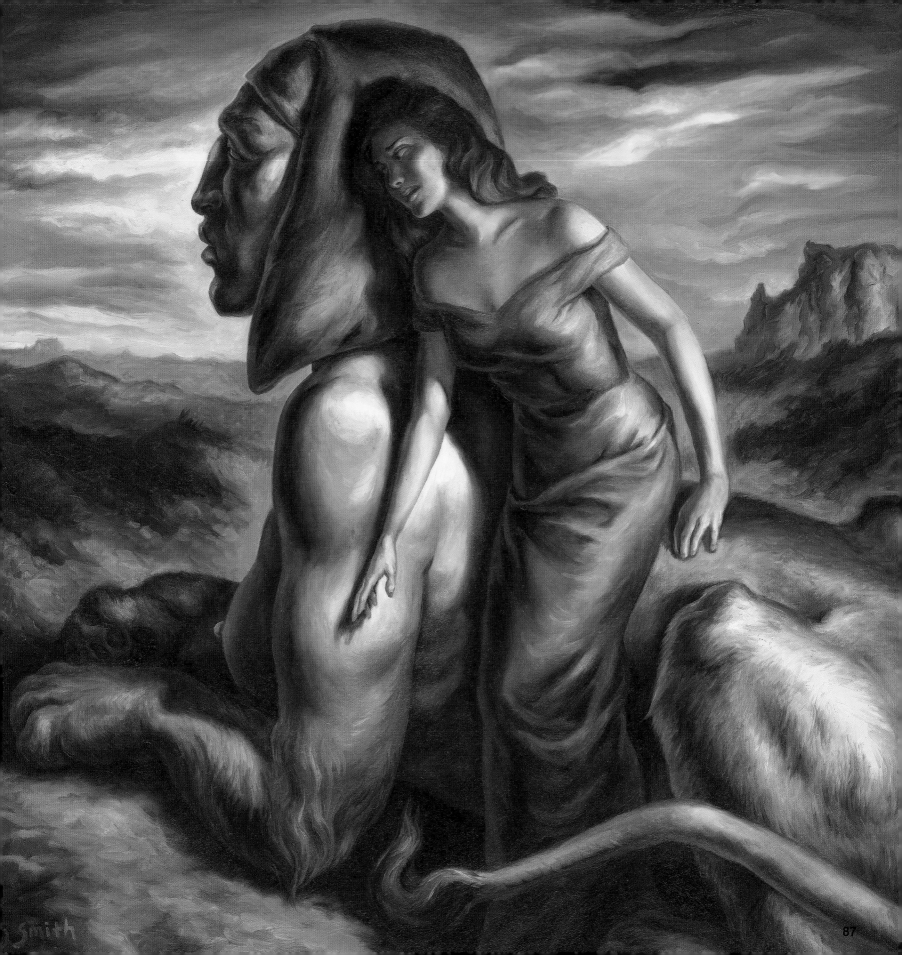

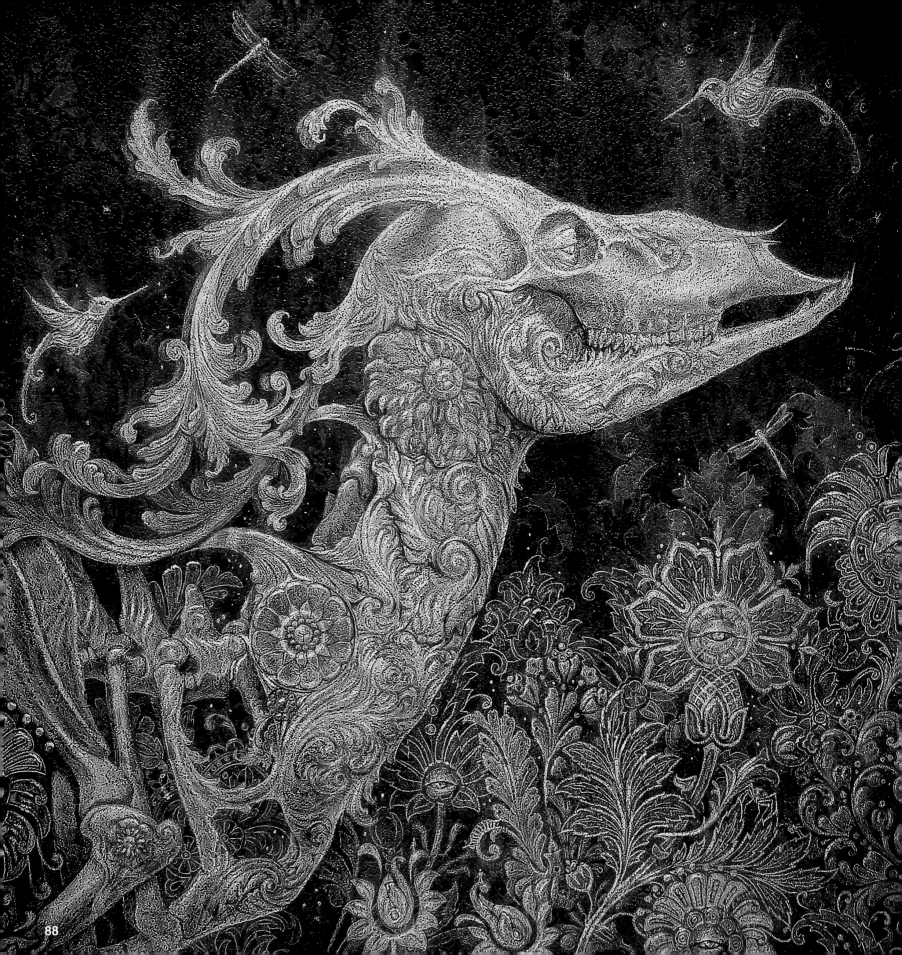

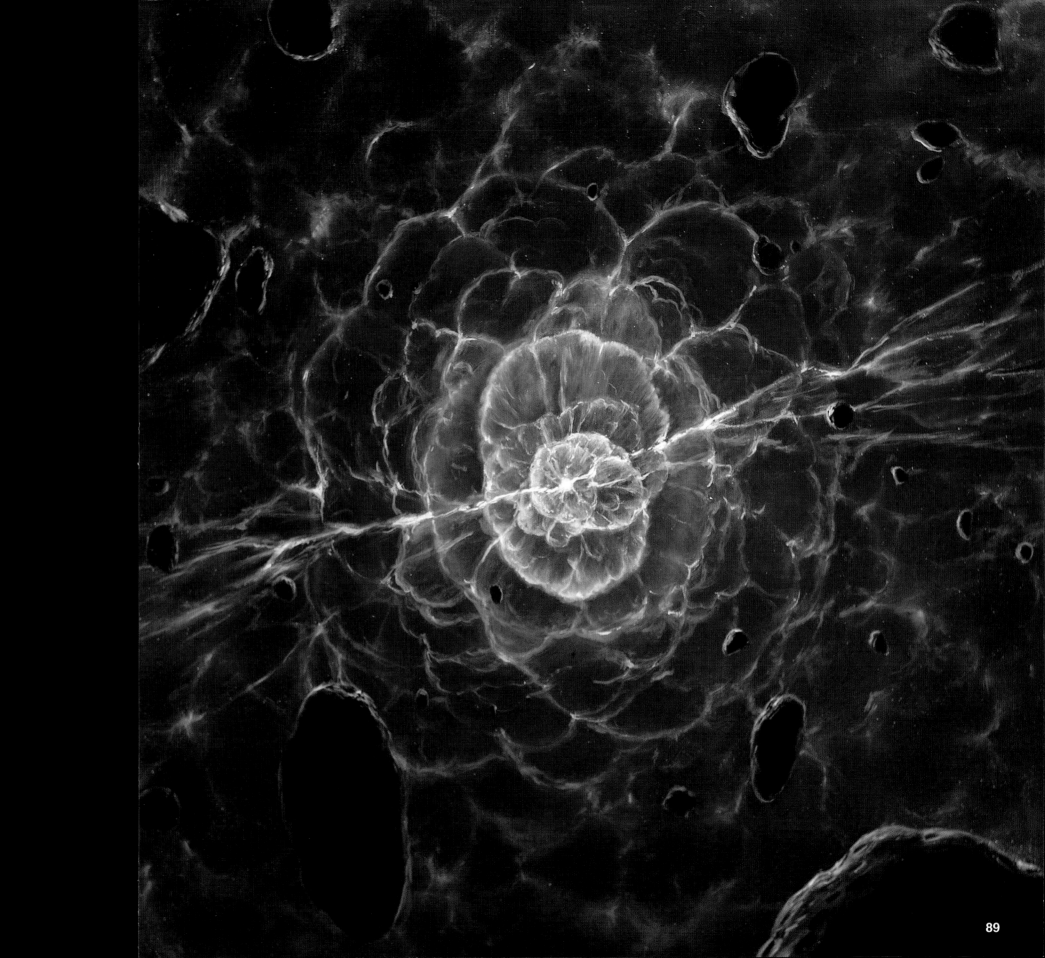

THE

LP
IN MY LIFE
by Steven Heller

Zap #1 was the spearhead of the comic book revolution. In my universe it was a revelation too—a zap to the brain. Before its 1968 premiere, underground comix appeared in underground newspapers, such as New York's *East Village Other* and its sister publication, *The Gothic Blimp Works*, where R. Crumb, Kim Deitch, Gilbert Shelton, S. Clay Wilson, and Spain Rodriguez launched assaults on convention. The word *inspirational* understates the incredible power of such fervent taboo-busting on those of us weary of trite comic superheroes and Archie. While the undergrounds looked and read like comics, in fact they were "comix," a combination of a conventional visual language and unconventional storylines heretofore banned from mainstream comic books.

Free at last! Comics were free at last!

Zap was a co-mixing of artists with collective contempt for accepted mores. Yet each individual had personal passions and obsessions. *Zap*'s earliest contributors included the founder R. Crumb, whose ribald and racy characters' repertory starred Fritz the Cat, Mr. Natural, Angelfood McSpade, Dirty Dog, and Schuman the Human; Victor Moscoso and Rick Griffin, the masters of vibrating psychedelic rock concert posters; and S. Clay Wilson, known for living out his perverse fantasies through dark comic figures. In a way, they were the real superheroes of the comics.

I recall *Zap* #1 like I remember my first sight of The Beatles and first listen to Bob Dylan. Shock and awe! Being a comic book fan, I immediately registered Crumb's Mr. Natural cover image as paying homage to pre-Code comics. As founding art director of *Screw* and publisher of *The New York Review of Sex*, I appreciated the necessary advisory, "Fair Warning: For Adult Intellectuals Only." I was barely an adult, but intellectual for sure.

A few years earlier, I was mad for *Mad* (even in its post-

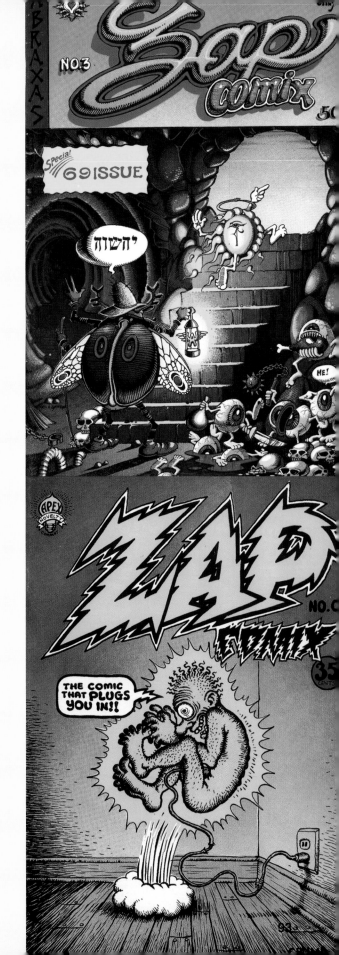

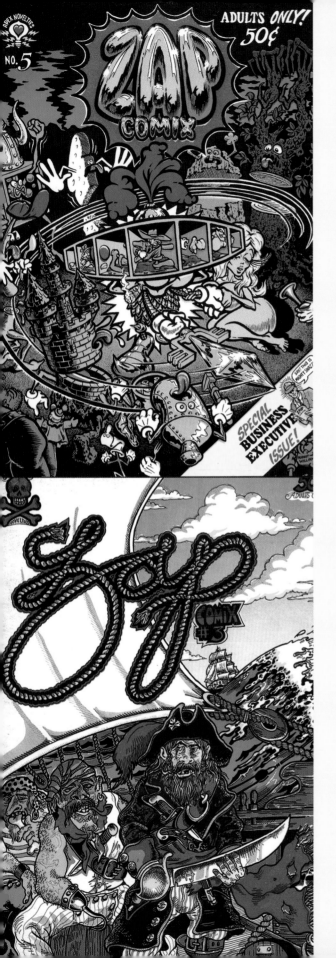

Code magazine incarnation). In *Zap*, Crumb introduced a selection of tales that had spiritual roots in *Mad* magazine's irreverent satire. But while *Mad* eschewed sex and politics, Crumb reveled in it. "Whiteman" was a tale of "civilization in crisis," "Mr. Natural Encounters Flakey Foont" was a jab at spirituality, "Ultra Super Modernistic Comics" was a tweak at high art, and his now classic "Keep on Truckin'" was absurdly funny slapstick. These comics were curiously tame compared to later underground raunchiness, but, at the time, even comical jibes at frontal nudity, recreational drug use, and racial stereotyping tested the liberal tolerance (i.e., Angelfood McSpade, a bug-eyed African cannibal, sold a product called "Pure Nigger Hearts").

By the time of *Zap* #1, Victor Moscoso, Rick Griffin, Wes Wilson, and Stanley Mouse had already triggered a style that undermined prevailing modern design notions of rightness by introducing vibrating color, illegible lettering, and vintage graphics to posters that were complex assemblies of type and image designed to be read while high. Always the experimenter, Moscoso, who had been interested in serial imagery when he was a painter studying at Yale in the early 1960s, was beginning to play with skewed sequential photographs for use as a Christmas card for an old high school friend, the animator and film title designer Pablo Ferro. Griffin had done a poster send-up on *The San Francisco Chronicle*'s comic section. After seeing this poster, which was "like Disney on LSD," Moscoso once told me, "It turned me in the direction of cartoons, as opposed to photos."

Moscoso and Griffin (who died in a motorcycle accident in August 1991) together created a series of posters for Pinnacle Productions in L.A., promoting Janis Joplin and Big Brother, B.B. King, and Pacific Gas & Electric Company. At the bottom were three comic panels Griffin drew that gave [*cont. page 103*]

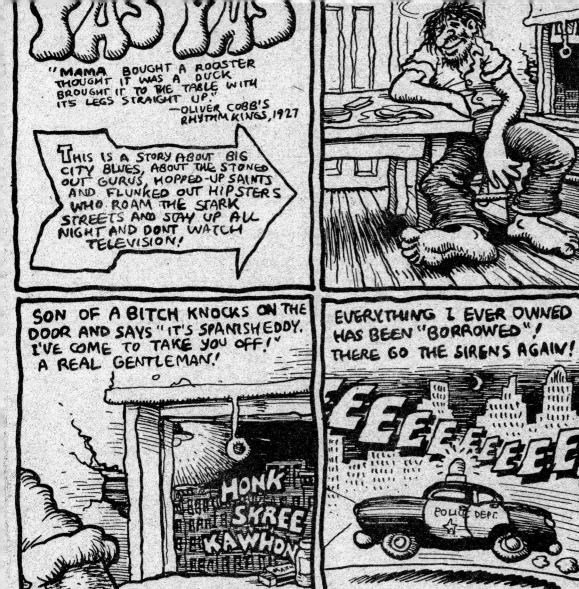

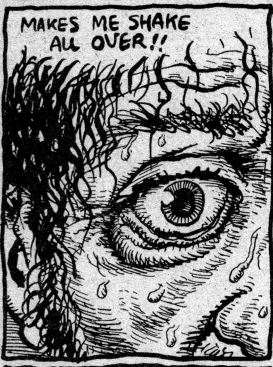
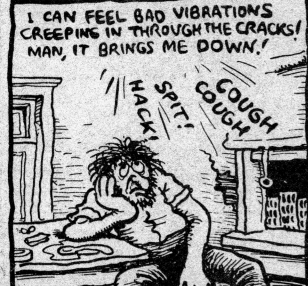
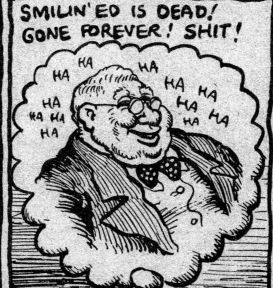

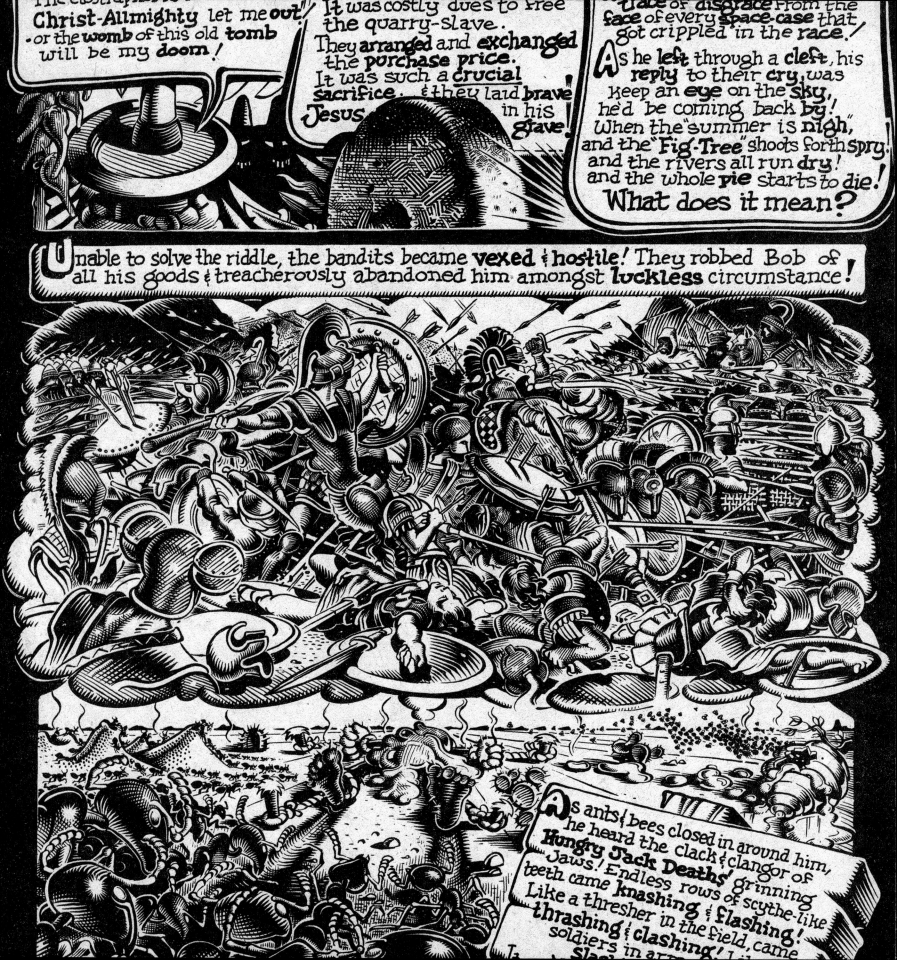

THE PARROT WAS ORDERED TO PAINT FOUR POMEGRANATES THAT SAT ON A TABLE BEFORE HIM.

IN A MOMENT THE PARROT RENDERED THE FOUR POMEGRANATES WITH SUCH FIDELITY THEY BECAME EIGHT.

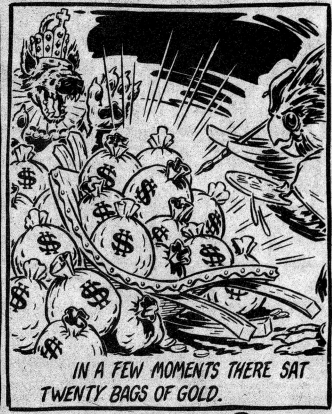

THE COURT MARVELED, BUT THE HYENA KING SAW MUCH GREATER POSSIBILITIES AVAILABLE, AND ORDERED TEN BAGS OF GOLD PLACED BEFORE THE PARROT.

IN A FEW MOMENTS THERE SAT TWENTY BAGS OF GOLD.

BEFORE THE CONFUSED PIRATE COULD BLAST THE DEMON—THE DEMON GUARD'S TWIN FOUNTAINS EXPLODED WITH GEYSERS OF COME WHICH PLUGGED UP THE PIRATE'S GUN!

THE PIRATE WAS SWIFT HOWEVER, HE RUSHED FORWARD KNOCKING THE DEMON COLD WITH THE BUTT OF HIS COME FILLED GUN... AND LEAPT OVER HIM INTO THE CASTLE....

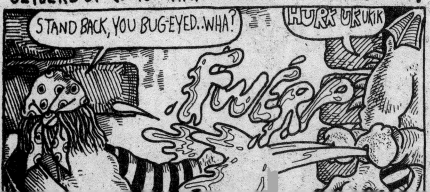

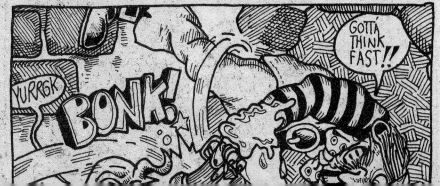

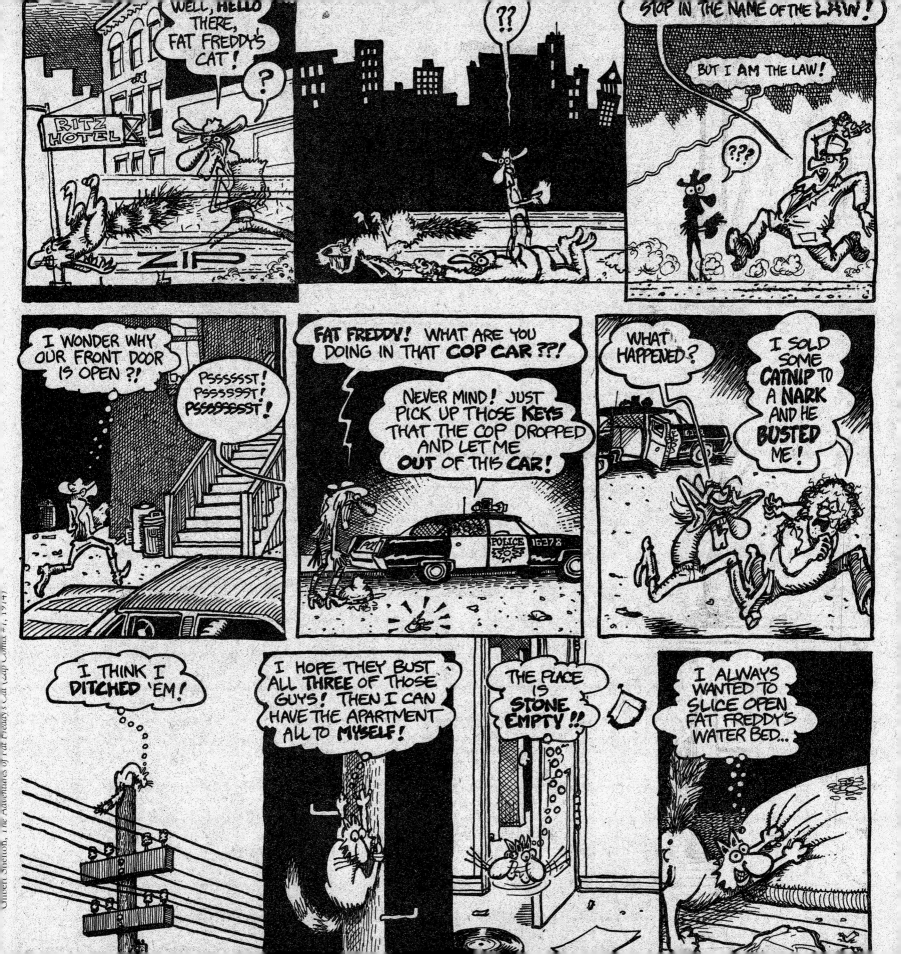

THESE CONVERSIONS NEVER LASTED LONG. CHARLEY COULDN'T STAY AWAY FROM THE LOOSE WOMEN, THE GOOD TIMES, AND THE MOONSHINE LIQUOR.

PATTON WAS KNOWN FOR BEING "HIGH-TEMPERED," "FLIGHTY," AND FOR HAVING A "BIG MOUTH" WHICH OFTEN GOT HIM INTO FIGHTS, THOUGH HE WAS ILL-EQUIPPED TO DEFEND HIMSELF PHYSICALLY.

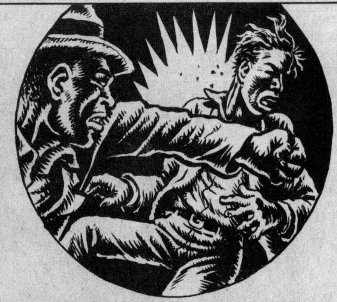

IT IS ALSO WELL-KNOWN THAT HE FOUGHT VIOLENTLY WITH HIS WOMEN. "IF THOSE WOMEN MADE HIM MAD, HE'D JUS' FIGHT, AND, YOU KNOW, KNOCK 'EM OUT WITH THAT OLD GUITAR," CLAIMED AN OLD ACQUAINTANCE.

SOMETIME AROUND 1931 SOMEONE TRIED TO CUT HIS THROAT, BUT PATTON SURVIVED WITH AN UGLY SCAR.

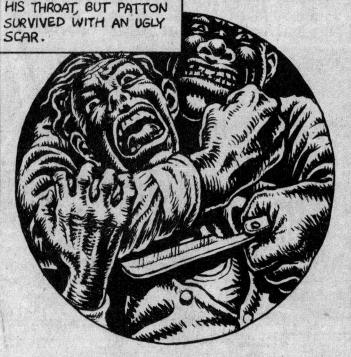

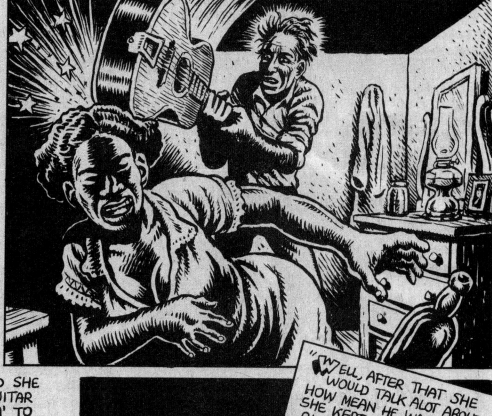

"I KNEW ONE OF HIS WIVES, NAMED LIZZIE, AND SHE SAID ONE DAY HE JUST WALKED OFF WITH HIS GUITAR AND NEVER CAME BACK. SHE HADN'T DONE NOTHIN' TO HIM. HE HADN'T DONE NOTHIN' TO HER."

"WELL, AFTER THAT SHE WOULD TALK ALOT ABOUT HOW MEAN HE WAS. BUT SHE KEPT HIS PICTURE RIGHT THERE ON HER MANTEL. SHE KEPT IT 'TIL THE DAY SHE DIED,"

them the idea to do a comic magazine that would combine their talents through alternating panels. "I did a template for each of us on eight by five inch cards," Moscoso said. "We were using a rapidograph at the time, and since we each had the same template, we'd start drawing anything that came into our mind in a box and alternately put one next to the other in a non-linear fashion so that the development would be purely visual."

Originally, the comic was just going to include Moscoso's and Griffin's collaborations. "We were already doing our respective drawings, when we saw *Zap* #1 when Crumb had started selling it on Haight Street," Moscoso recalls. "Crumb asked us to join, because he admired Griffin's cartoon poster. In fact, Crumb did a comic strip in *Zap* #1, which was a direct bounce off that poster. So he asked Rick, and Rick said, 'Moscoso and I are already working on this stuff.' So he invited both of us to join in." Crumb also asked S. Clay Wilson, who offered up a bawdy drug fantasy titled "Checkered Demon." Moscoso and Griffin decided to shelve their collaboration and each did their own strips.

The first two issues of *Zap* were fairly innocuous compared to *Zap* #3, the special '69 issue ("because it was 1969"). *Zap* #3 lived up to its "Adults Only" advisory, akin to Tijuana Bibles (the cheaply produced, sexually explicit eight-page comics imported to the U.S. from Mexico during the 1930s and '40s). This issue was sandwiched between two separate front covers designed by Wilson and Griffin and could be read front to back and back to front. The hinge was in the middle, a Moscoso-designed turnaround centerspread showing Daisy and Donald Duck having a spot of hanky-panky. Actually, they were enjoying oral pleasures all because Moscoso was getting back at Walt Disney.

At the moment *Zap* #3 was in process, Crumb found a set

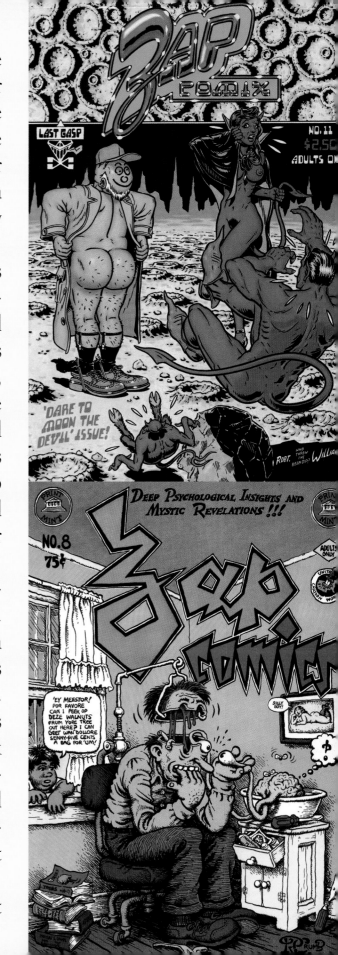

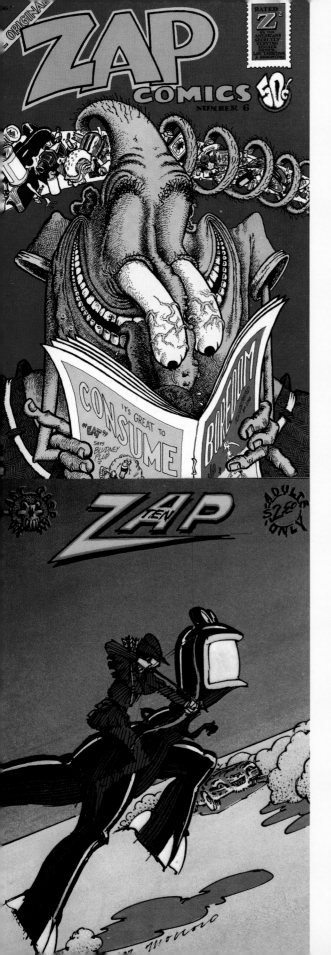

of photocopied pages that he originally had prepared for what was to be the first *Zap* but had given the artwork to a publisher who disappeared with the originals before publication. Moscoso and Griffin agreed that since Crumb had this entire comic book together, he should publish it just as it was without the other contributors, under the title *Zap #0*. This one issue, showing a man floating in a fetal position with an electric wall cord plugged into his ass, is probably the most famous of all *Zaps*.

The most influentially shocking of the *Zaps* were strips by S. Clay Wilson, "Checkered Demon" and "Captain Piss Gums and his Perverted Pirates." Moscoso told me, "We didn't really understand what we were doing until Wilson started publishing in *Zap*. I mean, he's not a homosexual, yet he's drawing all these homosexual things. He's not a murderer, yet he was murdering all these people. All the things that he wasn't, he was putting down in his strips. So that showed us that we were, without being aware of it, censoring ourselves."

Zap enabled the artists, and by extension us readers, to tap into addled fantasies. How far out could they go along the model that Wilson had set up? In this sense, *Zap* quickly became an arena to test the U.S. Supreme Court's "community standards" doctrine, which allowed each community to define pornography in relation to the local consensus. As on the edge as it was, *Zap #3* was unscathed. *Zap #4*, on the other hand, stretched those standards beyond the limit and was, therefore, enjoined by the San Francisco police. For between front and back covers of a dancing penis and comics like the explicitly titled "A Ball in the Bung Hole" by Wilson, "Wonder Wart-Hog Breaks up the Muthalode Smut Ring" by Shelton, and "Sparky Sperm" by Crumb, the seeds of discontent were born. But the strip that forced the police's hand was Crumb's "Joe Blow," featuring Dad and Mom and Junior and Sis in a satire of the incestuous all-American family. Or as Moscoso explains:

"You can cut off a guy's penis and devour it (as in "Heads-Up" by Wilson), you can even chop people up into little pieces, but you can't have sex with your children." The *Zap* artists thought that "we could knock down every taboo that there was." Instead, the police busted City Lights bookstore in San Francisco (not the first time the store or its owner, Lawrence Ferlinghetti, was in free-speech limbo), and in New York, *Zap* #4 was prohibited from being sold over the counter.

By the seventies, raunchiness in underground comics was the norm. And the courts protected it. Today *Zap* is a textbook example of how unleashing fringe removes them from being a threat to mores. In *Zap* #7, for example, Spain introduced "Sangrella," which serves as a paean to sado-masochistic lesbian eroticism with a sci-fi twist that addresses the extremes of such weird fetishism. In retrospect, it is little more than a ribald jab at the sexlessness of superheroes, which today has been rectified (especially in film adaptations). In *Zap* #8, Robert Williams' "Innocence Squandered," is less prurient than it is a satiric commentary on how pornography is adjudicated in the courts. By *Zap* #11, the strips became more experimental in terms of form and content. Crumb's "Patton," about the great blues performer Charley Patton, is a masterpiece of comic strip as documentary. In the same issue, Spain's "Lily Litvak: The Rose of Stalingrad" transforms a little-known historical fact into a comic strip that is kindred to the heroic comic books of the World War II era. And in *Zap* #13, even Gilbert Shelton turned his attention from fantasy to real life in "Graveyard Ghosts," a tour of Pére Lachaise Cemetery in Paris.

Over forty years later, American tolerance for bad taste has long ago stretched beyond *Zap*'s boundaries—just watch HBO. Today they are nostalgic reminders of what art was like before taboos disappeared. Sad to think it takes repression to make great art. **BW**

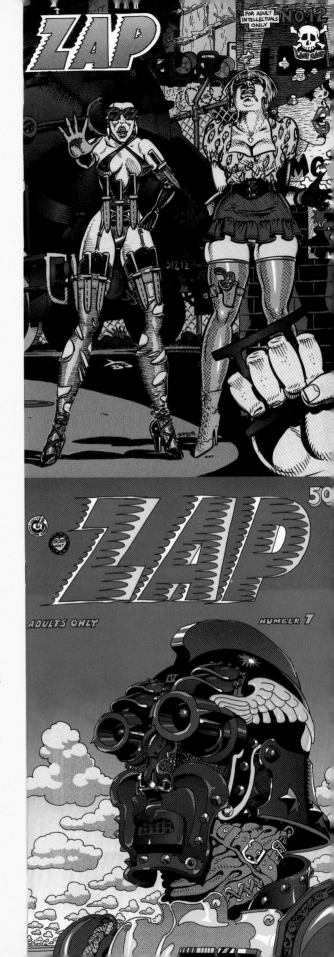

The Agnostic

LEFTOVERS
by Sergio Ruzzier

Bruno Passerini awoke one morning to the fact that he was dead.

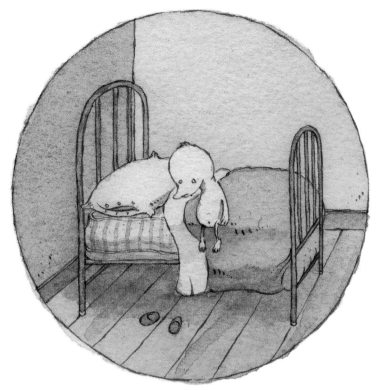

"Drat," he thought.

In the bathroom, his efforts proved
uncharacteristically futile…

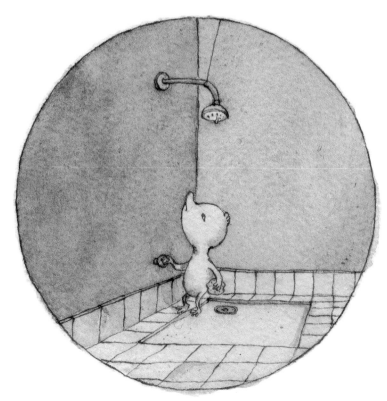

…as did his attempt to take a shower.

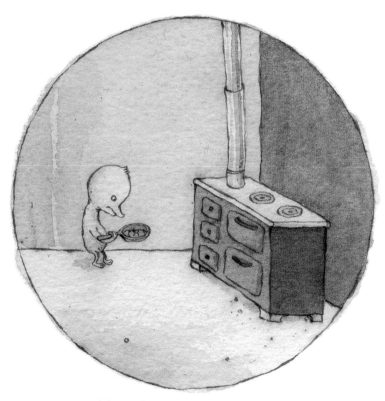

Unable to heat last night's leftovers…

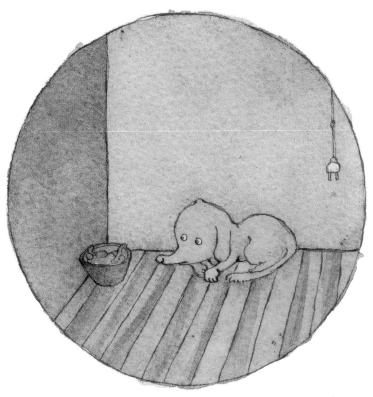

…he left them for his dog, who didn't touch them.

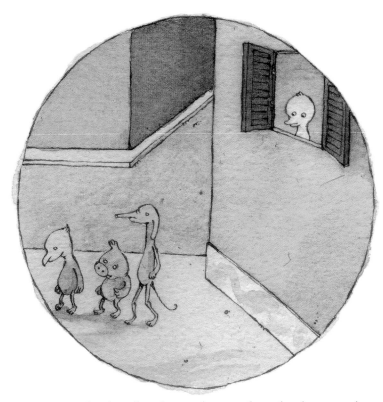

Bruno watched as his funeral passed under his window.
He failed to recognize anybody.

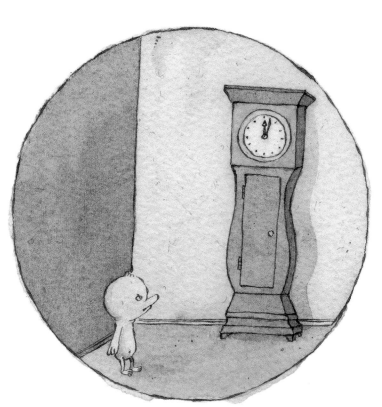

That midnight, the clock struck well over
twelve times.

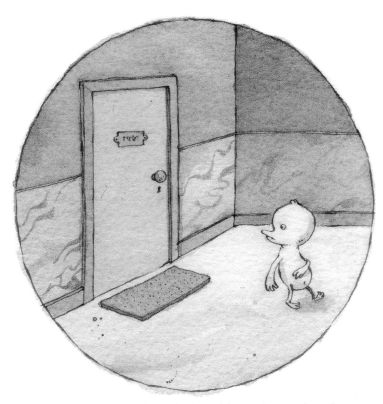

Closing the door behind him, he realized
he had left the key inside.

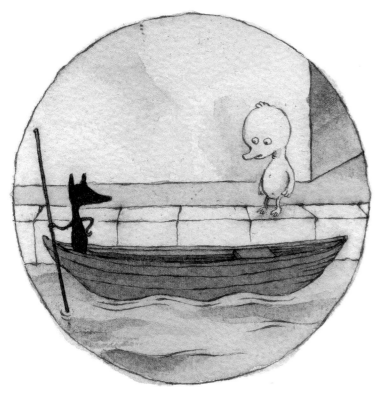

A boat was waiting for him.

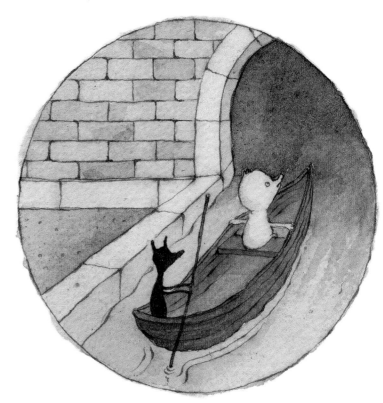

"Strange," he thought. "I don't recall a canal being around here."

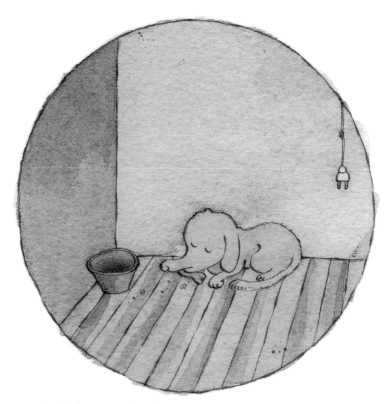

Back home, the dog finally ate the leftovers and fell asleep.

THE VEXING THING UPSTAIRS! — Denis Kitchen

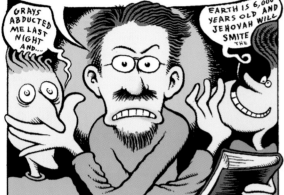

IT'S CRUCIAL TO NOTE UP FRONT THAT I'VE ALWAYS BEEN SKEPTICAL ABOUT RELIGIOUS AND SUPERNATURAL CLAIMS.

GRAYS ABDUCTED ME LAST NIGHT AND...

EARTH IS 6,000 YEARS OLD AND JEHOVAH WILL SMITE THE

IN THE 1980s I LIVED IN RURAL WISCONSIN IN A RUNDOWN FARM HOUSE NEARLY A CENTURY OLD.

I WAS MARRIED TO MY 2nd WIFE HOLLY. OUR DAUGHTERS SHEENA & SCARLET WERE NOT YET TEENS.

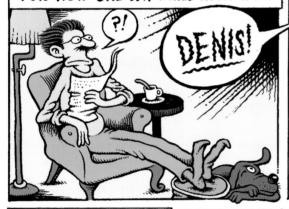

HOLLY AND THE GIRLS SOMETIMES HEARD VOICES AND FOOTSTEPS UPSTAIRS WHEN NO ONE WAS THERE, BUT I DID NOT. ONE DAY WHILE RELAXING...

?!

DENIS!

IT'S SHAKING! THE BEDSIDE TABLE IS SHAKING!

HURRY!

OUR SECOND-HAND BEDSIDE TABLE WAS RATHER ORDINARY OTHER THAN A METAL ASHTRAY SET INTO THE TOP. IT WAS *NOT* MOVING.

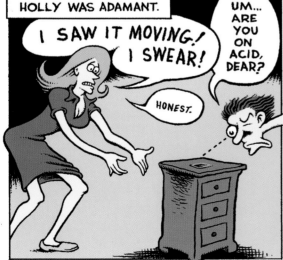

HOLLY WAS ADAMANT.

I SAW IT MOVING! I SWEAR!

HONEST.

UM... ARE YOU ON ACID, DEAR?

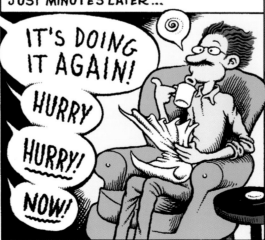

I RETURNED TO MY SPORTS SECTION. JUST MINUTES LATER...

IT'S DOING IT AGAIN!

HURRY

HURRY!

NOW!

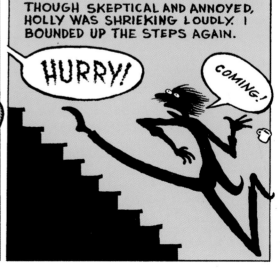

THOUGH SKEPTICAL AND ANNOYED, HOLLY WAS SHRIEKING LOUDLY. I BOUNDED UP THE STEPS AGAIN.

HURRY!

COMING!

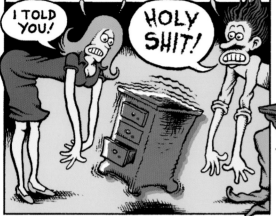

THIS TIME THE TABLE WAS SHAKING VIOLENTLY — SIDE TO SIDE AND UP AND DOWN — AS IF GRIPPED BY STRONG INVISIBLE HANDS...

I TOLD YOU!

HOLY SHIT!

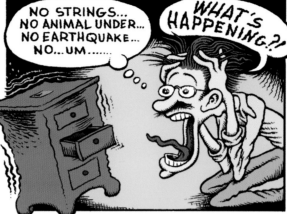

I COULD SCARCELY BELIEVE MY EYES. I LOOKED FOR **ANY** RATIONAL EXPLANATION. THERE WERE NONE TO MAKE SENSE OF WHAT WE WERE WITNESSING.

NO STRINGS... NO ANIMAL UNDER... NO EARTHQUAKE... NO...UM......

WHAT'S HAPPENING?!

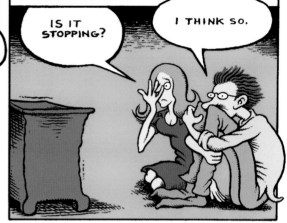

I CAN'T SAY EXACTLY HOW LONG THE PHENOMENON LASTED. PROBABLY JUST MINUTES. WE WERE UTTERLY STUNNED AND TRANSFIXED.

IS IT STOPPING?

I THINK SO.

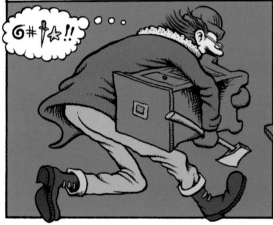

WAS IT AN INTELLIGENCE WE COULDN'T UNDERSTAND? A CAPTIVE SOUL? OR PURE EVIL? I DIDN'T THINK VERY LONG ABOUT IT AT THE TIME.

G#†☆!!....

I CHOPPED AND BURNED IT WITH A CERTAIN GLEE. IT WAS MY TURN TO BE IN CHARGE PERHAPS... THE THING HAD FREAKED ME OUT.

DIE CREEPY FUCKER!

SHOULD I HAVE SAVED IT? STUDIED IT? WAS THE "EVIL" OR "FORCE" IN THE HOUSE ITSELF? ALL I KNOW IS THERE WAS NEVER A RECURRENCE.

IN 1987 HOLLY AND I DIVORCED. A FEW YEARS LATER I MOVED EAST. I SELDOM THINK OR TALK ABOUT THE SHAKING TABLE.

ME? I COLLECT TACKY POSTCARDS AND DRAW CARTOONS AND...

HOW UM... FASCINATING... ...

OCCASIONALLY I'LL TELL SOMEONE. THEY'RE USUALLY SYMPATHETIC, OFFER THEIR OWN PSYCHIC EXPERIENCE, OR A QUICK "SOLUTION."

REALLY?! HIRE A GHOST DETECTIVE! Y'KNOW THAT POLTERGEIST ACTIVITY INTENSIFIES IF PREPUBESCENT GIRLS ARE IN A HOME? I SAW...

WELL I...

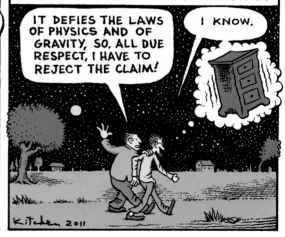

SHARING WITH A FELLOW SKEPTIC IS ESPECIALLY VEXING. THEY EXPECT HARD EVIDENCE, NOT ANECDOTES. JUST AS I DO. BUT WHAT'S LIFE WITHOUT SOME MYSTERY?

IT DEFIES THE LAWS OF PHYSICS AND OF GRAVITY, SO, ALL DUE RESPECT, I HAVE TO REJECT THE CLAIM!

I KNOW.

Kitchen 2011

THE GREAT SEA SERPENT
OF BRAZIL'S PARAHIBA RIVER

} BY MARK TODD {

On the morning of December 7th, 1905, a peculiar event was rumored to have taken place.

M.J. Nicoll & Edmund Meade-Waldo, two respected British zoologists, claimed to have witnessed an archaic beast, the likes of which had never been seen before.

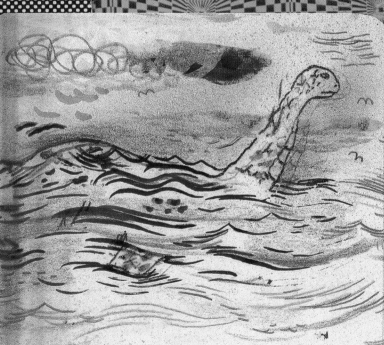

Not particularly enormous in size, perhaps nine feet from head to tail and fourteen feet in girth.

The creature at hand did not seem to be perturbed by the ship & its flustered passengers.

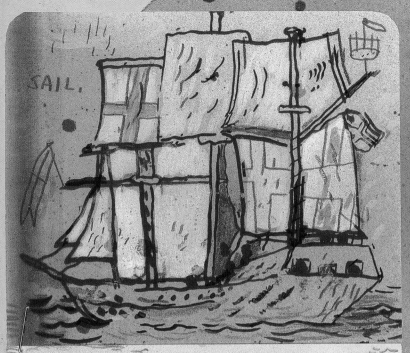

SAIL.

Turtle-like in appearance, it slowly meandered by, leaving a slight wake in its path, as if to make certain it was no apparition.

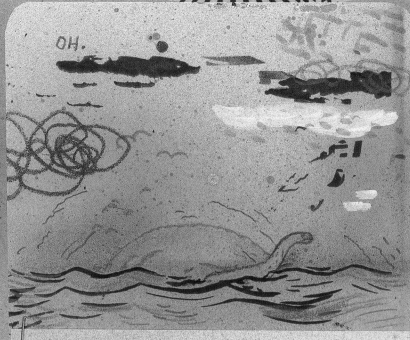

OH.

Within a few minutes, the creatures silhouette shrank into the mid-morning sun like a bowler hat with a finger sticking out of it balancing a turtle head.

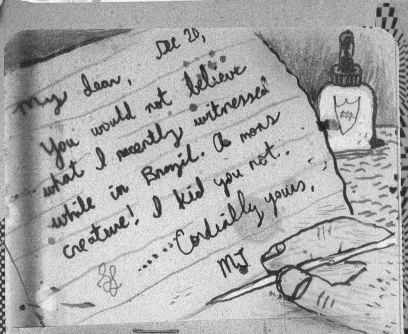

Estatic, the men set out to spread word of their tales. Letters to esteemed colleages were posted, lectures at high-minded universities were addressed.

BAD SIGN.

Dense & heavy books were written.

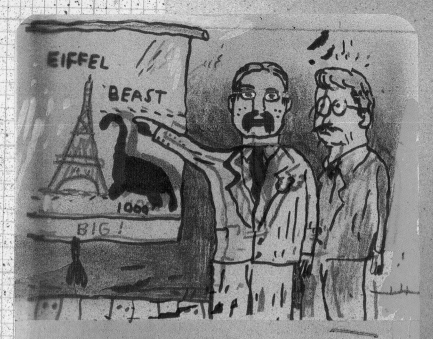

Occasionally, in their zeal to report what they had seen, & with absolutely no malice, facts & notations were confused or even omitted.

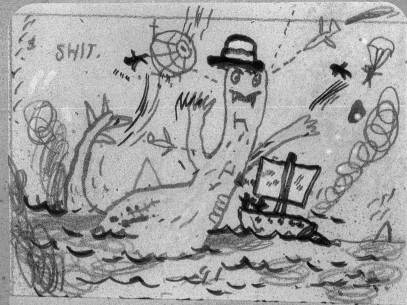

Stories abounded of additional sightings, each more fantastic than the last.

Before long, outlandish tales of the super serpent had reached fever pitch.

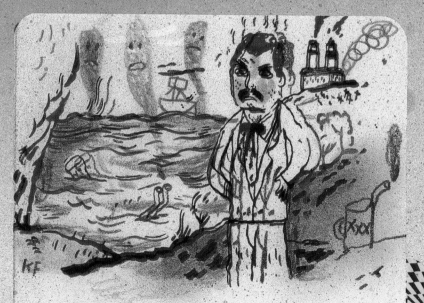

On more than one occasion, the beast was accused of mucking up the once beautiful & pristine Parahiba River with its "giant brown turtle logs."

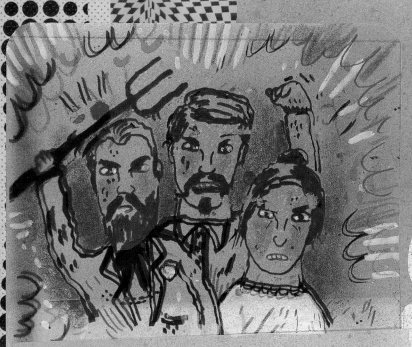

When anyone attempted to side with the loathsome forked tongued troublemaker, they were quickly branded as serpent lovers & heckled to tears. ———

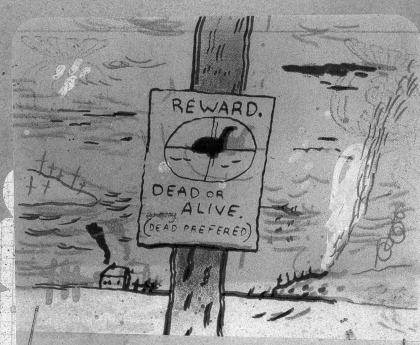

REWARD.
DEAD OR ALIVE.
(DEAD PREFERED)

By 1907, the giant serpent had gone from a source of pride for the Brazilians to an enemy of the people.

And then without reason, the stories abruptly ceased. —

Years have passed since the last sighting. The waters have settled & returned to their natural bluish-green state. Some speculate that the beast has died, laying along the river bottom, nutrient rich food for all the baby serpents it had with the stupid serpent lovers.

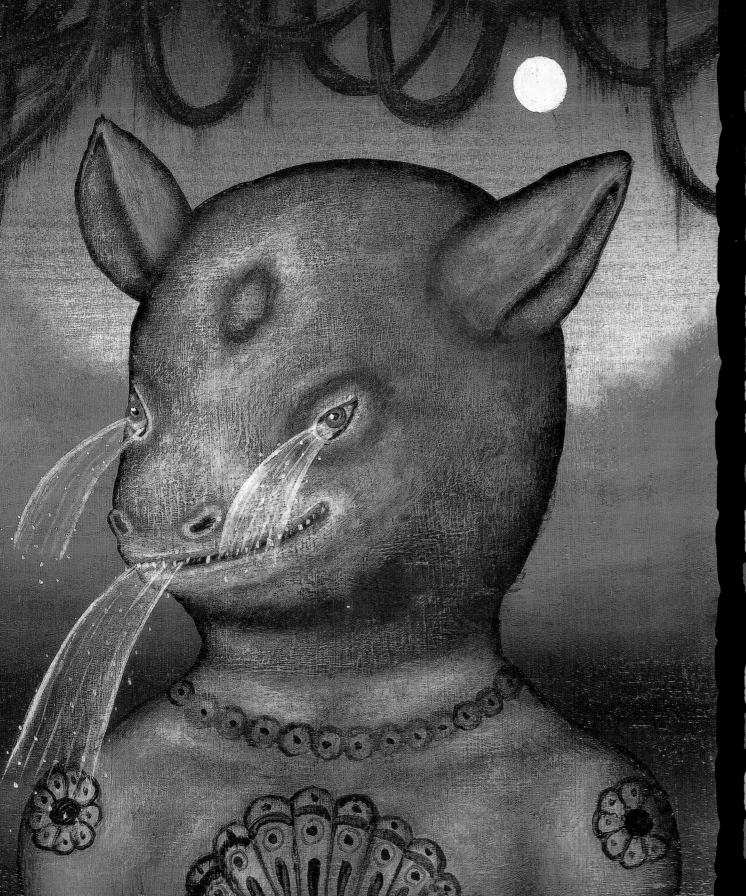

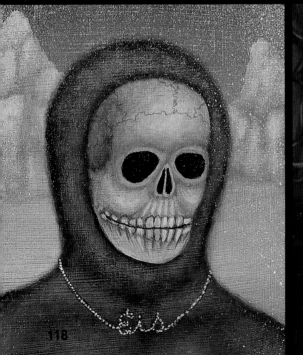

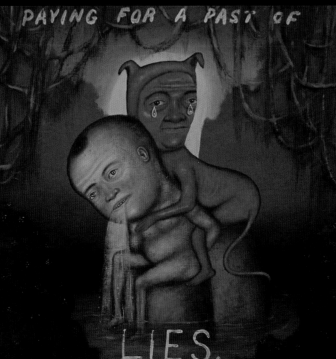

PAYING FOR A PAST OF

LIES.

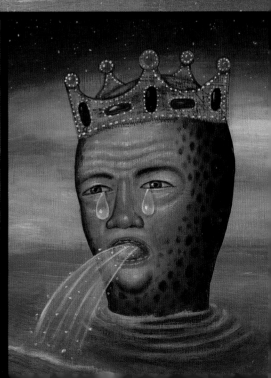

MILWAUKEE-BASED ARTIST FRED STONEHOUSE has been telling stories for nearly three decades. His unabashedly narrative images draw on themes that have concerned humankind for millennia. His art is resolutely humanist. Though profoundly personal, it is about us. All of us. A gifted draftsman, painter, and collagist, Stonehouse mines a wide variety of sources for his imagery, art historical and cultural. Italian and Northern Renaissance painting, Haitian and Mexican folk art, Catholic liturgy, comic books, and carnival graphics inform his work in equal measure. Considered against the backdrop of our own time, his art is a potent critique of a peculiar aspect of American thought and culture. Americans tend to privilege an approach to understanding that relies on polarizing objectivity. Things are either black or white, right or wrong, good or evil, with us or against us. We like our lines drawn clearly, and we want to know who or what is on each side. And we frequently favor the concrete over the abstract in our art, literature, and thought. This kind of thinking, a vestige of our puritanical heritage, has permeated American culture since the colonies' dawn. Stonehouse's work offers the thoughtful and receptive viewer a way out of and beyond this crippling tendency by engaging our often underutilized capacity for critical thought and pitting it against polar thinking. He is our guide through that vast and gray realm between the poles wherein the realities of human existence lie.

Stonehouse, who was raised in a working-class family in Milwaukee, recalls: "I drew before I can remember—a mixture in my mind of paint and pleasure. We lived above my grandparents, and I would entertain myself by going to their living quarters and look through a set of encyclopedias they had. I particularly loved the 'S' volume—it had a picture of Saturn plunging into the sea that I found fascinating and wonderful. I took my favorite orange crayon and 'enhanced' it. I felt in this way I was possessing it, making it mine. To this day I use such paper from maps, texts and books in my collages. Think of it as 'visual chatter'." But, "it was in kindergarten," Stonehouse says, "that I first realized that maybe I was better at [making art] than the other kids. That's when I first began to identify as an artist."

No one in Stonehouse's family had ever gone to college, and he assumed the course his life would take would be no different. In high school, he was able to make decent grades with little effort, which afforded him plenty of time to pursue his art. His senior year, with the necessity of gainful employment after graduation looming, the artist enrolled in an automotive technical education course. He soon realized the prospect of a life working on cars was anathema to him. Stonehouse was sure of one thing, though. He loved to paint. But how he might parlay that passion into a livelihood was quite another matter. He took a pragmatic approach and enrolled in art education at the University of Wisconsin–Milwaukee, hoping to combine his

love of painting with the practicality of a career as an educator. Though he found immense pleasure in his studio art courses, he never took a single art education course. At some point during his collegiate career, the artist arrived at a critical crossroads and "decided that when I got out of school I'd just get some crappy-ass job and then do the art I loved in my time off!" This realization is significant. It's the kind of thing that separates the serious artist from the poseur. For Stonehouse, being an artist is not a lifestyle choice. Making art is essential, and the imperative to do so will assert itself regardless of any other considerations. Like most artists worth our time and thought, Stonehouse has no choice. He must make art. No matter what.

The repository of historical imagery Stonehouse has at his command is immense. This is, in part, a collateral benefit of his student job in college as a slide projectionist for the art history department, which provided the opportunity to see and think about countless works of art from across the full range of history. Though he has a particular affinity for early Renaissance painters, especially the Northern artists like Jan van Eyck, Stonehouse is perfectly comfortable mashing up a mélange of stylistic influences from across epochs and continents. And he does so without the slightest hint of self-consciousness. Commingling in a single Stonehouse painting one might find a somber-toned, tightly rendered visage evocative of Northern Renaissance portraiture attached to a freakishly hybridized body; a smoky, atmospheric landscape in the manner of Leonardo; brightly colored and dripping balled spatters recalling the performative gestures of the New York School—all emblazoned with captions rendered with a graphic punch befitting a carnival banner. Yet, for all their strident disjunction, the paintings feel eerily comfortable and natural. Nothing about them suggests a forced imposition of weirdness for its own sake, the kind of youthful bad practice that can plague the work of younger artists seeking to establish their hipster credentials.

The theme of good and evil predominates throughout Stonehouse's work. Though moralistic, his imagery is not moralizing or prescriptive. And while figures abound, none seem cast as heroes or villains. They are, rather, despairing and freakish characters, often appearing beaten down, broken, and drained of their humanity, who manage to bear their lot with dignified and saintly comportment and quiet resignation. Often their faces bear a striking resemblance to Stonehouse—the artist as everyman. He is us. In the artist's hands, good and evil are not mutually exclusive, opposing forces. They are components of a larger whole. Moral ambiguity is a hallmark of many great works of literature—Shakespeare's *Hamlet*, for example. Stonehouse's work, too, shows us that the line between good and evil is fluid and constantly meandering and shifting.

In Stonehouse's world, humankind cannot be divided neatly into the good and the evil—both

Mas vale saber
Que haber.

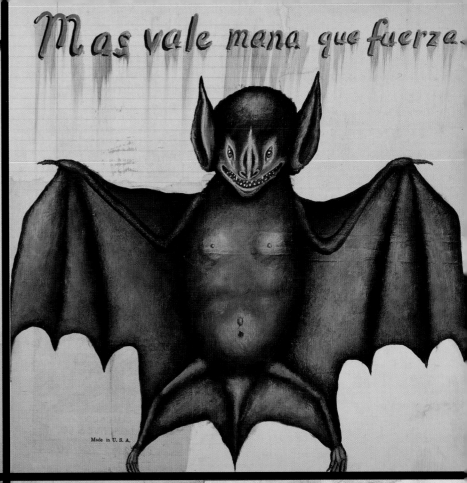

Mas vale mana que fuerza.

Mas ven Cuatro ojos
Que Dos.

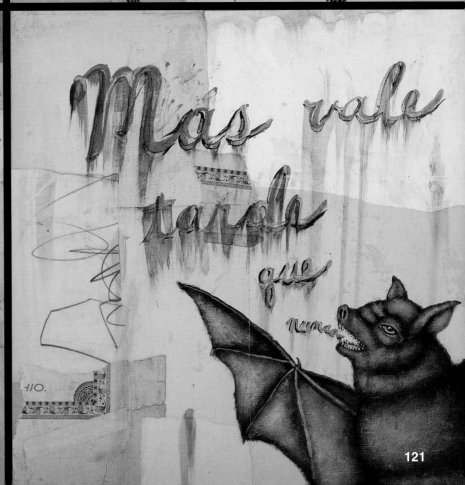

Más vale tarde que nunca

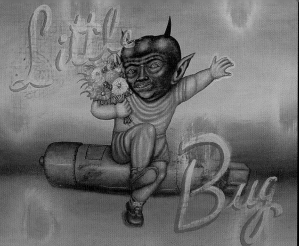

Little
Bug

SCOUR THE FLAMBEAU
ZOTZ
IN A
TROUBLING
MYSTERY OF THE SOURCE.

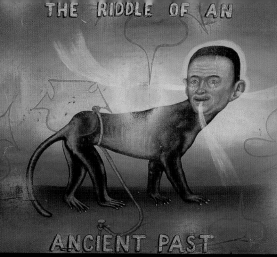

THE RIDDLE OF AN
ANCIENT PAST

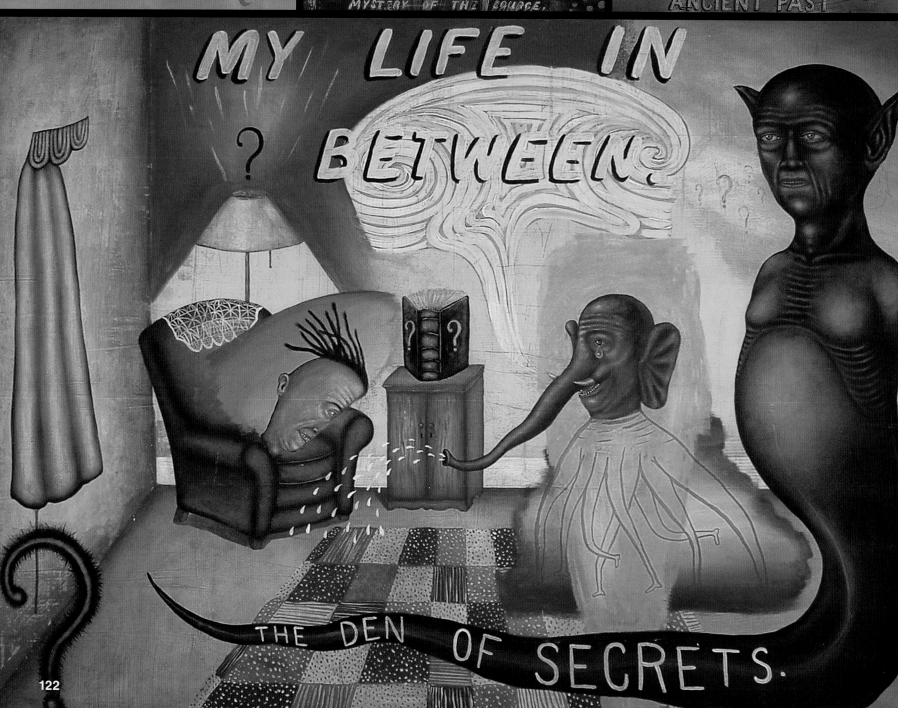

MY LIFE IN BETWEEN

?

THE DEN OF SECRETS.

conditions are resident in us all. The artist depicts the struggle with our dual nature in *A Journey of the Chonchón*. In this painting, two figures wrestle underneath a canopy of trees in a haze-enveloped swamp, each bearing the artist's likeness. One, black and winged, represents the Chonchón, a birdlike creature with origins in Mapuche mythology and Chilean folklore. These mythical beasts are said to be the transformation of benevolent sorcerers or shamans known as kalkus, on whose behalf the Chonchón carry out wicked deeds. As the noose held by the teary-eyed, red-headed figure suggests, we all have our own Chonchón and must take care not to give them free reign.

Little Bug, a painting of an impish, black-headed, pointy-eared, horned, and Caucasian-limbed child clutching a bouquet of flowers and seated atop a torpedo-shaped bomb, instantly invokes the American bombing of Hiroshima, Japan, on August 6, 1945, in World War II, one of the most morally contested episodes in human history. Clearly, Stonehouse's title is a play on "Little Boy," the code name given the atomic bomb that forever turned the world upside down that August day. It is a highly conflicted picture of evil (the bomb) shrouded in innocence (the "cute-as-a-bug" child) and goodwill (the flowers). More broadly, the title suggests disease (bug as virus) or a glitch or imperfection in humankind's collective genetic makeup that compels us to commit such horrific atrocities against each other in the name of good.

Evolution's inability to drain from our gene pool the human impulse to fuck things up is one of life's great mysteries and one that is an underlying theme throughout much of Stonehouse's work. Consider *The Riddle of an Ancient Past*, in which a human-headed, four-legged feline beast is seen tethered at the haunches to a stake in the ground. Empty heraldic, shield-like shapes drift past as the figure casts an incredulous stare toward these vacuous references to wealth and power, his disbelief heightened by the stream of wind that passes in one ear and out the other. A similar stream issues from his mouth as if an empty proclamation. Have we really advanced beyond the beasts? Will we ever listen? Will we ever learn?

Another painting, *Sea King*, seems to propose that humankind is doomed to endure an endless cycle of despair from which it can't free itself. The figure in this image, his trout-skinned head weighted down with a golden crown of jewels, is unable to rise out of the watery and infinite emptiness to which he is shackled. Two cold and leaden tears fall from his eyes and water spouts from his mouth, rejoining the murky abyss and underscoring the elemental nature of the human condition.

In *Schneemann* (Snowman), a celebration of futility, Stonehouse again points up the folly of the human drive to amass wealth and material. Here we see a skeletal figure clad in a fur

parka, his only protection against the eternal iciness of the landscape he inhabits. His gold tooth and diamond-studded necklace bearing the word "Eis" (ice), remnants of earthly bling, have even less utility now.

Stonehouse's collages combine his childhood attraction to the "visual chatter" of paper scraps and his penchant for creating rich, multi-layered images teeming with ambiguity. In a recent body of work, the artist takes for his subject a creature feared and reviled by most Americans, the bat. These square-format images usually feature a single painted figure of a bat against a background composed of fragments of old ledger book pages, bits of filigreed decorative borders from old labels, and odd scraps of paper with handwritten notes and scribbles. The aphoristic titles of these works appear in red, emblazoned across the top. Like many deeply held beliefs, Americans' fear of these flying mammals is irrational and misplaced. Bats constitute twenty percent of all known mammalian species and are ecologically invaluable. They are significant agents of flower pollination and seed dispersal, for example. They are also the only mammals capable of sustained flight. Despite their much maligned and misunderstood nature, some bats should not be trusted, as Stonehouse's *Mas vale mana que fuerze* (Brain is better than brawn) suggests. Occupying most of the frame of the artist's interpretation of an old Spanish proverb, a jug-eared, beady-eyed bat casts a thin-lipped, shit-eating grin as it draws its wings open like a flasher's trench coat. The creature's facial features suggest a caricature of a recent occupant of the White House, an identification strengthened by the "W" form of the animal's outstretched arms and the typeset "Made in U.S.A." appearing in the lower left. Running across the top, the red letters of the title bleed downward over a ledger sheet fragment, invoking the senseless cost of a swaggering "with-us-or-against-us" foreign policy.

My Life in Between is an apt summation of Stonehouse's life and art. Here, an array of seemingly disjunctive and fragmentary elements are gathered together in an interior space. Riddles abound. The cerebellum-shaped, pinkish thought cloud hovering above the scene suggests the divide between mind and body, rational thought, and instinctual behavior. Framing the scene is an armless and devil-eared humanoid with a face resembling the artist's. Its snake-like tail slithers across a patchwork rug and bears the inscription "The Den of Secrets." Providing compositional and intellectual balance, this figure is a picture of evolutionary equipoise. In one sense, Stonehouse's imagined interior can be understood as the place in which the artist works in those moments between the realities and obligations of life—familial, financial, and otherwise. In a deeper sense, the painting, like much of the artist's work, speaks to the hope residing in a balance struck between the poles of good and evil. **BW**

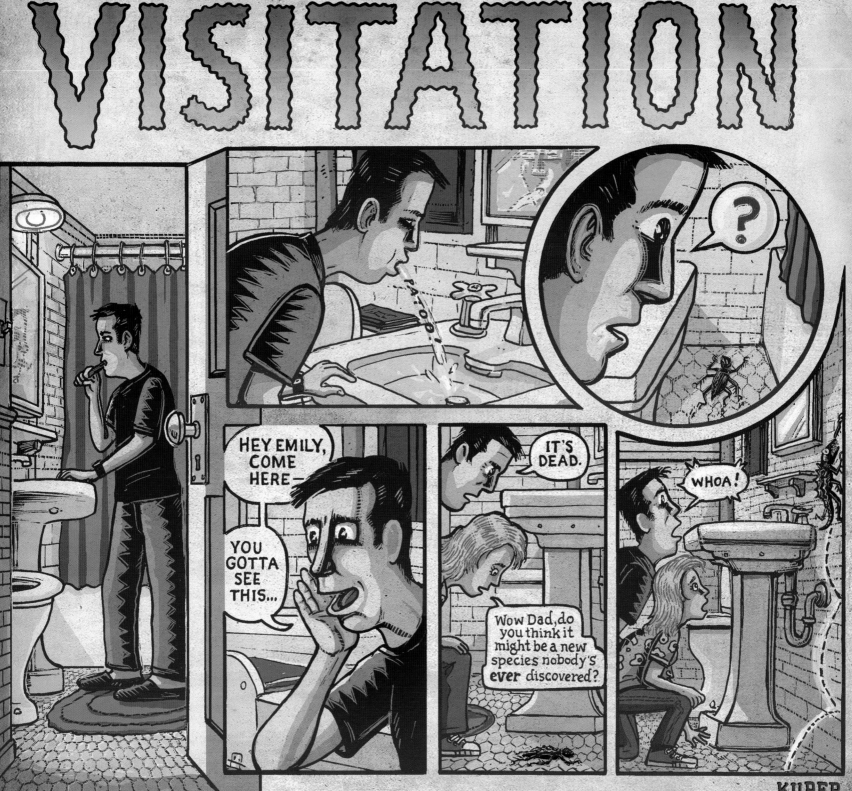

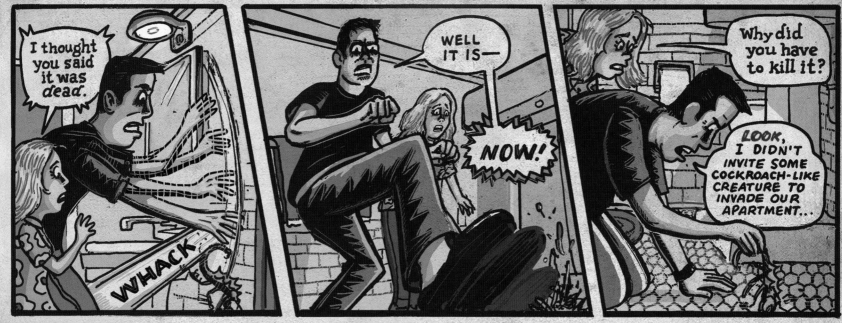
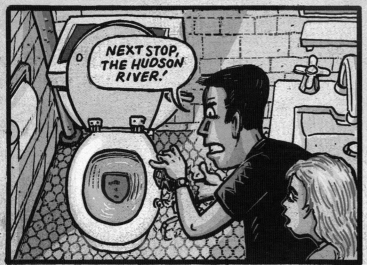
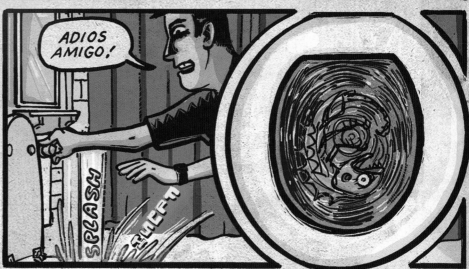
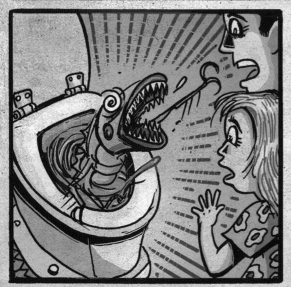

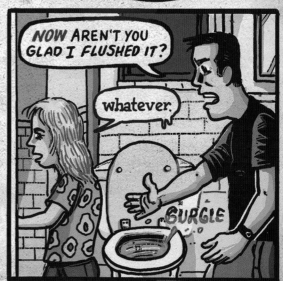

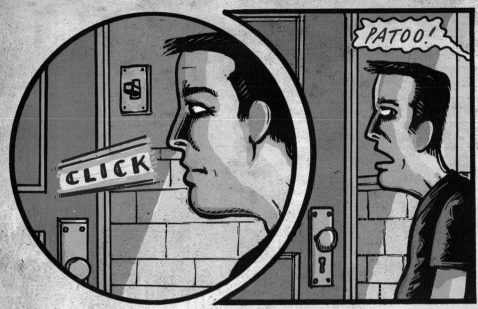
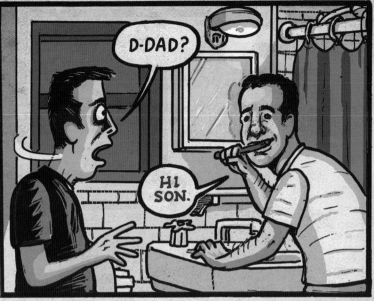
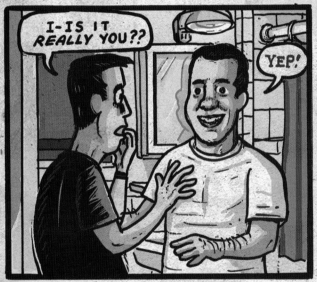
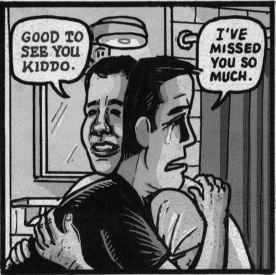
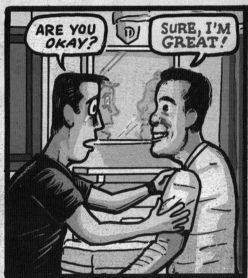
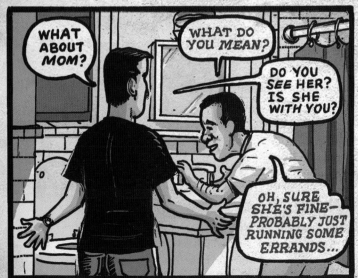
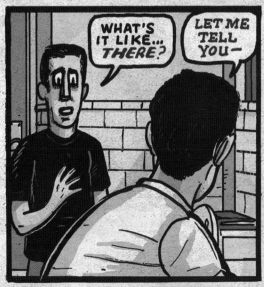
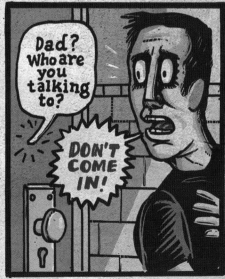

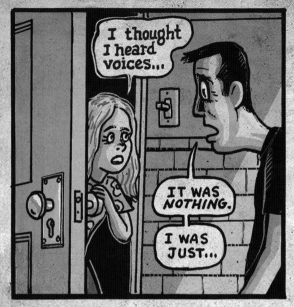
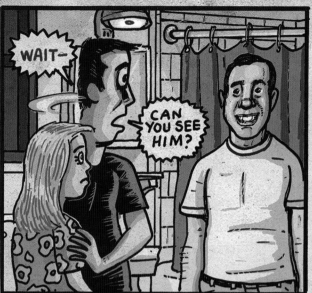
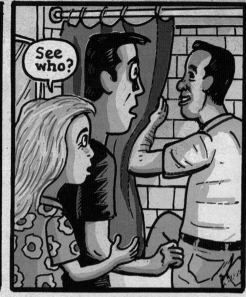
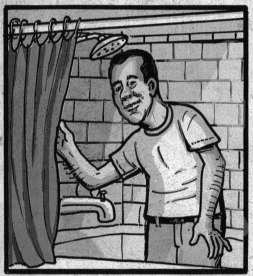
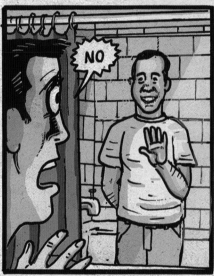
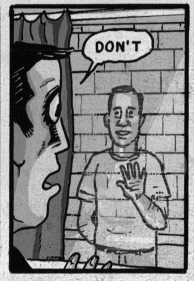
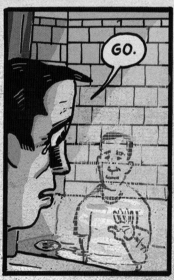
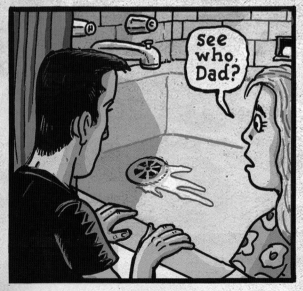
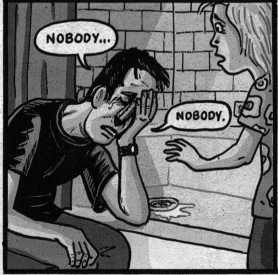
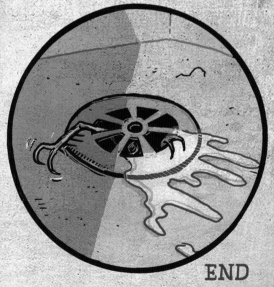

END

128